The Animation Producer's Handbook

The Animation Producer's Handbook

Lea Milic and Yasmin McConville

First published in 2006

Allen & Unwin
83 Alexander Street
Crows Nest NSW 2065
Australia
Phone: (61 2) 8425 0100
Fax: (61 2) 9906 2218
Email: info@allenandunwin.com
Web: www.allenandunwin.com

National Library of Australia
Cataloguing-in-Publication entry:

Milic, Lea.
 The animation producer's handbook.

 Bibliography.
 Includes index.
 ISBN 0 33522 036 3.

 1. Animated films - Production and direction. 2. Animation
 (Cinematography) - Production and direction. I. McConville,
 Yasmin. II. Title.

791.4334

Set in 9.75/14pt Stempel Schneidler by Bookhouse, Sydney
Printed and bound by CPI Group (UK) Ltd, Croydon, CR0 4YY

Contents

10
3D production 129

11
Post-production 140

1 Animation

Animated films and persistence of vision

An animated film is easily defined as any film where each frame is produced individually (or frame-by-frame) and where the illusion of movement is achieved by the lining up of either two-dimensional (2D) drawings or computer generated images or three-dimensional (3D) objects such as clay or Plasticine. When these frames are photographed by a camera, compiled together and then projected at a speed of 16 frames or faster per second, the illusion of continuous movement is achieved. For many years this illusion was explained by a phenomenon called the persistence of vision. In 1828 a Frenchman by the name of Paul Roget described it as an effect usually attributed to a 'defect' of the eye (or in some accounts the 'eye-brain combination'). What this means is that when the human eye views a set of images at high speed, as well as recognising the image directly in front of it, it also briefly retains the previous image. The images appear to be continuous and the illusion of movement is created.

Persistence of vision is also known in psychology as the effect of 'positive after images'. There are a few other theories out there regarding this phenomenon, but this is the most popular philosophy used to explain the mechanism for motion perception in cinema.

Animation is a highly creative film category. The term itself comes from the Latin word *animate*, which means to bring life to or to invoke life—a divine task indeed! The process of producing animation definitely brings to life something

that didn't previously exist, except in the minds of the idea creators. These ideas are transposed through the creative and production processes to wind up as the wonderful images we see on the big or small screen. These images have the power to elate an audience, ignite fear or horror, or bring a tear to the eye.

What is animation production?

Animation production is the process that brings the envisaged product to life by taking it from the esoteric level of an idea to the level of physical existence.

Animation production is commonly divided into the following segments:

- development
- pre-production
- production
- post-production

What is an animated project?

An animation project is any kind of visual structure created frame-by-frame. It is a micro-organisational entity that needs to be cultivated and cherished until it reaches the stage of being a finished product.

Why is it a micro-organisational entity? The major definition of organisational structures tells us that there are three key organisational levels: macro, **mezzo** and micro.

The macro-organisational level can be defined as the level of a particular branch at the country or state level. For example, a state government would fall into this category. Mezzo is the mid-organisational level and a good example of this would be any medium to large business. An animation company (Disney, for example) would fall into this section. The micro level would be used to define the individual projects being undertaken by any of those companies. So, the mezzo-organisational structure, say an animation studio, is producing an animated television series (that's the micro-organisational level), while adhering to the rules set out by the macro-organisational structure (in this case, the government).

In discussing what makes an animated project it is important to identify the different types of animation. The list below is a breakdown of the various types of animation based on their technological differences:

- Stop motion animation refers to the process of capturing or photographing an image one frame at a time. The image will be posed slightly differently in each frame or sequence of frames. Stop motion subjects can be created with clay, Plasticine, wood, wire and even patient humans. Animation that contains models made of clay will sometimes be referred to as Claymation. This term is actually a registered trademark of Will Vinton studios, who produced clay-animated advertising during the 1980s and 1990s.
- Pixilation is a branch of stop motion animation and uses live objects (usually people) as the subject.
- Puppet animation is yet another branch of stop motion animation. However, this genre uses marionettes or puppets as the subject.
- Computer-generated animation, or CGI, is any animation created using computer technology. Images can either be scanned into, or wholly created within, the computer environment. They are then manipulated using a variety of available software packages to create the desired effect.
- Cut-out animation or collage is the animation of flat elements (characters, props and backgrounds) that have been cut out of photographs, magazines, paper, cardboard or fabric. Today these cut-outs can be wholly generated digitally or taken from tangible objects such as those mentioned above, and scanned into a computer for further manipulation.
- Direct-on-film animation is created by painting, etching or drawing directly on to raw film stock.
- Drawn animation is created using images drawn on a plastic cel, paper or a similar medium. Historically, this has been the dominant form of animation production.
- Silhouette animation uses cut-outs to create a silhouette effect.

Mixing the above-mentioned categories, either among themselves or with live action footage, can also form different animation hybrids. The most common hybrids are 2D drawn animation with 3D elements and vice-versa.

Undisputedly the three major and most popular categories of animation are:

- 2D drawn animation such as *The Simpsons* or *Rugrats*
- 3D computer animation such as *Monsters Inc.* or *The Incredibles*
- 3D stop motion such as *Wallace and Gromit*

Applications for animation

Animation has many different applications. Here are the main divisions:

- product commercials
- educational films
- feature films (a theatrical film that is longer than 60 minutes)
- music videos
- web animation
- original animated video (a program created for home video playback, be it videotape, laserdisc or DVD)
- short feature films (a theatrical film that is longer than 30 minutes but shorter than 60 minutes)
- short or experimental subjects (a theatrical or television film that is shorter than 30 minutes)
- broadcast television series (at least 30 minutes in length, including segments)
- broadcast television specials (an hour in duration, including segments)
- broadcast television short subjects (also a series, but one which is between 1 and 21 minutes long)
- television bumpers (introductions/endings of program segments, only a couple of seconds long)
- video games
- architectural animation
- medical or other industrial films
- multipath movies
- logos, intros and credits for other structures
- avatars, banners and web advertising
- mobile phone images

Development of the animation industry

The animation industry has come a long way since 1906 when J. Stuart Blackton made the first animated film, *Humorous Phases of Funny Faces*. Blackton's film employed the methods of both drawn animation and stop motion by using hand-drawn faces against a blackboard, shot frame by frame. For each new frame he would simply rub out the previous face and draw another one.

In the past century, animation has grown from an experimental fringe art form into a staple of television broadcasting, advertising, cinema and web entertainment. Animation is a very labour-intensive and costly exercise and the development in production techniques for this medium have been closely related to the overall desire to decrease costs and production times. The animation industry in the early 1900s was made up of very small studios creating short films for the cinema. The first major development in this direction was the invention of the celluloid sheet by Earl Hurd in 1913. This opened up the idea of layering elements on top of one another so that static drawings, such as backgrounds, could be drawn just once and character elements could be animated over the top on clear cels, thus allowing the background to be seen. This technique saved an enormous amount of time and money in production because previously each animated frame had been entirely redrawn. In 1914 John Bray of JR Bray Studios pioneered the idea of the animation assembly line, which is still largely in use today. He later joined forces with Earl Hurd, to combine their methodologies and form the Bray-Hurd Process Company.

While World War I was waged, many European studios were unable to continue their experimental works. The United States, on the other hand, continued to produce and develop their domestic animation industry, laying the groundwork for their domination of the worldwide market. US studios flourished and as demand grew, animation production became a more realistic commercial venture. In 1928 Walt Disney released *Steamboat Willie*, the first successful animation short to use synchronised sound. During the 1930s and 1940s animation was regularly used in movie houses across the United States as a warm-up piece before the main movie. Disney, Fleischer Studios, Warner Brothers and MGM were making literally hundreds of short animated films for this market.

However the production boom was short-lived. In 1955, the animation industry in the United States began to crumble. Television had arrived, and animation was deemed to be much too expensive for this new medium. By the end of the 1950s many of Hollywood's animation studios had closed their doors. Something had to change in order for the industry to survive.

That change came in the form of a brand-new animation technique, pioneered by artists at UPA studios some years earlier and adopted by many of the larger companies in the 1950s as a way to produce cost-effective animation for the television market. This system was called 'limited animation' and effectively cut down on a lot of the repetitive work involved in redrawing entire characters for each frame of picture. Instead, the animation was limited, keeping character bodies static (like backgrounds) wherever possible and simply animating only the moving body parts on a separate level. For example, characters that were not required to

move or speak would be drawn as static images with only their eyes animated to blink on a separate level. Character bodies would be held static while their heads, mouths and eyes were drawn on separate levels and animated. This new system also made use of walk cycles or common animation sequences throughout the course of a series, as opposed to using them only once. These changes had a dramatic effect on the cost of producing animation. The technique wasn't without its critics though, with many in the industry complaining that studios had been too heavy-handed with its use, resulting in a sharp decline in the quality of animation being produced for television.

Cartoons became the staple of Saturday morning children's television throughout the 1960s, 1970s and 1980s. In the 1980s a revolution was to take place, again driven by the desire to cut the cost of producing animation.

The idea of finding cheaper labour offshore caught hold of the industry. Studios would retain the creative development and pre-production in-house, while all non-creative elements such as in-betweening and painting would be completed offshore, where the prices were cheaper. Many countries, like the United States, Australia, France, Great Britain, Canada and Germany outsource a great deal of their production work to this day.

Initially, animation was sent to China, Korea and Taiwan. After the fall of the Berlin Wall a few new players joined the game. Former Soviet republics, Poland and Hungary began to vie for their own place in the competitive animation market. The current hot spot for animation growth is in India, with the local industry becoming heavily involved in the 3D market. A lot of other 2D servicing studios have recently become involved in the 3D market as well. Increased competition in this market has resulted in a drastic reduction in the cost of producing animation.

There are other valid reasons for outsourcing part of an animation production. In the United States the reasons are purely financial. Canada and Australia also outsource for financial reasons, but the lack of traditional animators in these countries also makes outsourcing an attractive prospect. An interesting point is that both the Canadian and Australian governments have set up programs and initiatives for the protection and development of local content. This means that the creative elements make the projects eligible for some degree of taxation relief. A similar situation also exists within several European countries.

The seeds of another trend, which was to forever alter the landscape of animation production, began to gain momentum during the 1970s and 1980s. That trend was computer animation. While experimentation was done during the 1960s in laboratories, it took a while for the artistic community to be convinced that these cold and lifeless machines could be capable of producing art. Three-dimensional

imaging began developing during the 1970s but the largest step towards computerising the industry came in the 1980s with the development of digital ink and paint packages for 2D studios.

In 1990 computer animation became a standard process at Disney Studios and replaced the traditional method of hand-painting cels with a digital ink and paint package. *The Rescuers Down Under* was the first Disney feature to utilise this software. Two-dimensional computer animation with a small mix of limited 3D special effects became a popular choice for many animated features throughout the 1990s, such as *Aladdin* and *The Prince of Egypt*. In the early 1990s, three-dimensional imaging was still finding its feet and was still very expensive to produce, even by animation standards. The full 3D explosion occurred roughly midway through the 1990s. By this time, technology had advanced to the point where it became viable to start thinking about producing entire films in this genre. Pixar's *Toy Story* (1995) became the first feature to be fully animated in 3D and opened a veritable floodgate of high-quality 3D films.

Pixar was initially an arm of LucasFilm and was bought for US$10 million in 1986. At the time the company's main business was focused on the development of high-end visual processing computers for the medical industry, but the company also produced short animations as a way of demonstrating the power of the hardware they were trying to sell. The hardware never took off, but the short animations managed to capture people's attention. The animation department began to overtake the development department in terms of sales success when they began taking on advertising jobs. Pixar eventually cut back on their computer department and increased staff numbers in their animation department. This change of business tactic was marked by the company's US$26 million deal with Disney Studios to produce *Toy Story*. Pixar continues to be the trailblazer in 3D animation production, having followed up *Toy Story* with several high box-office grossing 3D features.

The majority of animated programs today are serials made for television and cable distribution. Technology is constantly evolving and animation design is becoming more abstract, with outlandish styles ranging from *Ren and Stimpy* to *The Powerpuff Girls* to *Dexter's Laboratory*. Shows like *The Simpsons* and *South Park* have bolstered the adult prime time market for animated shows.

Animé has become a driving force in the animation world in the past decade, with Manga gaining enormous popularity throughout Western countries. Some of the more well-known titles in this genre are *Ghost in the Shell*, *Princess Mononoke* and *Spirited Away*. The first animé series to gain popularity was Osamu Tezuka's *Astro Boy* in 1963. Animé developed further during the 1970s and by the 1980s

was one of the most popular animation forms in Japan. Animé is usually characterised by limited animation. However, many of the studios have elaborated on this technique through the use of still shots, with characters being moved across the screen, scrolling or repeating backgrounds, and using static images of talking characters and animating only their mouths. One of the most successful Japanese animé production houses is Studio Ghibli, which was founded in 1985. Often referred to as 'The Disney of the East', Studio Ghibli has been at the forefront of animé feature film production in Japan. Higher production values and attention to storytelling techniques have seen the studio produce the highly successful *Princess Mononoke*.

Technological advancements, both in the animation industry and with the Internet, have brought animation production literally to the people. Nowhere is this more evident than with Macromedia's Flash program. Developed throughout the 1990s as a program for web design, it has evolved into a robust program capable of creating streaming animation from a home computer. Studios, which were once shy of a program like Flash, are now beginning to sit up and take notice. As a result, the program is being heavily incorporated into professional studios for the production of broadcast-quality material.

Animation in one form or another is now firmly entrenched in film, television, advertising, music clips and games. The popularity of the animated feature appears to be growing. Some animated shows made initially for television have spawned such a cult following that they have been reworked for the big screen. A hit film can now spin off into an animated television show or computer game. Armed with a great idea and the practical know-how, the sky is the limit for animation production.

2

The producers

Before launching into the production pipeline, it is important to understand the varying roles of the animation producer. Factors that determine the part they play within a production structure include the medium of animation being produced (film, television, games, advertising), the size of the project, the structure of the studio they are working for and their level of expertise. There are also several different types of producing roles within the animation industry. Some productions may require that all or only some of the following positions are necessary.

The executive producer

The executive producer is involved with the project in one way or another from its inception right through to final delivery. This person is responsible for selling the concept and organising various deals in order to gain funding. Sometimes this is done in conjunction with a producer, but if not, the executive producer will be the person responsible for hiring the producer. There are two distinct types of executive producer—the business only executive producer, and the business/creative executive producer.

The business only executive producer will be involved in the buying and selling of concepts and completed shows. In established studios they will represent the company at all of the market-place events and industry meetings and will be the person responsible for selling studio concepts; securing funding, co-production partners and distribution partners; and ultimately keeping the studio in work. They

will also be responsible for approving budgets and schedules and will expect to be kept fully up to date in both of these aspects throughout the life of the production. This particular type of executive producer will be heavily involved with the concept evaluation and development. However, as the production moves forward into pre-production they will usually step back and allow the producer to take control of the show. This style of executive producing is common in established studios where several different productions are being undertaken consecutively because it leaves the executive producer free to work across all projects.

The business/creative executive producer will perform all of the tasks associated with the business only executive producer, but they will also be much more involved with the look and development of the show as it moves through the pre-production, production and post-production processes. This style of executive producing is common in the feature film arena, where executive producers will expect to have approval rights on character designs, storyboards, animatics and picture edits. When this is the case they will usually be the last internal approval point before work is sent to a client. This more hands on type of executive producer may also be involved in the hiring of some of the key creative staff.

Note that often the title of executive producer can also be given to the key deal-maker in the co-production or distribution company.

Regardless of their style, a good executive producer needs to be able to identify a concept that will have market appeal. This means that they need to keep up to date with market trends. There is no point in developing a concept only to find out down the track that another production company is already working on a similar idea, or that this year buyers are looking for only specific types of shows. A good executive producer will always be aware of what is currently being broadcast, bought, produced and developed.

The producer

The role of the producer is to drive the production from conception to delivery. They must keep in touch with every single facet of the production in order to ensure that everything runs smoothly. The best way to explain the magnitude of the producer's role is to read through all the elements in this book keeping in mind that the producer's job is to make each of these tasks happen with a minimum of fuss and within the bounds of the schedule and budget.

The producer can be involved with the project from the conception; in fact, the project may be the producer's own idea, or they may be assigned or hired for

a project at the beginning of the development phase. If the concept originates with the producer then they will often work with the executive producer in order to obtain funding and distribution. The different types of producer that exist within the animation industry can be divided into two very broad categories—the business producer and the facilitator producer.

The business producer will be involved with the project from day one and, as mentioned above, will work with an executive producer in order to sell a concept to obtain funding and distribution. It is not unusual for an independent producer to approach a studio with a project that already has some, if not all, of the funding secured. In such a scenario, the producer will be involved with the set-up of the project, contribute to the creation of the budget and schedule and negotiate with and hire any key creative personnel not provided by the studio. They will also work with the production staff to shape the artistic look and feel of the show through the scripting, design, storyboarding and post-production phases. The day-to-day running of the show will then become the responsibility of an appointed line producer (see below) who will keep the producer up to date on the progress of the production, the schedule and the budget. This style of producing is particularly common with producers who work on several different shows consecutively.

The facilitator producer may perform all of the roles detailed above but will also be involved with the day-to-day running of the production. This can range from managing department heads right down to micro-managing individual staff members, depending on the size of the production. Facilitator producers are often attached to a project at the start of development, although it is not unusual, particularly in the large studio environment where producers are retained on staff, for shows to be developed by a specialised team and then handed over to a producer and production team once the project has been 'green lit' (approved to go into production). In this instance there can be another style of producing, commonly found in the games industry and also seen in television production, where the producer steps back from the creative approval process once development has been completed, allowing the director to completely take the reigns and dictate and approve all creative assets.

The line producer

Strictly speaking, the line producer (or co-producer) will be the person responsible for constructing and managing the budget and schedule. In some studio structures a producer may take a concept through the development phase and then hand

over much of the organisational work to the line producer who will manage the project. This means that some line producers may be responsible for hiring staff, negotiating contracts and dealing with clients.

The associate producer

The title of associate producer may be given to an experienced production manager, or to a person whose expertise lies somewhere above the production manager and below the line producer. This producer generally works with the production manager to coordinate and track the pre-production and production processes and to oversee the asset management and overseas shipping if the production has used an offshore servicing studio.

The assistant producer

The assistant producer is literally the producer's right hand. They work directly under the producer and may work specifically to the producer's instructions or work a little more independently if the producer is prepared to delegate specific long-term tasks to them. Assistant producers are usually found only in feature productions or in studios with a constant slate of multiple productions.

The supervising producer

In cases of co-productions where clients have creative input, the executive contacts charged with assessing each milestone (scripts, storyboards, designs, etc.) would be given a producer credit. In studios with multiple projects and multiple staff producers, a supervising producer may be hired to oversee all of the productions. This person will usually report directly to the company owners.

Depending on the size and type of project and the structure of the studio the producers collectively will be responsible for the following:

- securing production funds
- facilitating the development process
- project assessment

- acquisition of studio space and equipment
- creation and management of the schedule and budget
- hiring all production crew and cast members
- negotiating rates of pay for freelance staff
- negotiating contracts
- obtaining clearance, copyright and licensing rights
- contracting servicing studios and outside facilities
- contributing to and supervising all creative processes, from scripts, to design, to storyboards, animatics, animation, line tests and picture and sound post-production
- coordinating with clients on all approvals
- overseeing all production arms, ensuring that quotas are met
- reporting to and updating executive staff/clients/studio owners
- conflict resolution and troubleshooting
- delivery of all elements as stipulated in the client contract
- liaising with broadcasters with regard to 'on air' dates
- liaising with ancillary groups such as the licensing, merchandising, promotion, distribution and publicity departments
- nurturing the creative environment of the studio and the staff within it

3 The concept and the pitch bible

Where do concepts come from?

An animation production, be it for television, film or the games industry, must begin with a concept. Concept ideas come from an endless list of sources, but they all fall into two major categories—either they are original concepts or they are based on existing properties. Basing a concept around an existing property, such as a book, comic, song or famous identity can be an easier sell when it comes to pitching the idea as it represents less of a risk to potential investors if the property already has a popular following. However, an original idea that ultimately proves successful can spawn many of these extras, opening the door for lucrative merchandising deals.

Evaluating the concept

Determining your target audience

The first and most important thing to do when embarking on an animation project is to determine the target audience. It is imperative to have a clear idea of who will be watching the program as this will set the parameters for every element of the project, from the scriptwriting to the overall design and style of the animation. It is also essential to have a clear idea of the audience when it comes to presenting material to prospective buyers as well as for initial classification approval.

The major classifications based on age groups are as follows:

- Pre-school—ages 2 to 4 years
- Young school—ages 5 to 8 years
- School—ages 9 to12 years
- Teen—ages 13 to 16 years
- Adult—ages 16 years and above

As a general rule, the younger the age group the simpler the animation will be. This is directly related to the attention span and perception abilities of the particular age group. Another general rule is that the younger the age group the slower the animation will be. For example, animation produced for the pre-school age group would mainly rely on using static images with lots of talking, blinking and head nodding. Animation produced for teens would use a lot of fast action and special effects.

The level of complexity also impacts on the cost of the production. Producing for younger age groups is cheaper than producing for the older ones because less movement naturally equates to lower cel counts.

When defining the audience, it's usual to have products that are geared to appeal to one gender more than the other. It is rare to find that one product will have the same appeal to both sexes or across a range of age groups. Of course products that capture a broader sector of the market do exist, but they are exceptions to the rule.

These divisions are a rough guide only. They are by no means canon as there is nothing to stop a program being pitched at the 3 to 7 year age group, or the group from 5 to 12, for example.

Program format and length

Once a concept has been decided upon, the next step is to determine the format it should take. Does the idea have enough scope to be developed as a television series? Would the idea be better adapted as a feature for the cinema or the straight to video market? Is it more appropriate to be used as an Internet property? A single concept may lend itself to a variety of different formats and it is the producer's job to identify which format has the potential to be successful.

Once the primary format has been decided upon it is necessary to evaluate the project to determine the appropriate duration. Film and Internet properties have a lot more flexibility with regard to total duration times. Television, on the other hand, is quite rigid as it needs to package each show with a set amount of advertising.

If the show is successfully sold then the buyer will often dictate the precise length of the project based on their own broadcasting needs. Below is a guide to average durations:

- Feature for cinema: 70 to 90 minutes
- Made for television feature: 65 to 80 minutes
- Commercial hour: 43 to 45 minutes
- Commercial half hour: 22 to 24 minutes
- Commercial quarter hour: 11 to 12 minutes

Durations for pay TV will vary slightly, allowing for a few extra minutes for each program. All durations above are averages and will vary from country to country.

The pitch

In order to have any chance of securing investment for a project, the idea has to be pitched to potential developers and buyers. A potential buyer could be an established production studio that would then develop the project and in turn pitch it to investors and distributors. On the other hand, a producer may pitch directly to a distributor or network.

Two things are essential for a successful pitch. The first is a strong written proposal that outlines the concept and the style of animation. It should also contain information about the potential audience, format and length of the proposed show and any funding attached. This should be sent to a variety of potential buyers with a view to the producer being invited to give a live pitch of the project.

The second important element is the live pitch. This is where a producer meets face to face with potential buyers in order to try and sell the concept to them. The most important tool for such a meeting is what is called the pitch bible. The bible is a brochure containing all of the relevant project information. It presents the story concept, analyses the targeted audience and sets forth the relevance of the project. It describes the format and length of the project and outlines the major character design and settings. It should also include some sample story outlines. Preparing a pitch bible can be a complicated task, so quite often many people will work together to give a wider creative input. If the resources simply do not exist to make such a comprehensive document, a pitch can sometimes be made using a script.

Lately it has become easier to produce 'home-made' 2D animation using Flash or similar programs, so it is now much more feasible to produce a pilot to accompany the pitch bible.

A pilot is a piece of animation, usually about one to three minutes in length, which is used to give a brief introduction to the characters, music themes, premise and style of the project that is being pitched. The pilot must be made to the highest standard possible if it is to represent the proposed animated project to potential buyers. In the last couple of years the Internet has proven to be a good pitching place. Web sites like www.icebox.com have been the testing ground for many new animated projects. Even the famous *South Park* has the Internet to thank for its big break. The success of this forum as a pitching ground can be linked to the fact that many animation buyers like to deal with properties that have a pre-existing fan base. In much the same way that comic books have been popular targets for animated shows because they have a ready-made audience, the proliferation of entertainment on the Internet is slowly moving up to match comic books as more and more people log on to the worldwide web and become familiar with the various characters portrayed there. As these Internet properties become popular, the idea of taking them further and developing material for television or film becomes a realistic proposition.

Potential concept buyers, such as production companies, will often have either one key person or a small team, depending on their size, to evaluate project ideas. They initially assess the project for its potential performance within the current market-place, its appropriateness for the target audience and its possible classification, as well as their own suitability to produce it. The idea may be seen and assessed by many people and selling a concept can take months, or even years, as buyers can often hold on to an interesting idea with the view to reassessing it further down the track if there is a shift in the market climate.

If a buyer is interested in the project a negotiation will take place and the project might become optioned for an agreed period of time. Alternatively, a buyer may purchase the property outright. An option is where the buyer pays for the rights to develop the property for a specific amount of time. The buyer will do this in order to see if the property can be developed into something with enough market appeal to put it into full production. If the production does go ahead, the buyer will pay the original concept owner an exercise fee, which can be between 2 and 5 per cent of the total production budget. A percentage of this exercise fee is paid up front as the option price, before the buyer takes the concept into any form of development. Just because a project is optioned, it doesn't mean that it will be

produced. Very often, projects begin development only to be stopped part-way through—in the infancy of a project the proverbial plug can be pulled at any time.

Funding

Once a property has been developed to the stage where the buyer is prepared to begin putting it into production, they will need to seek out investment for the project. Investors for film, television and Internet projects come from a variety of sources and it is almost always the case that one project will be funded by several different investors. Due to the fact that animation is much more costly and time-consuming to produce than live action projects, it can be difficult to find investors who can commit to a production on a long-term basis. Basically, the faster the return the easier it is to find potential investors, so many avoid sinking their money into animation. Having said that, there are investors out there who are eager to be involved with animated projects.

In most cases an executive producer will need to put together a group of investors for the one show. This group can be made up of distribution companies, co-producers, government institutions, free-to-air and pay TV networks, production companies and private investors, to name but a few. There are several different ways in which investors can contribute to productions. The most obvious way is through cash investments, although commonly investors prefer to extend loans to production companies or will contribute other resources, such as distribution, laboratory or offshore services.

The type of investment package will depend on the country of origin and the format the concept will take. Basic investment for television and film is usually found in co-producers, distribution companies and television networks as well as ancillary investment, such as licensing agents, home video and DVD companies, publishers, and interactive software companies.

In the main, partners will join a production as either co-producers or co-financers. Co-producers will generally contribute cash financing and creative services at a reduced fee for a return on the finished product, while co-financers will contribute funds in exchange for distribution or merchandising rights.

Distribution deals are essential to the success of a television project and securing global distribution can be key in funding a production. Distribution pre-sales (sales made before the project is completed) across a number of territories can often provide up to half of the production budget. Animation has a strong advantage

over live action productions in that it is easily translated into foreign languages, thus opening up far greater possibilities for international distribution.

Distribution within the film industry is generally dominated by the major US studios. These studios will fund films in exchange for full creative control, copyright ownership and worldwide distribution rights. Alternatively, studios will also co-finance or co-produce some shows, although they may only do this with an established producer.

Funding for Internet properties usually comes from the producer or the owner of the destination website. Revenue can take the form of up-front fees from the destination site with a percentage per download. In smaller productions, where the producer owns the host site, revenue can come from advertising built into the product or website. During the Internet boom of the mid to late 1990s, a lot of finance was raised via speculative investment in web companies.

Video and computer games are usually funded by publishers, who will pay for the production while retaining copyright and creative control as well as rights to the worldwide distribution. The developer or production studio will usually receive a profit of between 5 to 15 per cent of the worldwide sales. In this industry the distributors rarely contribute to production funds, preferring to simply take a commission on overall sales.

Many countries nurture their animation industries by supplying funding for film, television, Internet and computer gaming projects that meet with local content quotas. This usually means that the significant creative elements are completed locally and that the key production staff are citizens of that country. For example, a production falling under this category might undertake all of the development, design, scriptwriting, storyboarding, layouts and post-production while sending the actual animation overseas to be completed. The production would also need to use local talent, particularly in the key creative positions such as producer, writer, director, animation director, lead designer, voice talent and storyboard artists. Alternatively, some governments will insist that only a certain percentage of the entire budget can be spent offshore. Usually, in order to receive government funds, a pre-sale needs to have been made. Countries such as Australia, Canada, France, Germany and China all provide assistance from government bodies in one form or another and these government grants can make up a substantial part of a production budget.

The market-place

Every year, buyers' markets for film and television are held in various places around the world. Executive producers and producers flock to these markets, armed with bibles and pilots of their show with the hope of selling their ideas to one of the many network or distribution representatives present. One can never underestimate the importance of such markets. It is where deals and contacts are made on an international level. It is also the most important indicator as to the current trends in all genres of entertainment production. It is common for production companies to send their executive staff to several of these markets each year, regardless of the country they are being held in. Entertainment journalists also frequent these events, which is an added bonus for sellers as good publicity is always a great tool for attracting buyers.

MIPCOM

The most relevant market event for the animation industry is the MIPCOM television market. Held in Cannes during the Northern Hemisphere autumn, this market has the highest number of international buyers and sellers. MIPCOM is not open to the general public and you must be an industry professional in order to gain registration.

Further information can be found at the MIPCOM website: www.mipcom.com

MIPCOM Junior

MIP Junior is usually held just prior to the MIPCOM market and is solely dedicated to television programming for children. Again, you must be an industry professional to register and you are allowed to present up to six pilots or productions. Literally hundreds of specialised buyers attend this market (usually upwards of 350), which makes it probably the most important children's television market in the world.

More information on MIPCOM Junior can be found at their website: www.mipcomjunior.com

MIPTV

MIPTV is the leading international television programming market and caters to all types of broadcast for television. It is held in Cannes, during the Northern Hemisphere spring. It attracts a very similar crowd to MIPCOM and serves as the six-month catch up, if you like, for those who attended the MIPCOM market.

More information on MIPTV can be found at their website: www.miptv.com

MILIA

MILIA, also known as MIP Interactive, is a market held specifically for the buying and selling of interactive content. This includes anything from publishing, interactive entertainment, interactive television, broadband technology, digital media distributors and technology solutions. It is held in Cannes during the Northern Hemisphere spring.

More information on MILIA can be found at their website: www.milia.com

NAB

NAB is held in Las Vegas during April. It is aimed specifically at animation and special effects for film and television, as well as the New Media and interactive markets. Seminars, workshops and conferences are held in conjunction with the trade show.

More information on NAB can be found at their website: www.nabshow.com

E3

E3, or the Electronic Entertainment Exhibition, is held in Los Angeles in May and is a trade show dedicated to animation, special effects and new and interactive media. Seminars, workshops and conferences are held in conjunction with the trade show.

More information on E3 can be found at their website: www.e3expo.com

Siggraph

Siggraph is a trade show dedicated to animation, special effects and new and interactive media. It is usually held in the Northern Hemisphere summer, travelling to a different location within the United States each year.

More information on Siggraph can be found at their website: www.siggraph.org

NATPE

NATPE is held in Las Vegas in January and is a trade show for the television industry. Seminars and conferences are held in conjunction with the trade show.

More information on NATPE can be found at their website: www.natpe.org

Tokyo International Animé Fair

The Tokyo International Animé Fair is a trade show held in March in Tokyo which caters specifically to animation for broadcast. This is the main market for Japanese animé.

More information on the Tokyo International Animé Fair can be found at their website: www.taf.metro.tokyo.jp

4 Project development

Project development sets the foundation for all of the production stages to follow. It is the stage where all of the basic elements of the project, from staff to scheduling and budgeting, initial design and scripting, are established.

The key things that need to be done during the project development stage are:

- establishment of the core production team
- script development
- artwork development/conceptual design development
- research and resolution of copyright issues
- evaluation and planning of the project
- establishment of a budget and schedule

Establishing the core team

A core, or nucleus, team is a small group of indispensable personnel who are absolutely essential to the life of the project. Most studios have core people on staff; otherwise they are hired on a freelance basis. Often, studios will have a well-known industry name, such as a famous director or producer, attached to a project, giving it a little more credibility when pitching it to the market.

Depending on the type of production, size of the project and organisation of the producing studio, the team positions may vary, but the following is a basic model.

Producer

The producer is responsible for driving the production from this stage onwards. Development is a very busy time for the producer as they will be responsible for sorting out the type of crew they will need, recruiting, budgeting and scheduling. At this stage the producer is also working to control the creative assets of the project, namely the script and the style development, as well as negotiating and planning the next stages of production. They will also have to make sure that all requests from the buyer are taken care of in a timely and efficient manner. This stage sets the foundation for pre-production, so vigilance and concentration on the producer's part is imperative. Any mistakes at this time can result in negative repercussions during the rest of the production process.

Director and/or animation director

Every so often the roles of director and animation director are separated. The director is responsible for the overall creative development of the project, from collaboration with writers through to guiding designers and storyboard artists, voice casting and selection, composer briefings and colour styling approvals. They are also responsible for approving the layout and animation, calling retakes, approving music and the final mix and then ultimately, they are the person responsible for signing off on the final project. Usually the director comes from an animation background. For example, they may be an experienced animator or storyboard artist who has worked their way up to the directorial role. However, sometimes the director will come from a film background and despite a multitude of talents won't know how to draw, or doesn't know all the tricks of the trade of animation. If that's the case then it is better to partner a director with an animation director. The animation director will need to be brought into the production from the very beginning.

It should always be remembered that the director doesn't act alone. They are in constant communication with the producer and buyer/client and must always take into account the feedback received from them. It is very important that the client's input is taken into account.

Script producer

This person is responsible for organising the scripting process from start to finish. They must supervise the script editor and writers and are ultimately responsible for the scripts being completed on time, within budget and to the correct project and classification specifications. They are always contracted on a full-time basis for the duration of the scripting process. On shows with a smaller budget, the job of script producer and script editor will often be combined.

Writers

Writers can be contracted for the life of the project, on a script-by-script basis, or they can be full-time staff writers. A good script is the foundation of the final project. It is almost impossible to have a successful project if it is based on a weak script, so the part the writers play in the overall production is paramount.

Art director/visual development director

This person is in charge of the overall look and feel of the project. They will work closely with the director to achieve the visual aims of the project while supervising the visual development artists to this end. Their role in the development stage is enormous as talent and good communication with the director will determine the final look of the project.

Technical director

The technical director is responsible for the assured flow of all technical aspects of the project. They must evaluate the design and script expectations from a technological viewpoint. They must recognise all possible obstacles and limitations that could be experienced and suggest how to overcome them. The technical director works closely with the director and producer and is relied upon to give sound advice to the producer on possible problems within the digital production pipeline. In real-time 3D animation projects the technical director (along with the head of modelling) will evaluate the project and advise on possible problems such as polygon counts, overdraw factors, the use of special effects and the need for tagging objects for different computer configurations.

Legal department

Larger studios will have this department in place on a permanent basis. Smaller operations may contract an entertainment lawyer for their project. In either case, this department is responsible for negotiating contracts for investors, servicing

studios, voice and motion capture actors and employees. They also look after all agreements regarding copyright and rights and clearances of music or images included in the property. They are responsible for dealing with all government and classification bodies and negotiating union agreements. The legal department will also work with the producer to ensure that all contractual agreements are met within the screen credits.

Production accountant

At the beginning of a project the producer and production accountant will work together on creating a budget. Throughout the production the accountant will track everything being spent and present cost reports on a regular basis to the producer and studio owners. Cost reports will usually be constructed on a monthly or bi-monthly basis and will contain a line-by-line breakdown of the money spent to date as well as an average for each task in the budget. This will help to estimate the final cost of the project and will identify areas of overspending. The production accountant, along with their accounts team, will look after the regular payment of all staff, contractors and studio overheads such as rent and electricity.

Information technology specialists

This department or person (depending on the size of the studio) is responsible for maintaining all computer hardware and software for the studio. They will work with the producer during the development stage in order to ascertain the type and volume of software and computer equipment needed for the project. This will often involve a great deal of research and development.

Each of these roles represent the different sectors of production, but they are all fully interlocked. All production staff need to work cohesively in order to fulfil their tasks on a daily basis and ensure the smooth operation of the project.

Script development

Once a script producer or editor is in place, they can begin preparing a specialised version of the bible, often called the writer's bible. This needs to include very detailed and accurate descriptions of all of the characters—their ages, likes and dislikes, quirky habits, physical features, their environment and their relationships with one another. It also has to include a thorough description of the world in which all of the characters live, and, if the show is a series, it needs to plot the

series 'arc', or the personal journey of the main characters. Generally, all of these elements will be locked down during a series of meetings or brainstorming sessions between the script producer, director, producer and client. If the client is not present during these meetings, they will need to sign off on all of these ideas and may call for multiple revisions during this time. After all, this is the time to make absolutely sure that all of the characters are going to work well in the show, both on their own and as a group, and it is often the case that the character descriptions and story ideas can change quite drastically from the initial pitch bible.

When dealing with scriptwriting for a series, the script producer will at this stage need to hone in further and lay out story ideas for each individual episode. Different studios will vary in the way they approach this phase of the script development. Story ideas can be left to writers who will submit ideas based on the bible for the studio to consider. Other studios will hold brainstorming sessions with the core crew and compile a list of ideas, or give the majority of control to the producer, buyer and script editor. Sometimes the buyer will come to the studio with the script outlines and sometimes the studio will put out a general call inviting any of their staff to submit story ideas for consideration.

When dealing with smaller projects this process will, of course, be far less elaborate. Often the script will be written as part of the initial pitch and during development may only need to be polished, or revised to accommodate client requests. Very short subjects may not have a fully written script at all, as it is often the case in this situation that the storyboard will begin to take shape around a detailed outline of the show, including notes for specific lines of dialogue.

In larger series projects it can be a good idea, if time permits, for the script producer or editor to write the first script. This will then set the benchmark for the quality of the remainder of the series and will provide the best possible example for the writing team to follow.

Conceptul design development

Development is a crucial stage in the conceptual design process. The foundation for the look of the project is established with the pitch bible, but as nothing is carved in stone, everything can be changed at this stage. The most influential decision maker with regard to the look and feel of the project is the buyer/client. Nothing can go ahead without their approval.

During this stage of development the final look of the characters and backgrounds will need to be locked off, paying particular attention to the finer details. This

includes issues such as the look of the backgrounds. Will they be soft or sharp? Will they include line work? Will the use of strong shadows suit the show, or should they be flat? Would the show look better if it contained drop shadows or side shadows? Will it be necessary to create night colours for the characters? Is there a need to make provision for an underwater set? All of these things (and many more) need to be considered, and decisions need to be made with regard to how to design and execute them.

The project may dictate the need to go with hybrid technology (by mixing 3D and 2D animation, for example). Any decision of this nature will invite numerous technological questions and obstacles, so it is important to be prepared for that. Many of these issues will be tackled as the project moves into pre-production, but ideas on how to work with and around such issues need to be conceived during development.

By the end of the development stage it is absolutely crucial that all designs are finalised and approved by all required parties. Changes at this stage are easy to make, but changes further down the line can incur enormous costs and delays. It is the producer's responsibility to ensure that everything is locked off and signed off.

Copyright

Licensing fees for the optioning of an existing property, such as a book or comic, will have been addressed before the development phase begins (see chapter two). However, there are several other copyright issues that need to be dealt with during the development stage as they will impact on the budget. The issues referred to here are the use of creative elements within the production, such as existing songs or pieces of music, trademarked graphic elements or logos, and likeness rights which may be necessary if a character is designed to mimic a famous celebrity or public figure.

Music fees will vary depending on the length of the piece, the number of times it is used within the production, its prominence within the show, the type of show being produced and its potential audience. Music licensing fees will usually consist of up-front fees, and as such they must be factored into the budget. If a song or piece of music is going to appear on a soundtrack connected with the film then the up-front fees may be reduced to account for royalties earned from CD sales of the soundtrack.

The use of graphic elements, such as trademarked brands or logos, or likeness rights will require the payment of both licensing and permission fees. These fees can take the form of up-front payments or royalties, or a combination of both.

Game developers must also account for the costs associated with acquiring rights for software tools and the right to use console owners' names in their marketing.

The legal department is responsible for researching and tracking down the various publishers and rights holders and negotiating all licensing and permission fees. The sooner these items can be identified the better. However, sometimes smaller copyright issues do not become apparent until the scripting or storyboard stage. For this reason it is important for the producer to supply the legal team with copies of the finished scripts and storyboards so they can identify potential copyright issues. If the budget does not include provision for acquiring such permission rights then it is the producer's job to inform the creative team so they can ensure that such items are not written into the production in the first place.

Evaluation and project planning

By this stage of the project the format, length and projected delivery date should be well-established and confirmed by the client. These three elements influence almost every aspect of the production.

Every project needs to be evaluated in order to prepare a functional production plan. The production plan is based upon input given on a creative and technical level. It should outline the complexities of the project and map out the pipeline (the breakdown of individual tasks and the order in which they are to be executed) needed to achieve the end result. The producer is the major moving force behind all of this and will work with the core team and the clients to establish the factors that need to be taken into consideration for the project.

To begin formulating a project plan, the following issues need to be discussed with the core team and client.

Creative

This department considers the script complexity and makes decisions on the look of the project. They will examine factors within the script that will determine this, such as the possibility of hybrid elements, the intensity of the backgrounds in relationship to the characters and the dominant gamma. Then the production style

guide will be produced. This will be a comprehensive booklet containing all main character designs and personal characteristics and descriptions, all known settings/locations and a series overview and objective. It should also include any other information that might be helpful for scriptwriting and general presentation purposes. Certain technical aspects should be included and the producer will work with the key production staff in determining what information will be relevant. The more information the better, as everyone working on the production will use this booklet as a guide.

Technical

This department will technically assess the project and take the necessary action to ensure that the goals of the production can be achieved. Will it be necessary to buy new software? Can the technical requirements of the script be met? Sometimes the script will need to be changed in order to meet technical limitations; sometimes a decision will be made to purchase, develop, outsource, train or do anything else needed to meet the script requirements, particularly in the area of special effects. Post-production/editing requirements also need to be considered. What format will the project be shot on? Film? Video? Digital Betacam? Will it be high definition or standard definition? What aspect ratio or screen size will need to be used? The producer will consult with the technical director regarding these issues.

Strategic planning

Questions of a strategic nature need to be considered. When is the project going to be released? Is it going to match the release of a video game of the same title, or is it going to match the theatrical release of another movie from the same series? Will there be a desire to develop a web page with bulletin boards and opt-in facilities that will enable an online community to be built around the title? Will there be merchandise to go with this product? Can the show be released at a time that will maximise the sales for both elements? The producer has to work with many other departments in order to get answers to these questions so they can plan the project efficiently.

Organisational

A decision needs to be made on the best production strategy for a particular project so that the budget will be met while still producing the best quality of work possible. At this stage, decisions also need to be made on where the work will be

done. Should some of the work be outsourced to contractors or completed in-house and how will this influence the crew plan and the cost related to it? These are just some of the questions the producer will have to consider and act upon.

Financial planning/budgeting

This is directly connected with the strategic and organisational arms of production and reflects all elements from the producer's initial schedule. For example, the number of weeks required to perform certain tasks, the number of people needed to complete those tasks and their pay, which reflects their level of experience, are all factors to consider when initialising a financial plan. Other factors are things like services to external sources (see budgeting).

Human resources

The human resources department will look at the following questions. How do we build a team that will function harmoniously and seamlessly? What avenues should be used for recruiting? How do we plan a realistic team structure and avoid over- or under-staffing? Most large companies have human resources departments, but in smaller companies the producer will be the person responsible for all recruiting.

After consulting with the various members of the core team, as well as the client, the producer should have information on all of the following issues:

- the final delivery date
- the format of the project
- the length of the project or individual episodes
- the types of animation the show will use
- the complexity of animation needed for the show
- the average number of shots or scenes required
- a rough idea of the average number of drawings required
- the average number of key backgrounds needed for the show
- a pipeline plan (the order in which tasks will be completed)
- a list of production stages to be outsourced, and quotes from overseas studios
- a crew plan, including skill requirements
- special cast or crew arrangements and related costs (bringing in experts from overseas)
- the type of software to be used and any training details

- the format on which the show will be shot
- the format on which the show will be delivered
- a list of all deliverables, such as press kits, press images, audio elements, etc.
- the aspect ratio of the show
- client approval stages
- the payment schedule (where money is made available from investors as key milestones are achieved)
- details of required reference or research material
- a basic schedule
- details of necessary office space and equipment required

Scheduling and budgeting

Scheduling

Once the project is defined and the final delivery dates are decided, the construction of the schedule can begin. The schedule is the summary of all work needed to complete the project, broken down into stages and services and expressed in the form of a timeline.

If the project is a multi-episode series there should be an overall project schedule as well as schedules for each of the individual episodes. These smaller schedules must follow the general timeline for the entire project. Department-based schedules will also be constructed.

The schedule needs to be realistic. If a schedule is unrealistically tight it might become necessary to introduce extra resources or change the production plan by outsourcing more of the work. This can result in spending over the budget limit. It is therefore important for the producer to consult with their director and key creative colleagues if they are unsure of time requirements for specific tasks. Non-working days also need to be accounted for as they can affect a schedule quite significantly. Extra time should be added to the first couple of episodes (if dealing with a series) or the beginning of each new step in the production (for films or short subjects). This is because it takes a while for the crew to become accustomed to the style of the show, and allows for some settling-in time.

When compiling a schedule it is necessary to know the types of technology to be used, as well as the standards for each different stage of animation. Knowing how long to factor in for script development, how many layouts can be completed per week and the weekly expectation of animation output is also necessary. If new technology or software is being used one must always account for extra time in

case software glitches occur. The same applies for new equipment as people need extra time to gain proficiency with it.

Microsoft Project is an excellent program for scheduling. It is easy to use, has different chart display options and can be itemised down to the level of each individual person working on the project. It can also show the level of use for all resources and provide warnings if people or departments have been over-allocated. It can be customised for holidays and weekend work and has many options for task linking. Microsoft Excel is also a good initial scheduling tool as it allows the flow of the entire project to be viewed at once (see figure 1), in a much more concise form than the Gantt charts in Microsoft Project (figure 2).

The crew plan

The crew plan is drawn from information in the initial schedule and is a representation of the number of staff needed to perform each task in order to meet the schedule. The crew plan needs to list the number of staff required, the number of weeks they will be needed for and their start and end dates.

The producer will also need to research and include the market salary rates of each potential crew member. Media and arts unions will be a good starting ground for this but most salary expectations will be well above the award. Producers will base their figures on past productions and may even consult associates on current rates.

A well-devised crew plan enables the producer to budget for the project appropriately and also allows for the planning of office space and equipment.

Budgeting

The budget is a financial construction of the project based on the creative elements and goals, estimated duration, complexity of the project and estimated need for human resources. Other elements that need to be known in order to prepare the budget are:

- licensing fees
- rights and clearance fees
- facility rental/lease
- training costs
- new equipment fees
- travelling expenses
- promotional costs
- public relations costs

Figure 1 Overall 2D schedule for 13 x 22-minute episodes of children's TV

WEEK	1	2	3	4	5	6	7	8	9	10	11	12	13	14	15	16	17	18	19	20	21	22	23	24	25	26	27	28
EPISODE 1		SCRIPT/casting								PRE-PRODUCTION													PRODUCTION					
EPISODE 2					SCRIPT							PRE-PRODUCTION													PRODUCTION			
EPISODE 3							SCRIPT							PRE-PRODUCTION														
EPISODE 4								SCRIPT								PRE-PRODUCTION												
EPISODE 5										SCRIPT								PRE-PRODUCTION										
EPISODE 6												SCRIPT								PRE-PRODUCTION								
EPISODE 7														SCRIPT								PRE-PRODUCTION						
EPISODE 8																SCRIPT								PRE-PRODUCTIO				
EPISODE 9																		SCRIPT										PRE-P
EPISODE 10																				SCRIPT								
EPISODE 11																						SCRIPT						
EPISODE 12																								SCRIPT				
EPISODE 13																												SCRIP

- supply costs
- courier and international shipping costs
- telephone expenses
- electricity expenses
- relocation costs
- payroll taxes
- goods and services or sales tax
- medical benefits
- sick pay and annual leave entitlements
- overtime rates

| 29 | 30 | 31 | 32 | 33 | 34 | 35 | 36 | 37 | 38 | 39 | 40 | 41 | 42 | 43 | 44 | 45 | 46 | 47 | 48 | 49 | 50 | 52 | 53 | 54 | 55 | 56 | 57 | 58 | 59 | 60 | 61 | 62 | 63 |

POST

POST

PRODUCTION — POST

PRODUCTION — POST

PRODUCTION — POST

PRODUCTION — POST

PRODUCTION — POST

)N — PRODUCTION — POST

)RODUCTION — PRODUCTION — POST

PRE-PRODUCTION — PRODUCTION — POST

PRE-PRODUCTION — PRODUCTION — POST

PRE-PRODUCTION — PRODUCTION — POST

)T — PRE-PRODUCTION — PRODUCTION — POST

The list is long and may vary from production to production and will also depend on the structure and facilities of the studio. In larger, established studios overheads such as studio rent and electricity will generally be packaged together and added into the budget as a percentage based on the length of the production.

The cost of producing animation will vary greatly depending on the quality and style of work being produced, the staff requirements and the country it is being generated from. Studios keep a tight lid on their production costs so it is difficult to garner exact figures from past productions to use as a guide. However, trade magazines list the cost of producing *Toy Story* and *A Bug's Life* (Disney/Pixar) at between US$30 and $80 million. *The Lion King* (Disney) reportedly cost around

Figure 2 Itemised 2D schedule for 5 x 22-minute episodes of children's TV

SCRIPTING

	WK 1	WK 2	WK 3	WK 4	WK 5	WK 6	WK 7	WK 8	WK 9	WK 10	WK 11	WK 12	WK 13	WK 14	WK 15	WK 16	WK 17
Plotting	EP 1								EP 1								
Scene Breakdown		EP 2								EP 2							
Draft 1			EP 3								EP 3						
Draft 2				EP 4								EP 4					
Edit					EP 5								EP 5				
Polish																	

PRE-PRODUCTION

	WK 10	WK 11	WK 12	WK 13	WK 14	WK 15	WK 16	WK 17	WK 18	WK 19	WK 20	WK 21	WK 22	WK 23	WK 24	WK 25	WK 26
Funpack		EP 1									EP 1						
Storyboard			EP 2									EP 2					
Animatic				EP 3									EP 3				
Final Storyboard					EP 4									EP 4			
Layout Model Pack						EP 5									EP 5		

PRODUCTION

	WK 21	WK 22	WK 23	WK 24	WK 25	WK 26	WK 27	WK 28	WK 29	WK 30	WK 31	WK 32	WK 33	WK 34	WK 35	WK 36	WK 37
Layouts								EP 1					EP 1				
Key Animation									EP 2					EP 2			
In-betweening			EP 3							EP 3					EP 3		
Ink & Paint/Composite				EP 4	EP 5						EP 4					EP 4	EP 5

POST-PRODUCTION

	WK 34	WK 35	WK 36	WK 37	WK 38	WK 39	WK 40	WK 41	WK 42	WK 43	WK 44	WK 45	WK 46	WK 47	WK 48
Rushes Assembly/Sync	EP 1	EP 2	EP 3	EP 4	EP 5										
Rough Cut		EP 2	EP 3	EP 4	EP 5										
Fine Cut			EP 3	EP 4	EP 5										
Sound Post/PSD/Retakes										EP 3	EP 4				
Final Mix											EP 4	EP 5			
Master												EP 5			

US$80 million, *SpongeBob SquarePants* (Nickelodeon) US$30 million and *Dinosaur* (Disney) US$130 million. (Figures are production costs only and are quoted from www.the-numbers.com/index.php 25/03/2005.) At the time of writing, the cost of producing 2D and 3D animation for feature films was generally the same.

Television production budgets will be considerably lower on a per footage basis than film productions as they are made to lower production standards. Half-hour prime time and 3D shows will sit at around US$500 000 to $800 000 per episode while shows produced for children's slots will be considerably lower, at between US$200 000 to $500 000 per half-hour episode, due mostly to a decrease in the number of drawings for each show.

The cost of producing computer games can vary dramatically. The reasons for this huge gulf are generally technology based. If a game requires new software to be written then the development costs can be almost as high as the actual production costs. Internet properties vary greatly in cost for this reason also.

The budget is usually prepared by the producer and then presented to a company financial controller, although often they will work on the budget together. The producer usually prepares a preliminary breakdown of all pre-production, production and post-production costs and then the accountant will pad it up with costs to cover studio rentals, fringe benefits and other related costs. Also if there are loans taken out to finance a production any interest must be accounted for. Most companies have a standard budget form. In some companies, where routine production practices occur, the accounting department might even prepare a rough budget and give it to the producer for checking and correcting.

There are animation production standards that help when projecting the budget. If any segment of animation is outsourced there is no need to make a detailed breakdown of that stage. A simple summary of expenses for that part of the production will suffice. For example, if the pre-production is done in-house, and then a studio in Taiwan is contracted to complete the layout, animation, in-betweening, clean-up, scanning, paint and camera and to deliver the finished work, all of the stages done in Taiwan will be expressed by only one figure in the budget.

Two ways of negotiating costs with overseas studios are for payment either by the footage (on a per minute basis) or by the number of drawings. If the project is contracted out on a cost per minute basis then payment is made based on the exact footage sent, although naturally there is a bit of flexibility. However a deal based on the number of drawings per project will give greater flexibility as it defines the project as either an A, B, C or D level show. A Saturday morning program animated by the standards of the B category would account for roughly 18 000–20 000 cels.

There are two kinds of budget, each containing a varying level of detail. These are referred to as the detailed budget and the summary budget. The detailed budget reflects every specific area of spending within each of the categories, indicating specific job positions, the duration of jobs and their cost. The summary budget draws its information from the detailed budget and, as the name indicates, summarises the costs related to major production phases and departments. Every budget should also have an unexpected expenses category or contingency. This is a percentage (usually around 5 to 10 per cent) that is kept as a safety net if the project starts going over budget.

The summary budget is also known as the external budget. The external budget is created for the benefit of the project investors. This budget will always reflect the highest possible forecast for all costs. The internal budget reflects the true estimate of all costs a studio would expect to pay under normal circumstances. Of course there is a discrepancy between these two. The money that is left over once the production is complete becomes part of the production house profit.

Above the line and below the line costs

Every budget has above and below the line costs. Above the line costs, which are sometimes also called creative expenses, encompass all of the expenses related to personnel retained on contract. This includes directors, producers, writers and music composers, to name but a few. Things like costs for royalties and options also need to be included in the above the line costs. Below the line costs refer to all other costs, such as crew members and equipment.

It is very important to make a realistic budget and not to try and underplay the costs involved. An overly tight budget can put a production in danger of being shut down if the money runs out and no extra finances are available.

It is also important to keep a close eye on the production spending in order to stay within budget. Many production houses now have integrated time sheet software, which is connected to the expenses database. This means that when people do their time sheets, by selecting the allocated project's codes and service codes labour costs can be directly entered into the appropriate expenses database. The same system can also be implemented for tracking other spending. Through automated templates the costs can be directly projected from material and external work orders. It is also important that the accounting department regularly supplies spending reports with all variances.

Most small companies use Microsoft Excel for budgeting. The most popular professional software for building budgets at the present time is Movie Magic. See figure 3.

A final word on project development

The principal of invigilation

The word 'invigilation' comes from the Latin word *invigilatus,* past participle of *invigilare* meaning to stay awake, be watchful. The principle of invigilation goes something like this: if the correct preparation is undertaken prior to the start of any large scale operation, then throughout the actual operation, be it producing a television series or building a house, the producer or project manager need only stay alert and watchful.

In other words, if development and pre-production are done properly and if all possible scenarios have been examined and the appropriate action taken to prevent them at conception, then during production all that will be needed is to invigilate, or to stay watchful. The greater the effort and thought put into the project during its initial stages, the greater the chance that things will run smoothly during production.

Figure 3 Budget 1-hr TV special

Title:	XXXX				
Length:	1 x 44-minute episode (1 DVD)				
Prepared by					
Production Period:	6 weeks Script + 32 weeks Pre + Prod				
	4 weeks post = 42 weeks				

	PROJECT SUMMARY				
Acct #	**Description**				**Total**
1000	PRESENTATION MATERIALS				30,000
1100	DEVELOPMENT & STORY				10,000
1200	PRODUCTION STAFF				120,000
1300	VOICE CASTING & RECORDING				18,350
2500	ANIMATION				450,000
3200	TITLES				6,000
4100	MUSIC				15,000
4200	POST-PROD / SOUND				6,725
4300	POST-PROD / VIDEO				4,400
5100	ADMINISTRATIVE EXPENSES				22,755
6100	CONTINGENCY				34,162
	TOTAL PROD BUDGET				**717,392**

	PROJECT DETAILS						
Acct.#	**Description**	**#**	**Units**	**x Rate**	**Sub Total**		**Total**
	SET UP						
1000	**DEVELOPMENT**						
	Pitch material for funders,						
	licencees, etc.			30,000	30,000		30,000
1100	**STORY**						
1101	Script	1	script x	10,000	10,000		10,000
LA	TOTAL FOR 1100						40,000
1200	**PRODUCTION STAFF**						
1201	**Producer**	32	weeks x	2,500	80,000		80,000
	Executive Producers	32	weeks x	1,250	40,000		40,000
	Executive Producer	30	weeks x	0	0		0
LA	TOTAL FOR 1200						120,000
1300	**VOICE CASTING & RECORDING**						
1301	Voice Director (JH)	1	episode x	1,500	1,500		1,500
1302	Casting Agent amort item	1	allow x	5,000	5,000		5,000
1303	Casting Record amort item	4	hours x	200	800		800
1304	Casting Edit amort item	6	hours x	125	750		750
1306	Actors	6	actors x	750	4,500		4,500
1309	Dialogue Record	12	hours x	200	2,400		2,400
1310	VO Session Edit	12	hours x	125	1,500		1,500
1311	ADR/Pick-ups	4	hours x	350	1,400		1,400
1312	Stock, etc.	1	allow	500	500		500
LA	TOTAL FOR 1300						18,350

Figure 3 continued

	PRE-PRODUCTION									
2100	**STORYBOARD (inc. in animation bid)**									
2101	Storyboard	1	board	x	0	0				
B	TOTAL FOR 2100								-	
2200	**DESIGN (inc. in animation bid)**									
2201	Characters	1		x	0	0				
	Props	1		x	0	0				
	Backgrounds	1		x	0	0				
B	TOTAL FOR 2200								-	
2400	**MODELLING (inc. in animation bid)**									
2401	Characters	1		x	0	0				
	Props	1		x	0	0				
	Backgrounds	1		x	0	0				
B	TOTAL FOR 2500								-	
	PRODUCTION									
2500	**ANIMATION**									
2501	Key Frame CGI Animation	1	episode	x	500,000	500,000			500,000	
B	TOTAL FOR 2500								500,000	
	POST-PRODUCTION									
3200	**TITLES**									
3202	End Credit Bed/Graphics	1	allow		1,000	1,000			1,000	
3203	Moving Logo	1	allow		5,000	5,000			5,000	
LA	TOTAL FOR 3200								6,000	
4100	**MUSIC**									
4101	Main Title Song (amort item)	1	allow		5,000	5,000			5,000	
4102	Underscore	1	allow		5,000	5,000			5,000	
4103	Songs	1	songs	x	5,000	5,000			5,000	
ORL	TOTAL FOR 4100								15,000	
4200	**POST-PROD. SOUND**									
4201	Dialogue Re-Record	4	hours	x	300	1,200			1,200	
	Spot/Plan	2	hours	x	100	200			200	
	Sound Design	10	hours	x	125	1,250			1,250	
	Audio Pre-Lay/Layback	3	hours	x	275	825			825	
	Stock		allow		250	250			250	
	Final Mix	10	hours	x	300	3,000			3,000	
LA	TOTAL FOR 4200								6,725	
4300	**POST-PROD. VIDEO**									
4305	On-line Edit	6	hours	x	150	900			900	
4306	Video Layback	2	hours	x	250	500			500	
4308	Stock / Dubs / VHS viewing	5	allow		500	2,500			2,500	
4309	Quality Check	1	allow		500	500			500	
LA	TOTAL FOR 4300								4,400	
	ADMINISTRATION									
5100	**ADMINISTRATIVE EXPENSES**									
5101	E&O Insurance	2	years		3,000	6,000			6,000	
	Liability	1	allow		10,000	10,000			10,000	
5102	Shipping Domestic	3	months	x	100	300			300	
	Shipping International	3	months	x	200	600			600	
	LA Messenger	3	months	x	150	450			450	
5103	Office supplies/LA	3	months	x	135	405			405	
5104	Legal	1	allow		4,000	4,000			4,000	
5105	FTP software	1	allow		1,000	1,000			1,000	
	TOTAL FOR ADMINISTRATION								22,755	
	PRODUCTION BUDGET								**554,880**	
6100	CONTINGENCY			5%		34,162	34,162			34,162
	GRAND TOTAL PRODUCTION BUDGET								**589,042**	

5 Setting up the pre-production process

Pre-production sets the course for the main production phase and is indisputably the most important stage for securing a successful animation production. By the time pre-production starts, all of the funding needed for the project should be secured. However, it is sometimes the case that companies will be ready to go into pre-production once 70 per cent or more of the funding has been secured.

By this stage in the production, the crew size begins to expand as tasks become more specialised.

Recruiting

As mentioned earlier, the human resources department will take care of recruitment. They keep a log of applications accumulated over time and will refer to these when searching for staff. They will also contact people recommended by the producer and director. On the other hand, some studios will prefer to use the services of specialised recruiters.

In the absence of a human resources department, the producer, with input from the director and animation director, will be responsible for the recruitment of all staff. The animation industry is a very tight-knit community, so many people will be offered positions in the production based on past working relationships with the producer and directors. Producers will always have a list of past crew

members and will refer to this pool of people when they need to begin assembling a crew. The same is true for the director and animation director.

However, recruiting outside this smaller circle is always necessary. In this respect recruitment can be done via advertisements placed in newspapers or specialised publications. Another good place to advertise is on one of the many specialised websites, like www.awn.com, or in magazines like *Animation Magazine,* or alternatively through different job lists like the ones found on mandy.com or *UTA* (United Talent Agency, a closed list of talent which is circulated throughout the industry on a regular basis). Often producers or human resources departments will prefer to advertise in a specialist publication in order to hone in on industry professionals.

Of course in the studio situation there will always be people contacting the human resources team in order to introduce themselves and enquire about work, and this is a good place for a producer to start if they are looking to recruit some new people.

When recruiting for a creative position, particularly storyboard artists, designers and painters, it is quite common for the producer or director to give several prospective crew members a small test to do. This test would consist of a sample storyboard scene, designs based on a portion of the script, or a painted key background from the show. This enables the producer to evaluate a candidate's ability and suitability for the project.

The crew—who is who?

Let's identify the various crew members for this stage of production. The structure of the team will depend on the pre-production model that has been adopted. Part of the crew will be comprised of people who are full-time employees of the company; another part will consist of people on a non-creative contract (freelance); some will be on a creative contract (also freelance); and others will be signed to a service-giving contract.

Below is a list of the people involved in pre-production. Depending on the style of production and the studio structure, some or all of these people will be required:

- The production manager is a close co-worker of the producer and is responsible for managing the pre-production and production pipelines. Their role is vital to the production process, so often the person employed to do this job is granted the title of associate producer.

- The production coordinator is the assistant to the production manager. This position is one step up from the production assistant role and is usually needed for larger series production and films. Smaller projects or studios with a strong line producer, production manager and assistant will not usually require a production coordinator. The production coordinator is responsible for monitoring and tracking daily artwork and approvals.
- The production assistant is often a direct assistant to the production manager, especially when there is no production coordinator. They will assist with their progress tracking as well as filing, labelling, maintaining art and office supplies and other administrative duties. In smaller studios, the production assistant will be the one to make the coffee, buy the sandwiches and perform some reception duties.
- The production secretary handles most of the paperwork associated with the production under the directive of the producer, production manager and production coordinator.
- The animation director is responsible for the overall look and creative quality of the project, focusing specifically on the finer points of the design, storyboard, layout and animation stages. Sometimes this person will be involved in the project from the onset of development and sometimes they will be brought in at the pre-production stage. This will depend on how experienced the director is with animation.
- The art director is responsible for the style of the project and aids the director in this. They are also responsible for supervising the design and background departments. This position may only be filled in film and high budget television production. In television productions with a smaller budget this job would be divided between the directors and character designers.
- The character, set and prop designers are the creative executors of the director's and art director's ideas.
- The key background painters paint background keys under the instruction of the art director or director.
- The colour stylists create colour models for characters, props and special effects under the direction of the art director or director.
- The script producer looks after the script development and makes sure that all scripts, as well as the dialogue within them, are written with a consistent quality and style.
- The script writers write scripts based on a briefing from the producer and script producer, also taking into account the requests of investors or other assigned persons.

- The script coordinator helps organise the script properties, checks consistency of characters, arranges locations props, and looks after special effects naming and the format of the script. They also help organise scripts for the voice recording sessions. On smaller productions this role is often performed by the production coordinator or assistant.
- The storyboard artists create the storyboards based on a briefing from the director.
- The reference animators produce the reference animation for characters and special effects that will be shipped overseas. The reference animation is used as a guide for the specific animation of characters, turns and special effects (things like snow cycles and waves). They are responsible for referencing anything that is too important to be left to the servicing studio to develop.
- The sound readers produce the voice breakdown from the recorded dialogue track.
- The animation timers produce timing charts based on the dialogue track and storyboard.
- The lip-sync specialist inserts lip-sync (mouth movement) instructions into the x-sheets.
- The voice talent provides the voices for the animated characters.
- The casting agent organises talent-casting sessions for the initial character voice selection.
- The recording director directs the voice talent during a recording when the director is unable to do so.
- The recording technicians are members of the technical crew responsible for the studio recording of the dialogue script.
- The sound engineer is the person in charge of the technical quality of the dialogue recording.
- The copyright clearance specialist is a person or company who is responsible for checking all script properties against the existing registered copyrights to make sure that the script is not in breach of any brand or trademark.
- The marketing/merchandising/public relations liaison is the person in charge of the publicity of the property. They advise on the preparation of all the necessary publicity/promotional materials needed to sell the product.
- The overseas supervisor is the person in charge of supervising the production in the overseas studio. They are usually an experienced animation director, although sometimes they can be a non-artistic person (a good production manager or producer).

Taking care of the production team

The mark of a good producer is one who remembers that they are working with people and that the final project is the result of a collective effort. A good sense of fairness coupled with a non-judgmental attitude is the basis of a good operation. This leaves no room for office politics. Backstabbing or a boys or girls club mentality should be completely left at the door if a producer is to build a healthy work environment. This can be difficult to impose in an industry already riddled with these attitudes, but the ideal of 'fair play' and awarding promotion based on merit should always be upheld.

The producer must make it their business to be aware of what is going on around them with regard to their team members. Everyone has families, problems and personal issues. As long as personal issues do not endanger the project, flexibility within the workplace is the answer here. If someone has to start work later because they need to drop their child at kindergarten then that should be fine as long as they understand that they will need to work later at the end of the day.

People like to be appreciated so it's important for the producer to acknowledge that crew members are doing a good job. People also like to be involved. Weekly production meetings are a good way of involving staff members in the production process as a whole. Every company has regular production meetings for each department but it is also important for the producer to organise meetings that involve the entire team. This provides a good forum for the producer to ask for opinions and suggestions and to give the team regular feedback on the progress of the production. It is important that the producer communicates with their staff as this is the only way they can truly keep their finger on the pulse. A good way to achieve healthy communications is to introduce a 'studio round'. This is where the producer will make some time either every day, or every two to three days if things get hectic, to walk around the studio and talk to all members of the crew. They can make small talk with them about things that are not specifically work related or even share a joke with them. The point here is that everyone on the team is being made to feel significant and appreciated. In this day and age, where everybody spends a lot more time working than they do enjoying the company of their family and friends, it's important to feel as happy as possible at work.

Long hours spent sitting behind a desk is part of an animator's routine. Studies have shown time and time again that to be consistently effective during the course of a working day it is important to take regular breaks from sitting, particularly for those who work in front of a computer. There are many things the producer can implement to help combat worker fatigue and to make sure the crew are as

comfortable as possible. The most obvious of these things is to make sure the immediate work environment is comfortable, to check if the desks and chairs are ergonomically shaped and to make sure all computer monitors are at the right height. Staff should be encouraged to stand up and do a couple of minutes of stretching exercises every two hours. A producer who is able to show their staff that they care about them and their well-being will lead a much happier and far more productive team.

Staff amenities are also an integral part of this. The lunch room should be clean and well lit and should have facilities like a refrigerator, microwave and water dispenser. There should be a common area to post up articles, audience letters or any sort of publicity regarding the project so the crew can see that others also appreciate the results of their work. Introducing massage sessions is another way to help relieve the strain from sitting for long periods of time. It can be at the expense of the company, or partially subsidised by them so that it becomes a service provided to staff members at a reduced rate. The company can also provide its staff with snacks and drinks (like tea, coffee or soft drinks). Looking after the team is important. A well cared for crew will have a greater respect for the project they are working on and the people around them. This will always be reflected in the standard of work they produce.

Performance expectations and standards

In order to plan the production properly it's important to be aware of the performance expectations for each of the job descriptions. Let's use a low budget commercial half-hour program as a base. It goes without saying that the job durations listed below will change according to the complexity of the project, so these are by no means the absolute timeframes but rather averages to use as a starting point:

Scriptwriting	6 weeks	script team
Character design	1 week	1 x designer
Prop design	1 week	1 x designer
Location/set design	1 week	1 x designer
3D character model	2 to 5 days	1 x modeller
3D prop model	1 day	1 x modeller
3D location model	1 to 3 days	1 x modeller
Storyboard	6 to 8 weeks	1 x artist
Recording	1 day	

Sound cutting/dialogue editing	1 day	1 x sound engineer
Animatic and storyboard fixes	2 weeks	editor, director
Voice breakdown	1 week	1 x track reader
Lip-sync	1 week	1 x lip-sync artist
Exposure sheet production	2 weeks	1 x timing director
Layouts	25 to 30 per week	1 x artist
Animation	3 to 7 seconds per week	1 x artist

Note that not all scenes are the same. For example, some scenes will only consist of one character simply standing still, while other scenes may call for multiple characters to perform a complicated set of movements. So some scenes will take longer to complete than others and this needs to be taken into account.

Contracts

All members of the crew (full-time and freelance) are bound to the company and to the project by some kind of contract. The human resources department is responsible for the preparation of all staff contracts. Each and every contract can be different and they are usually subject to negotiation. It is for this reason that all contracts must have a confidentiality clause. The contract also explains the rights and obligations of the contractor and sets forth the provisions for working hours, overtime and holidays.

There are two types of freelance contracts—one representing non-creative services and the other dealing with services of a creative nature. For example, a freelance contract for a recording technician is a non-creative contract, but a freelance contract for a composer is treated as a creative contract. In the case of the creative contract there has to be an assurance that all issues of copyright regarding the creative contributions are legally covered and that there is no possibility that some of the creative co-workers are going to retrospectively claim rights on some of the creative properties of the project. The legal department is responsible for ensuring that every contract is constructed in such a way as to prevent this from happening. See figures 4 and 5.

Figure 4 Non-creative contract

[INSERT COMPANY NAME]
NON-CREATIVE SERVICES AGREEMENT

INDEPENDENT CONTRACTOR

The following sets forth the terms and conditions of the Agreement dated as of [INSERT DATE] Between [INSERT COMPANY NAME] ('The Employer') and [INSERT EMPLOYEE NAME] ('The Contractor') in connection with the animated movie project presently entitled [INSERT PROJECT NAME] ('The AM').

The contractor agrees to render ADMINISTRATION services in the AM in one or more roles as [INSERT COMPANY NAME] shall determine in its discretion. Such services shall be rendered commencing on [INSERT DATE] and continuing until [INSERT DATE] or at a date agreed upon between the employer and the contractor.

In full and complete consideration for the Contractor's services, the Contractor shall be entitled to [INSERT PAYMENT SCHEDULE], payable on the employer's regular pay day, one week in arrears, or upon completion of the Contractor's services in connection with the AM for services of less than one full week duration. The contractor acknowledges that the employer is under no obligation to contribute to Superannuation or Health funds, as is the standard practice for Independent Contractors.

The contractor agrees to keep all company business, documents, statistics and artistic creations confidential. Failure to do so will result in the termination of this agreement.

The Contractor hereby licenses to [INSERT COMPANY NAME] the right to use and permit others to use the Contractor's name, and biography, in connection with advertising, publicising and exploiting the AM or any part thereof.

In the event of any claim of a breach by the employer of any provisions of this agreement, the Contractor shall be limited to the right, if any, to obtain damages at law and the Contractor shall not have any right in such event to terminate or rescind this agreement or any of the rights granted to the employer hereunder or to enjoin or restrain the developments, production, advertising, promotion, distribution, exhibition or exploitation of the AM and/or any of the employer's rights hereunder.

The Contractor agrees to execute such additional documents as the employer may require in order to carry out the intent of this agreement.

This agreement shall be subject to those standard terms and conditions customarily found in agreements of this type in the entertainment industry (which standard terms and conditions shall be deemed included herein) including, without limitation, provisions regarding warranties, indemnities, disability, force majeure and default. This agreement shall replace and supercede all prior agreements regarding the subject matter hereof and shall constitute a binding agreement between the parties hereto.

[INSERT COMPANY NAME]

Signed: _____ _____
 (Contractor) (Date)

Signed: _____ _____
 (Witness) (Date)

Signed: _____ _____
 (Producer) (Date)

Signed: _____ _____
 (Witness) (Date)

Figure 5 Creative contract

<div>

[INSERT COMPANY NAME]
CREATIVE SERVICES AGREEMENT

INDEPENDENT CONTRACTOR

The following sets forth the terms and conditions of the Agreement dated as of [INSERT DATE] Between [INSERT COMPANY NAME] ('The Employer') and [INSERT EMPLOYEE NAME] ('The Contractor') in connection with the animated movie project presently entitled [INSERT PROJECT NAME] ('The AM').

The contractor agrees to render STORYBOARD services ('The Work') in the AM. Such services shall be rendered commencing on [INSERT DATE] and continuing until [INSERT DATE] or at a date agreed upon between the employer and the contractor.

The Contractor shall be entitled to [INSERT PAYMENT SCHEDULE], payable on completion and acceptance of the work. The contractor acknowledges that the employer is under no obligation to contribute to Superannuation or Health funds, as is the standard practice for Independent Contractors.

The contractor agrees to keep all company business, documents, statistics and artistic creations confidential. Failure to do so will result in the termination of this contract.

The Contractor acknowledges that all results, product and proceeds of the contractor's services including literary and musical material, designs and inventions of the Contractor (including all original ideas in connection therewith) are being specially ordered by [INSERT COMPANY NAME] for use as part of the AM and shall be considered a 'work made for hire' for the employer and, therefore, the employer shall be the author and copyright owner thereof for all purposes throughout the universe.

[INSERT COMPANY NAME] shall be the sole and exclusive owner throughout the universe in perpetuity, of all rights in and to the proceeds and all rights in the work completed by the contractor including the right to merchandise and exploit such work and all rights generally known as 'the moral rights of authors'.

If and to the extent that all or any of the provisions of this agreement do not operate to vest fully and effectively in the Producer all or any such rights, the contractor hereby grants and assigns to the employer all rights not so vested. The contractor hereby grants to the employer the full unrestricted and absolute right to make use of copy, reproduce, modify, adapt, distribute, transmit, broadcast, publicly perform, project, synchronise with images and otherwise to exploit such results and proceeds of the contractor's services by any means, methods, processes and technologies now known or hereafter to become known (the 'Licensed Rights') alone, or in composite with other materials including without limitation audio, video, animation, text and graphics. The licensed rights are to be used in connection with the creation, development, production, manufacture, packaging, distribution and promotion of the AM in any format and through any means, methods and technologies now known or hereafter to become known.

The Contractor hereby licenses to the employer the right to use and permit others to use the Contractor's name, photograph or biography in connection with advertising, publicising and exploiting the AM or any part thereof.

In the event of any claim of a breach by the employer of any provisions of this agreement, the contractor shall be limited to the right, if any, to obtain damages at law and the contractor shall not have any right in such event to terminate or rescind this agreement or any of the rights granted to the employer hereunder or to enjoin or restrain the developments, production, advertising, promotion, distribution, exhibition or exploitation of the AM and/or any of the employers rights hereunder.

</div>

(continues)

Figure 5 continued

The contractor agrees to execute such additional documents as the employer may require in order to carry out the intent of this agreement.

The employer shall have the right to assign this agreement and all of the licensed rights granted by the contractor hereunder to any party. The contractor shall not have the right or power to assign this agreement. This agreement shall be subject to those standard terms and conditions customarily found in agreements of this type in the entertainment industry (which standard terms and conditions shall be deemed included herein) including, without limitation, provisions regarding warranties, indemnities, disability, force majeure and default. This agreement shall replace and supercede all prior agreements regarding the subject matter hereof and shall constitute a binding agreement between the parties hereto.

[INSERT COMPANY NAME]

Signed: _____

(Contractor) (Date)

Signed: _____

(Witness) (Date)

Signed: _____

(Producer) (Date)

Signed: _____

(Witness) (Date)

In-house productions and productions with overseas elements

Of course, a great deal of control can be imposed when an entire production is happening in-house as it's easier to troubleshoot and rectify any problems when they are occurring within the same building. However, the reality is that most of the television projects currently in production in the United States, the United Kingdom, Europe and Australia are completed, in part, offshore. Pre-production is almost always done in the home studio, while the remainder of the production (layouts, in-betweening, animation) is outsourced overseas. This is one of the reasons why the pre-production needs to be foolproof and why the greatest of care must be taken when securing the materials before shipping them. It's better to check everything ten times than to send wrong or misleading information.

6

The 2D pre-production process: Part one

Model development

The basic style of the show has been established in the development stage. However, it needs to be further developed, defined and locked off at the beginning of pre-production. For any type of production, be it a film, television special or series, the start of pre-production is marked by the collation of the main model pack.

What is inside the main model pack?

The main model pack contains illustrations of the characters (including poses, expressions and lip-sync), backgrounds, props and special effects that will be used over and over again during the production. It is also sometimes referred to as a 'stock pack'.

Character models

The main character packs (or show character packs) contain illustrations of all main characters in the show. Special attention needs to be given to development, preparation and presentation of the main characters. These characters are the focus of the show, and in the case of television serials are going to appear in every episode. For this reason it is important that they are displayed correctly at this stage to ensure that every time they are used in the show they are faithfully created to match the original models. The best way to achieve this is to include as much

detail as possible within the model packs. The individual packs should contain the following views for each character:

- full-frontal view
- half-frontal view
- left-side view (left profile)
- right-side view (right profile)
- full-back view
- half-back view for the full figure
- facial expressions
- key character poses
- walk cycle
- character mouth shapes for lip sync
- size comparison

If time does not allow for all of these views to be developed there should at least be a half-front, half-back and one profile view (either left or right).

Action poses should also be developed for each of the main characters to exemplify their particular look. Any special articles the character wears or carries with them should be detailed at this point. If a character wears a baseball hat, for example, the hat must be included in the drawings. The inside and outside of the hat should be shown clearly, as well as any other additional specifications such as logos or tags. In such a case the hat will be included with the character set and not in the prop packs.

If the heroes change clothing or uniforms on a regular basis, then the variety of costumes they need should also be included in the main model pack. This shouldn't be confused with isolated costume changes (which would only occur once in an entire series and be part of the model pack for a specific episode). For example, if one of the characters appears in every show both at work and at home, then they will need to be displayed in their work uniform as well as their everyday clothing. If the characters have any specific markings, like earrings or tattoos, then the details for these need to be clearly shown on their model sheets. An illustration of each character's open hand (inside and outside) as well as a drawing detailing their feet (top and bottom) should also be included. See figures 6 to 9.

Lip shapes

The main model pack also needs to contain the lip shapes (a mouth chart or lip-sync) for every talking character. This would take the form of several close-up

Figure 6 Main character model—PANCHO Poses #1 (© Jim Keeshen Productions)

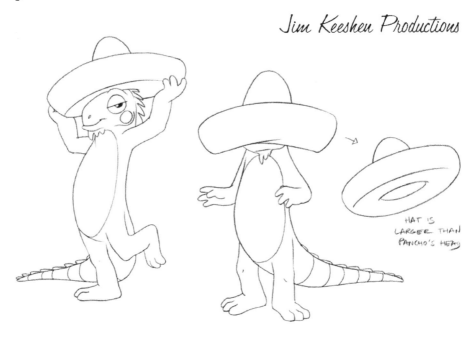

Figure 7 Main character model—PANCHO Poses #2 (© Jim Keeshen Productions)

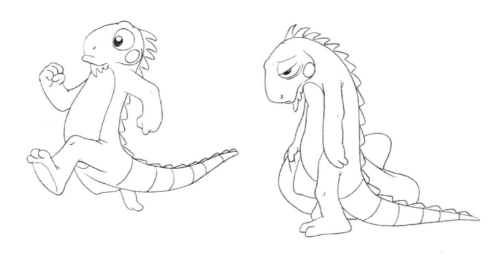

Figure 8 Main character model—PANCHO Poses #3 (© Jim Keeshen Productions)

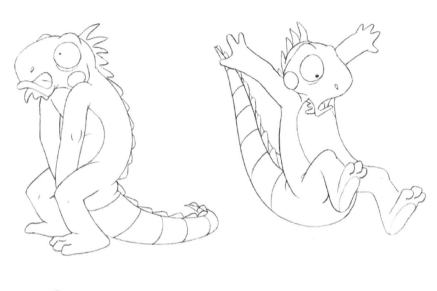

Jim Keeshen Productions

PANCHO POSES #6

Figure 9 PANCHO Turnaround (© Jim Keeshen Productions)

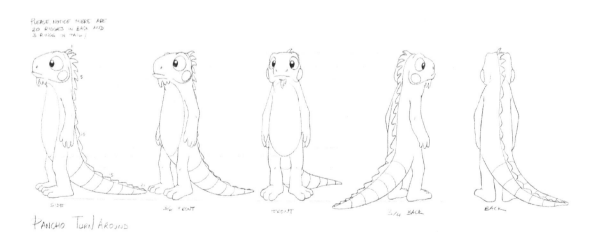

PANCHO TURN AROUND

images of each character with their mouth posed in different positions to symbolise key mouth shapes. The number of lip shapes in 2D animation can be as low as six shapes and as high as 12. In 3D animation it is possible to use up to 24 mouth shapes. However it can get a bit tricky when talking about maximum numbers. It is possible to have different sets of mouth shapes for each mood of a character. So for the normal mood, the character could have about nine shapes; the happy, sad and angry moods could also have a similar number. So it is possible to ultimately end up with over 30 mouth shapes for just one character. In this case the number of basic lip shapes per mood can be counted as the final figure (in other words refer to that particular character as only having nine mouth shapes), because it is the basic number of shapes used across the board.

Lip shape conventions vary from studio to studio, but some international standards do exist. For example, the position where the lips are closed and have no expression is always referred to as the A position. Some studios prefer to use numbers instead of letters in their naming conventions, so occasionally you will see this referred to as the #1 position. See figure 10.

Figure 10 Lip shapes (© Michael Zarb 2005)

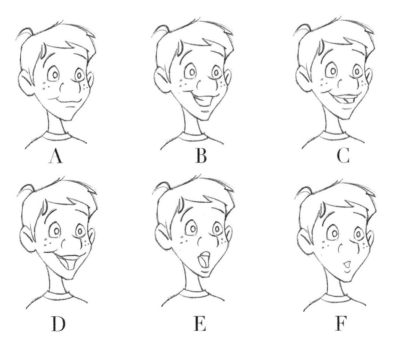

Size comparison

Every character model pack needs to include a size comparison line-up. This is a chart of all the characters displayed side by side, so that their 'real' size relating to the rest of the characters can be identified. The line-up is often drawn with horizontal lines in the background for easier orientation in determining individual character size. When the size comparison chart has more than one page, the absolute main character should always be displayed on each and every page. This will make it possible to relate the rest of the characters back to his or her size. See figure 11.

Figure 11 JAROCHOS—Size comparison (© Jim Keeshen Productions)

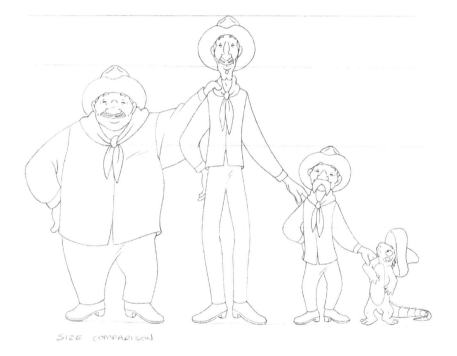

Prop models

The main props set will contain all the known props that will be used in the production. Again, in the case of series television, these are the props that are used over and over again from episode to episode. If a prop belongs to a particular main character then that character will be used for a comparison size against the prop. For example, if the show includes a character's bicycle, this will be illustrated with an image of the character next to it in order to indicate the correct scale. If the

character itself is not included in the illustration, a line that will match their height is placed on the model sheet. If the prop is something smaller, like a doll, then the character's hand will need to appear on the side of the drawing for comparison. If the prop doesn't belong to a specific main character then the absolute main character will be used for comparison. For example, an old-fashioned car, which may belong to a group of people (perhaps all of the main characters), will have the absolute main character included on the model sheet for a size indication. Instructions on how each prop should be constructed and used within the show should also be included, particularly if they are complex items. Wherever possible, the props should be organised into sub-categories within the pack for easy access. See figure 12.

Figure 12 Prop—Handkerchief (scene 52) (© Jim Keeshen Productions)

Special effects (SFX) models

The main special effects (or SFX) set will contain all the known special effects that will be used in the production. Once again, in the case of series television, these are the special effects that are used over and over again from episode to episode. The same method of size comparison applies here as for props. If a special effect is linked to a prop—for example an old car that backfires—the special effect needs to be drawn with at least a silhouette of the prop in the background. A thorough explanation needs to be given with regard to the use and treatment of all special effects. It is also important to clearly mark on the storyboard exactly what will be required with the special effects.

Main location designs

A set of the main location designs or general key locations must also be included in the model pack. They should be illustrated in various angles and atmospheres and should also be shown in the larger context in which they appear by way of a world map. This larger map will pinpoint all of the locations inside the world that has been created for the show and will detail their distance from one another. The location pack for a film production will be more detailed than that of a television serial, because with episodic television new locations are usually created throughout the series as dictated by the individual scripts. See figure 13.

All of the model lists are compiled by the production manager or production coordinator/assistant and checked by the animation director. In television production the model illustrations are drawn by character designers. In film production the art director will provide sketches of the basic characters and the character designers will refine these. Prop designers draw the props and special effects. A dedicated background designer will draw the locations. All of the models are cleaned by clean-up artists and approved through the established studio approval procedures. The producer/production manager oversees the approval process.

Figure 13 Key background (© Jim Keeshen Productions)

It is important to note that all the original artwork should be kept in the studio and not distributed among the studio staff or freelancers. In all instances, photocopies should be used for this purpose.

Shadows

If shadows are to be animated then it will be necessary to develop a shadow pack for all of the characters and props. The shadow pack contains details and examples regarding the casting of shadows on all characters. These particular shadows are referred to as side shadows. Some productions (usually the less complicated ones) do not use side shadows. Other shows use shadows instead of a night palette or night colours (more will be explained about this in the section on colour styling). Side shadows are animated over the top of the characters.

Many shows will also make use of drop shadows. These are the shadows characters cast on the ground underneath them or on the objects around them. Under normal circumstances it won't be necessary to produce a separate model sheet for the drop shadows. It would only be appropriate if the script indicates that something specific is required. For example, if the script calls for a character's drop shadow to dance on its own, or for any other unusual shadow to be cast, then reference models will need to be developed.

The shadow packs need to be inserted or bound with the model packs.

Model checking

It is imperative that all models are checked thoroughly—preferably by two separate people. The director/animation director will make the first check and a model checker will make the second. Each person will check different aspects of the models. The director checks and approves the creative side of the model and the model checker will ensure that each model pack is technically correct. This consists of making sure that all the lines are where they should be, that no elements are missing and that where models are represented a number of times there is consistency each time they appear. Model checking requires a sharp eye and a good understanding of space and perspective.

Failing to detect problems with models at this point will lead to complications during the colour styling process and possible further mistakes in animation. This will most certainly result in scenes needing to be reshot at the end of the line.

Once the main packs have been checked, it is a good idea to photocopy all of them and bind them together to make a book. The production assistant should be given this task. The models can then be divided up into the relevant sections (characters, props, special effects and sets) and a summary of all models should be placed in the front of each section. An overall summary should also be placed at the beginning of the book. It is always helpful to have a certain number of copies prepared and kept for easy and fast distribution to all of the artists involved in the production.

Every single model that is created needs to be approved internally and externally. Internally, the art director, the directors and the producer will approve these items. Externally, the client/investors and classification bodies need to approve them. The production manager is responsible for tracking the progress of all design and approval procedures.

Scriptwriting

In serial television productions, once the format and style of the show has been established, work can begin with the scriptwriting team to finalise story ideas for each episode. A scriptwriting team on a television series will usually consist of around six to eight people. The script producer and/or editor will run these sessions together with the director and producer. Story ideas for television serials need to be plotted in a methodical fashion to ensure that each episode runs in a consecutive and logical way. In productions for film or television specials, there will usually only be one or two writers who will sit down with the script producer, producer and director in the same way and lock off the story structure.

Once the story idea has been locked off, the scriptwriters can begin their scene breakdown. This is the process of taking the plotting notes and structuring them scene by scene, thus producing the skeleton of the script. The producer, script producer, director and client will then need to approve the scene breakdown before the writer can move on to the first draft.

A script will go through several drafts and the writers will have to work with the script producer, director and client to ensure that all necessary elements are included. The writer will also need to time their script with a stopwatch before submitting each draft for approval to ensure that it is running at the correct length. As a guide, the average script for a half-hour show (22 minutes) would be around 35 to 40 pages long. A 90-minute feature script would contain around 135 to 165 pages. In animation, the famous thumbnail rule of one page for every minute of

script doesn't always work. It is more accurate to say that one page covers between 35–45 seconds of screen time, although this will always vary depending on the amount of action needed.

When the writer's script has been approved it will go to the script editor, who will refine the script further before it is ready for lock off. It will then go through a polish, which is the process of finalising the dialogue.

If the project is bound by a tight schedule or small budget, then it is important that limits are set with regard to the number of characters, props and locations the writers can include in the script. They must also clearly understand the pacing and action requirements for the overall series. For example, if the budget is low it will not be possible to animate a large number of scenes that include crowds or large groups of people. This sort of thing needs to be considered carefully at this stage in the production.

Scripts will often need to be submitted to a classification board for approval. It is important to contact the classification body in your country ahead of time. They can provide advice on the articles they expect to be submitted in order to obtain the correct classification certificate. This is particularly important when applying for children's television classification as the project material will need to adhere to strict guidelines. Generally, broadcasters will not put a show to air without the correct classification certificate. It is the script producer's responsibility to make sure that all of the series writers are familiar with the classification system and that all scripts adhere to the classification guidelines.

Script breakdowns

Once the script has been locked off (completed, with no further changes to be made to it), the script breakdown can be compiled. When time is an issue, or a script is running late, an initial breakdown can be made from the second draft. The breakdown itself will consist of a table, with columns listing the scene numbers, backgrounds and locations used and the characters, props and special effects pertaining to each individual scene. It will also include the atmosphere, or the time of day of each scene. Information will then be drawn from this master list in order to make individual character lists, scene lists, background lists and so on. These lists will be used to organise the incidental design and recording stages. Usually, the production manager or production coordinator is responsible for the script breakdown.

When the script is locked, all of the lists should be rechecked against the final script and any discrepancies need to be corrected. In later stages this list will be checked and expanded to reflect anything new included in the storyboard.

The basic breakdown for incidental design development is one that includes listings of all characters, backgrounds, props and special effects. Some studios combine the props and special effects together into one list, but it's better to list them separately.

- The character list needs to include every character that appears in the script (indicating the page where the character makes their first appearance). This listing should include all humans, aliens, animals and insects—basically every single living thing, although sometimes it can be hard to draw the line! Is the robot that starts acting independently a character or a prop? In cases where an object demonstrates independent action it should always be classed as a character. Put simply, everything that has its own will for action should be included on the character list.
- The background list needs to include all backgrounds that appear in the script (indicating the page where the background first appears). It is very important to produce a detailed list of all backgrounds, including all of the possible angles. Reverse angles and anything that may not be visible on the general key backgrounds must be included in this list. It can also be useful to call for a diagonal view of all backgrounds, where every location is then represented by two drawings. The first drawing should show the location from the front angle and the other needs to show a cross-section of the area cut on a diagonal axis, with the overlapping sections on the ends. This might require a bit more work, but it saves a lot of trouble further down the track because all of the possible ground for each location has been covered, allowing less chance for misinterpretation. If it's clear from the script that two angles are not going to be used, then this should be indicated in the background list.
- The props list needs to include all props that appear in the script (including the page of script where the prop first appears). If a prop belongs to a character then this needs to be clearly indicated on the list. Something as simple as 'Mike's lamp' will do. Or if the prop directly interacts with a background then the list also needs to include a note like 'match to background number XXX'. When props that are connected with backgrounds are 'acting' at some stage it's better to call them held cels. A held cel is another level, if you like. It is a single cel that needs to be painted to sit on top of the background. A held cel is used when part of the background needs to be altered (for example, an object in the

background may need to be broken or a door may need to open and close). This can then be done using the separate cel, without altering the background. A prop will never have visual consistency with a background, but when a prop becomes a held cel it must be treated as a part of the background.

- The special effects list needs to contain all of the special effects that appear in the script (including the page of script where the special effect first appears). This list needs to include every single item of smoke, dust, snow and glows, etc. Everything subject to colour styling needs to be on this list.
- The talking character list is prepared for the purpose of organising the voice recording. If the studio uses a script coordinator, the list, together with other relevant materials (see recording), should be handed to them. If no script coordinator is used, the list should be sent to the recording director or the studio's regular recording contact person. See figure 14.

The funpack

In episodic serials, once the model lists have been made, the funpack design can begin. The funpack comprises of all the designs called for in the script to be used by the storyboard artists. These are designs that would not have been included in the main model pack because they have been added to the production in the course of the scriptwriting process. Usually this will be split between two people— a background designer, who will design rough backgrounds based on the locations described in the script, and a model designer, who will design all of the props and new characters that appear in the script. A new funpack will be made for each episode and these designs will form the basis for the final episode model packs.

Casting voice talent

Talent casting and selection can be done through a casting agent or directly by a member of the production staff, usually the producer and director. The director may already have an idea of the talent they want to use, or talent agents can be asked to suggest people on their books for audition.

In order to begin the casting process (either through a casting agent or through talent agents) the requirements of the project need to be specified in terms of the types of voices desired. This is done by providing the agents with descriptions for each and every character, including particular specifications such as accents or

Figure 14 Scene breakdown

Scene	Location	Atmosphere	Characters	Props		FX	Comments
				Joint	Separate		
1	Side of house/Tim's Room (Int)	Day	*Tim (F)	Closet Elephant sculpture (intact)	Birds Alarm Tim barefoot		Tim's POV-looks in mirror and sees that he is a 'freak'
2	Carnival A (Ext)	Night	*Tim (N) *Jen Misc Clowns	Carnival rope	Jen skateboard Tim skateboard		Flashback
3	Freak tent (Ext) Back of Freak tent	Night	*Jen *Tim (N)	Carnival rope	Jen skateboard Tim skateboard Shadow	Shadow appears around corner	
4	Freak tent (Int) / Freak tent (Ext)	Night	*Tim (N) *Jen *Voice Two-headed dog	Baby animals in meth jars; Mirror Carnival rope	Jen skateboard Tim skateboard Shadow	Tim sees himself as freak in mirror	
5	Tim's room (Int)	Day	*Tim (F) *Mom	Closet Elephant sculpture (intact)	Tim barefoot		
6	Tim's room (Int) / Tim's closet (Int)	Day	*Tim (F) *Mom *Dad	Closet Elephant sculpture (intact) Clothes	12-gauge, Remington shotgun Cupboard screen	POV – Tim watching action from inside closet	
7	Tim's room (Int)	Day	*Tim (F) *MomDad *Dad	Closet Elephant sculpture (intact) Clothes	12-gauge, Remington shotgun		
8	Tim's room (Int) / Closet (Int)	Day	*Mom *Dad *Tim (F)	Closet Elephant sculpture (intact) Clothes	12-gauge, Remington shotgun Cupboard screen		POV – Tim watching action from inside closet

*Denotes talking characters

speech impediments. Sometimes it can be helpful to provide a reference comparing the voice to someone famous. The casting or talent agent will then send some voice sample discs or tapes for the director to chose from.

The director will make a selection of people they feel should be auditioned. The producer/production manager will then have to prepare the following casting materials:

- a clear description of all characters
- character model sheets
- selected script lines for the casting for each character. The lines should be character specific and give a good interpretation of the personality of the character, including things like speech pathology (if any) and any catch-phrases the character may use

After receiving the materials the agent will organise a casting session. If the recording is going to take place locally the production manager can organise a casting session where the producer, director and animation director can be present. The production manager should also prepare one set of materials (the descriptions and script excerpts) for each person to be cast, as well as copies for the directors, sound engineer and technicians. These materials should actually be delivered to the voice talent at least a couple of days prior to the casting in order to allow them to prepare properly.

The casting sessions will be recorded so that a tape or a disc can be made of each audition. The director and producer will listen to the materials together and make their final casting decisions. If required, a tape of the preferred voices will then be sent to the client for approval.

Once the cast selections have been made, the casting or talent agents can then be contacted in order to negotiate the recording fees. If the production is using lesser-known voice actors then the appropriate union regulated fees will apply. If an established actor is being cast then their rate will need to be negotiated. It is important to know at this stage if the show is being sold overseas. If this is the case, additional fees will apply for all voice talent in order to buy the right to use their voice across several territories. If possible, the safest way to go is to buy worldwide rights, which will free the project up to be sold anywhere. Once these items have been established a contract can be drawn up for each individual voice artist.

Recording voice talent

There are two major approaches to the voice recording—recording with or recording without the storyboard. The majority of animation studios do their recordings without the storyboard.

People who support the use of the storyboard for recording claim that it gives better control and enables the full detection of any ancillary noises like grunts, groans, impact noises and so on. Those in support of recording the dialogue before work on the storyboard begins would argue that this method allows for a better quality of storyboard because the artist has the dialogue as a reference and can hear the character voices and emotions as they work. It is often the case that tight schedules dictate the need for fast or multiple script recordings in a short time, making it impossible to have the entire storyboard completed to match the recording schedule. At the end of the day, both approaches work.

The recording can take place with or without the director/animation director present. If the recording is being done in another city or country, there are two options. The first option is to employ a recording director to oversee this process and the second is to set up a phone patch into the studio so they can direct the recording without being physically present.

Once the script is locked off, all dialogue lines as well as any other sounds that the human mouth produces (even if they are not indicated separately as a dialogue line) need to be numbered. It's a good idea to use only even or odd numbers. This way there will be unused numbers to allocate to any unexpected extras that might need to be recorded. Once the dialogue numbering is complete, and if it is preferable, the script can be stripped of anything that is not going to be recorded, leaving only the numbered lines. This task is the responsibility of the script coordinator. In companies without such a person the role falls to the production manager, production coordinator or production assistant. Alternatively, some studios will leave the script as is and simply mark each actor's specific lines with a highlighter pen.

From the script, a list of talking characters needs to be made. In film productions every single character would have been cast during the voice selection process. In television series production the incidental characters will usually only be known to the director as each script takes shape. In this case the director will choose existing cast members to fill the roles of the incidental characters. It is important to be aware that union regulations in some countries dictate that a voice actor can only perform a certain number of different characters in the one show. The producer

should check with the legal department to see if this situation applies and then cast accordingly.

At least two days prior to the recording, the production manager needs to supply the following materials to the casting agent (if the recording is remote) or to the cast and members and the recording team if it's local:

- numbered script
- recording script
- model sheets for all speaking characters
- character description for all characters
- contracts and paperwork
- all other references that might be useful for the recording (storyboards, if available)
- recording date information—location and time or session

Recording sessions can take place with all cast members at once, or in several sessions with the cast either split into groups or booked to record individually. The budget, size and availability of the cast, capabilities of the recording studio and the director's preference will determine this. If the cast size is relatively small then it is best to record all of them at once as this enables them to bounce off one another and ultimately give a better performance. However, if a well-known actor is attached to the project, scheduling difficulties may dictate that they need to record their dialogue separately to the other actors.

With all voice recordings, as with live action shoots, it is important to remember that the talent must be supplied with sustenance. Breakfast, lunch, dinner and snacks should be made available to the cast and recording crew. Usually the recording studio will take care of this, but it is always a good idea to double check with them that they include this in their service.

In television series productions, actors are generally only called for recording twice for each episode. The first recording session will be the initial dialogue record and the second will be the ADR session, which is recorded after the show has been edited in order to add additional dialogue (more on this later).

In features, sometimes a scratch recording is made before calling the voice talent in. This is where team members will record the initial dialogue for the purpose of the animatic reel. This allows the director to play around with the track and refine the timing, finalise dialogue and cement the way in which they will direct the delivery of the line when the real dialogue is recorded. Once the animatic is complete, the voice actors will be called in to record their parts. With feature

productions an actor may be called into the studio to rerecord lines three, four or even five times as the project is developed. These sessions can often be filmed, as the actor's movements when they deliver the lines can be a great help to the animators when translating the feeling of that delivery into the animation.

Rehearsals, or a read through, will need to take place before the recording session. Rehearsals for film productions will often take place over a number of days, whereas with high turnover television serials the rehearsal may simply take the form of a quick read through right before the recording session.

The director can select their preferred takes during the recording or keep the majority of the takes and select them later, after the recording. Once the takes are selected, the session material is cleaned up so that all unnecessary material (pauses, breaths, etc.) is removed. This, along with the recording documentation (the recording edit decision list, or EDL) is then given to the animation studio.

The 'as recorded' script

The 'as recorded' script, or post-recording script, is made after the recorded dialogue track has been received from the recording studio. During the recording process the director or cast (with the director's approval) may make slight changes to the dialogue. A production assistant will need to listen to the dialogue track and record any such changes on the script. This is done more often in series production, where an up-to-date copy of the script is needed when the animatic reel is being built.

A cast list will also need to be generated. This is a simple form listing the character name and the cast member responsible for the voice performance. This is an important record to have, particularly in serial productions where actors may perform many different incidental characters over the life of the project.

7 The 2D pre-production process: Part two

Aspect ratios

Before work begins on the storyboard it is important to lock off the aspect ratio in which the show is to be produced as the storyboard panels will need to conform to this screen size. The term aspect ratio refers to the width to height ratio of the screen. The aspect ratio for standard television is 4x3 or 1.33:1, meaning simply that the width of the screen is 1.33 times wider than its height. This is also the most common aspect ratio for computer screens. The aspect ratio for standard widescreen is 16x9 or 1.77:1. See figure 15. The aspect ratio of a project will generally be determined by its final mode of screening—shows made for television will usually, although not always, be made to the standard television aspect ratio of 4x3. Feature film productions will be made to the standard film aspect ratio of 16x9. It is important to note that these are the two most popular standards but many other sizes do exist. High Definition TV will use an aspect ratio of 1.78:1 and Cinemascope uses a 2.35:1 aspect ratio.

TV safe (or TV cut-off) areas also need to be factored in when preparing the blank storyboard panels. The TV safe area is the portion of the screen that will be visible on all television sets. When producing anything for television this must be taken into account to ensure that important action is not cut off or clipped around the perimeter of the television screen.

Figure 15 Aspect ratios

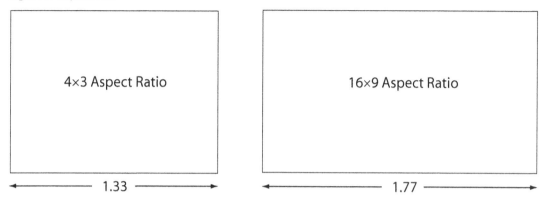

Storyboarding

Storyboarding is the process of translating the script into pictures and converting the words into visual sensations. The storyboard artist will represent the story through a series of drawings that depict the characters in their location, the framing, camera angles and movement for each and every scene. In television productions the storyboard artist will accomplish this by adhering strictly to the script. This is because time and money is usually limited on these types of productions and straying too far from the original script can take extra time and resources in checking and reworking the storyboard. In feature productions, where the budget may be relatively more substantial, storyboard artists are often given the freedom to interpret the script and elaborate on it in order to tell the story. The script in this case is considered secondary to the storyboard development.

The animation storyboard is organised into acts (sequences) and the sequences are organised into individual scenes. One or more artists can produce a storyboard. For example, a television serial storyboard usually comprises of three acts and it's common to hire three artists, one to complete each act. It is preferable to have one person complete an entire storyboard, but production schedules are always very demanding, so it is often unavoidable that the task will be shared. If a storyboard is to be divided up among several people it is often necessary to employ a storyboard supervisor. This person works with all of the storyboard artists in order to ensure uniformity in style and pace.

Storyboarding can be done in-house or by external contractors, but the majority of studios usually use freelance artists to complete their storyboards. As with other areas, storyboarding in-house allows for more control but outsourcing achieves fine results as well. Where storyboards are split between several people, it is important to maintain strong lines of communication between the artists. If the need arises for a storyboard to be divided between two or more people, then it is better to do the storyboard in-house if possible. Time allotments for the storyboarding process can vary a great deal. For a 22-minute television show, one artist can be given between four and eight weeks to complete a board on a low to medium budget show. On a higher budget series that time can be stretched to 16 weeks. Naturally, these time frames are reduced when multiple artists are assigned to the project. In a feature-length production the storyboarding process can take up to 12 months.

The storyboard artist will need to be given the following items before beginning the board:

- character, set and prop designs
- key background designs (some studios prefer to go with rough designs only at this stage and have the key backgrounds done from the finished board)
- the script
- series bible (for an overview of the project)
- a contract
- tape/disc with recorded dialogue (if recording has already been done)
- art supplies/storyboard paper with panels that mark out the correct aspect ratio and allow for TV cut-off
- any other reference, such as existing storyboard samples

The animation director briefs the storyboard artist and explains the style of the show, along with their expectations for the look of the board. The briefing needs to be done precisely to ensure efficiency. The storyboard artist must understand the imposed limitations of the budget and the schedule. Their work will directly impact the amount of work done by all other production personnel involved in the series. It means that the pace (number of scenes), level of effects, number of characters within the frame, camera requests, the use of panning and multi-planes (scenes that involve continuous camera moves set at different speeds and distances) will directly impact the cost of production.

The average storyboard for a 22-minute show directed at young children has between 300 and 350 scenes. A show of the same duration pitched at older age groups will contain between 400 and 450 scenes.

Once the storyboard artist has been briefed, they will begin work on thumbnail drawings of the script, which represent a limited visual breakdown of the story. This is usually done on pieces of paper with 20 or so small panels per page (and looks like film strips on contact copy). It can also be done right on to a copy of the script. The thumbnails must be submitted to the animation director for approval before work can begin on the main board. After the approval the storyboard artist can begin the rough pass. The rough pass is drawn to the full size of the storyboard. Storyboard paper usually has three panels per page, but it can have six panels as well. Some studios storyboard on legal size paper, some on A4, B4 or B3 sizes. Each panel must conform to the aspect ratio in which the show is to be produced.

The storyboard artist is in regular contact with the animation director throughout this process, continually submitting sections for approval. When the director and animation director have both approved the rough pass they will give the board to the producer. Providing the producer is happy with the board, it is usual at this stage to send a copy of it to the client and broadcasting/classification bodies for approval. All comments received from clients/financers and the classification board must be respected.

In feature productions where multiple storyboard artists are employed, the animation director will break the script down into much smaller sequences for distribution. They will brief each animator and may organise an initial planning meeting between each storyboard artist with the directors and producer. During this meeting the rough concept for the section of the storyboard will be worked through and the thumbnails for the storyboard will begin to take shape. The storyboard artist will then go away and lock off his thumbnails before beginning on the rough pass. Once this is complete, the rough pass will be presented to the producer, director, animation director and client for comments. In contrast to a television series, there is usually a lot more time available on a feature production to workshop and revise the storyboard on a detailed level. This can mean that each sequence is presented to the creative team a number of times until everyone is completely satisfied with it.

Once any and all changes have been integrated, the storyboard can be cleaned up. This is the process of removing all of the rough lines and making sure that each drawing is clear and conforms to the model sheet. This can be done by the storyboard artist or by a clean-up artist. It is often cheaper to have a specialised

clean-up artist work on this and allow the storyboard artist to move on to the next section of the board.

The final storyboard must have a clear indication of the studio and project name. Each page needs to be numbered correctly and all scene numbers are to be clearly indicated. All of the locations should be marked and every location change should be written in. The final storyboard must also indicate day and night shots, camera movements (truck/in, truck/out, zoom, pan, etc.), fade ins/outs, dissolves or any other effects. The numbered dialogue should also appear in the board, underneath the corresponding panels. All drawings must reflect their comparison size and all locations need to be recognisable. The intention here is to achieve clear animation direction that leaves no room for mistakes.

It is quite common for servicing studios to use the finished storyboard panels in place of traditional layouts. This is usually achieved by having the storyboard artist produce a much cleaner and more detailed storyboard. Each storyboard panel is then blown up to the correct size and sent out as finished layouts. The results of this technique will vary depending on the quality of the finished storyboard.

It is also very helpful if the storyboard character illustrations are identical to the model sheet provided. Quite often, storyboard artists will draw quite roughly and characters will appear off model. This presents a problem if the layout and animation work is being outsourced as it will sometimes be the case that artists do not follow the model sheets closely enough, preferring to use only the storyboard. This can begin a chain reaction, where layouts end up being off model because the storyboard was, and in turn the key animation can eventually be drawn off model because the artists were paying too much attention to the way the models appear on the layouts.

Storyboard timing

Once the storyboard has been completed the correct timing for each and every scene needs to be established. Timing the storyboard will ensure that the show is going to be the correct length. It is also necessary because of the time and cost associated with producing animation. Too much footage will represent time and money wasted. Too little footage coming in at the post-production stage will require extra material to be animated, which will add a great deal of time to the schedule and will result in overspending.

The storyboard timing can be done in two different ways. The first method is by compiling an animatic reel, or alternatively the episode can be sent out to an

Figure 16 Storyboard sample (© Brilliant Digital Entertainment)

BASKETBALL EPISODE 12 "THE HOOP"

DIALOGUE 164 CROWD

Cheering.

TRANSLATION

DIALOGUE

TRANSLATION

Crowd goes silent.

DIALOGUE 162 CROWD

Cheering.

TRANSLATION

PAGE (27)

experienced timing director who will literally act out every movement using a stopwatch to time each scene.

Animatic reel

The animatic reel is a moving version of the storyboard and is compiled in order to correctly establish the timing for each scene. It is also used to check the storyboard continuity and shot composition. In order to make the animatic, the storyboard needs to be scanned page by page into a computer. One of the computer camera operators or an assistant editor will use Premiere, Final Cut Pro or a similar software package to create an assembly edit that will contain every scene and basic camera movement. The dialogue track will also be placed into this assembly. An editor, together with the director and animation director, will go through the assembled storyboard scans and apply the correct timing to each and every scene. The director will also check for continuity problems and set-up problems and will make sure the story is working. Problematic storyboard panels will be revised at this time and scanned back into the animatic cut. It is also common during this process for additional lines of dialogue to be recorded if the director feels it is warranted. These are commonly referred to as 'pick up' lines. These need to be noted and included in the script for reference during the voice breakdown stage. If a song or piece of music is to be written and included in the show, then a click track will need to be supplied at the animatic stage. This is a track that simply lays out the beat of the song and provides a guide for the timing and animation of the material.

When the animatic is finished, the director/animation director, together with the producer and client, need to either approve it or request changes to the project based on it. The completed animatic will then be given to a production assistant, who will go through it scene by scene to ensure that the master storyboard is identical to the animatic.

Different studios make animatics at different stages of production. Some studios make animatics based on layouts. Instead of the storyboard, the layouts and background layouts are scanned into a computer and then positioned together, usually in Photoshop. Then, as with the storyboard animatic, the camera movements, dialogue and timing will be added. This method is useful as an additional tool for checking the layout quality and background continuity.

Some studios skip the animatic stage altogether because the process of making them can be expensive and time-consuming. Making an animatic for a 22-minute television episode usually takes three to four hours of scanning the storyboard, two days to assemble the shots with the dialogue and up to ten days to edit, review and approve.

Feature film productions will often go even deeper by creating animatics with cut-outs of the characters which can be moved from shot to shot to better establish the layout and positions within a scene. The animatic process on a feature film will be much more organic than in television production and will continue right through the layout and animation stages. As elements are updated throughout the various phases of production they are dropped into the animatic for viewing and directorial approval. Once actual test footage is dropped into the animatic it can technically be called a leica reel. A leica reel is characterised by the addition of pencil tests (in 2D animation), motion tests (for stop motion) or wire frame model tests (for 3D animation). The term itself came from the 2D world, where the pencil tests were shot on a German camera of the same name. The leica reel provides an up-to-the-minute production reel. Sound effects and temporary music may also be added.

Storyboard slugging

Slugging is the process in which the instruction for the timing of character and camera movements and the exact positioning of the dialogue is written into the storyboard. Slugging is the vehicle for successful exposure sheet production. There are two different variations on this process. If an animatic has been completed then a production assistant will need to sit down in front of the finished animatic and make sure that every panel in the master storyboard matches the picture on the animatic and that all of the dialogue represented in the animatic also appears on the master storyboard in the correct place. Once this is complete, the production assistant will go back through and transpose the scene timing from the animatic on to the storyboard. Once this is completed the storyboard will be given to the director for one last check.

Some studios make the animatic before the storyboard slugging as a guide for the slug. Other studios make an animatic after the slugging has been done as a way of checking the storyboard continuity as well as the animation timing. If this is the chosen method the animatic will be assembled and timed according to the storyboard slugging.

If an animatic is not being made, then the storyboard must go to an experienced timing director who will use a stopwatch to time all of the action manually and then write the timing instructions into the storyboard.

For the timing director to perform this task properly they need to be given the following items:

- a copy of the storyboard
- a tape or disc containing the recorded dialogue

- a post-recording script
- a set of model sheets
- a stopwatch
- an employment contract (if the timing director is a freelance artist)

The storyboard received from the animation timer at the end of this process is called the slugged board. On the basis of the completed slugged board it is possible to now go ahead and edit the dialogue to the exact length and position. If an animatic is being made after the storyboard slugging, the timing will form the basis of the animatic assembly.

Voice breakdown/sound reading

The voice breakdown or sound/track reading is the stage in which the recorded sound is converted into a phonetically written transcript. This is done on sheets that have been specifically created for the purpose of breaking down the soundtrack. It will provide the animators with information about the exact pronunciation and timing of the dialogue in order for them to create the correct lip shape movements (lip-sync) for each of the talking characters.

Traditionally, the soundtrack was converted to 35mm magnetic tape that was then passed through a synchroniser in order to get the sound reading. The synchroniser is a simple machine that allowed the user to break the elements of the sound down on a frame-by-frame basis. The tape could be passed through the synchroniser at a variety of different speeds, depending on what was needed for the project. This can be done much more simply these days, with modern sound and editing packages that allow the user to move back and forth along a track on a frame-by-frame basis. If using such a package, the sound reader would only need to be supplied with an electronic file of the audio. An MP3 or Wav file would suffice. There are also a few different software packages available now that can break down electronic files of dialogue automatically. Magpie is one such package, and there are several more being written and tested. It is important to remember that the sound file supplied must match the dialogue track from the edited animatic (if an animatic was completed).

The sound reading can either be written directly on to an x-sheet, or a separate sound sheet can be used. Sound sheets are very similar to x-sheets, but as the name suggests, they are only used for the purpose of recording the sound breakdown

on paper. The x-sheet is used in the next stage for animation timing, so if the breakdown is directly written on to the x-sheet it will save the time of cutting up the sound sheets and sticking the information on to the corresponding x-sheet. See figure 17.

Once the sound reading is complete the sound charts can be sent to an experienced animator or a specialist lip-sync artist, who will go through the voice breakdown and apply the correct mouth shapes to enable each individual mouth movement to be animated. The lip-sync will be written on to the sound chart in the correct frame position (in relation to the voice breakdown). Each different mouth shape will be represented by a letter—A, B, C, D, E, F and so on, depending on the number of different mouth positions designed for each character.

Exposure sheets

Once the slugging and voice breakdown are finished, the exposure sheets can be made. The exposure sheet is the universal compass for animators as it is a document that contains every piece of information needed to create the scene.

The exposure sheets are produced by the timing director who will use the instructions from the slugged board and animatic, together with the phonetically broken sound, to mark out instructions for the movement of every single character. Each x-sheet is marked with horizontal lines and each line represents one frame, or one segment of time. They also contain vertical lines that are used to place the sound reading (preferably with lip-sync shape instruction), animation instructions, animation levels, camera instructions and detailed requirements about treatment of the special effects. All of these elements, with the exception of the sound reading, will be placed on to the x-sheet as it passes through further stages of production.

To make the x-sheets the timing director needs to be supplied with the following materials:

- slugged storyboard
- dialogue tape or disc
- animatic
- post-recording script
- model packs
- the sound breakdown or separate sound sheets
- employment contract (if they are a freelance artist)

Figure 17 Sound chart

STUDIO PRODUCTION

NO	SOUND	LS	SOUND	LS	NO
1		A			1
2	Sox				2
3	G	B			3
4	OO				4
5		E			5
6					6
7					7
8					8
9					9
10					10
11					11
12					12
13					13
14					14
15					15
16		B			16
17	D				17
18					18
19					19
20					20
21					21
22		A			22
23			Blackie	A	23
24				B	24
25			TH		25
26			EH	C	26
27			Y		27
28			S	B	28
29					29
30					30
31				C	31
32			EH		32
33					33
34					34
35			Y	B	35
36			N		36
37					37
38					38
39					39
40					40
41					41
42					42
43			U	C	43
44					44
45			TH	B	45
46					46
47			IH	C	47
48					48
49				B	49
50			NG		50

NO	SOUND	LS	SOUND	LS	NO
1					1
2		A			2
3					3
4	Millie				4
5		F			5
6	WH				6
7	EH	C			7
8					8
9					9
10					10
11	N	B			11
12					12
13					13
14	Y				14
15	OO	F			15
16					16
17					17
18		B			18
19	S				19
20	U				20
21		C			21
22					22
23	CK	B			23
24	S				24
25					25
26					26
27	EE	C			27
28					28
29					29
30					30
31					31
32					32
33					33
34					34
35		B			35
36	D				36
37					37
38					38
39		A			39
40					40
41					41
42					42
43					43
44					44
45					45
46					46
47					47
48					48
49					49
50					50

SHEET NUMBER:

The x-sheets also need to contain the following additional information:

- the project name
- the show name and number
- a footage total for every page
- the act number and scene number
- the sheet number (some studios number each act individually, but it is preferable to have the numbers running consecutively from the beginning to the end)

X-sheets should be checked against the storyboard to insure that nothing has been missed and that everything matches. The information on the x-sheets needs to be clear, straightforward and easy to understand. Don't forget that the sheets may be sent to a non-English speaking country (if part of the production is being outsourced) and that everything from the charts, as well as the storyboard and all other elements supplied, will be subject to translation.

If the layout production is going to be completed in-house then the x-sheets will have to contain the background instructions as well.

Most often, the x-sheets are charted one after another, but it is much clearer if each scene starts on a new page. This makes for easier distribution to the layout artists and animators because there won't be the need to photocopy heads and tails all the time.

It is also very important to keep copies of the sound reading and x-sheets once the originals have been sent overseas.

Final model packs

Once the final storyboard has been approved by all the relevant parties, the model lists need to be reviewed and updated against the finished board. The character, set, prop and special effects lists need to be updated and the identification of each item's first appearance needs to be replaced by the relevant page and scene number from the storyboard. The lists need to be expanded to include any additional elements that could not be identified from the early scripts. New (additional) characters, sets, props and special effects need to be created and final model packs for the show locked off.

Two different types of model pack can be made at this time. The rough model pack will contain all of the models necessary for the episode in a rough version. This is ample information to then pass into the next phase of production, which

Figure 18 X-sheet

SC STUDIO PRODUCTION

ACTION	DIAL	LS	DIAL	LS	EXP	A	B	C	D	E	F	G	H	EXP	CAMERA
H/U		A			1									1	
	Sox				2									2	
Socks sits down	G	B			3									3	
	OO				4									4	
		E			5									5	
					6									6	
					7									7	
					8									8	
					9									9	
					10									10	
					11									11	
					12									12	
					13									13	
					14									14	
And folds his arms					15									15	
		B			16									16	
	D				17									17	
					18									18	
					19									19	
					20									20	
					21									21	
		A			22									22	
			Blackie	A	23									23	
				B	24									24	
			TH		25									25	
Blackie walks			EH	C	26									26	
to the table			Y		27									27	
			S	B	28									28	
					29									29	
					30									30	
				C	31									31	
			EH		32									32	
					33									33	
					34									34	
			Y	B	35									35	
			N		36									36	
					37									37	
					38									38	
					39									39	
					40									40	
And leans up					41									41	
against its edge					42									42	
			U	C	43									43	
					44									44	
			TH	B	45									45	
					46									46	
			IH	C	47									47	
					48									48	
				B	49									49	
			NG		50									50	

is the layout stage. The final model pack will be the clean version of these models and must be ready by the time key animation begins. Particularly in television productions, where schedules are tight and the volume of work is high, producing a rough model pack can help move production along if all other elements are ready for the layout process to begin.

Once the storyboard is complete it is a good idea to check through it for some inspirational poses or expressions to add to the main model pack. This practice is common at the beginning of a television series and is usually done with only the first few completed storyboards.

Key and intermediate backgrounds

The set design (background or location) is completed at the same time as the other models. Artists specialising in background design and creation finalise the key backgrounds based on the locked storyboard. They will also use the initial rough funpack designs for reference.

There are two types of backgrounds in 2D animation—key and intermediate. The key backgrounds depict wide shots of all the different locations in the show and will be used as the basis for the creation of all other backgrounds. Each location within the script should have its own key background created. The keys can be made to full size so they can be literally used as is, usually for establishing shots. Alternatively, they can be created in a smaller form and used as reference only. In cases where the exact set-up of the key is used and it hasn't been painted in the original size, the drawing will be blown up and the background repainted. The traditional size of a key background is 12 fields (see the sample field size/animation grid). Sometimes, especially for establishing shots where the camera tracks-in, there might be the need for a larger background size. In this case the background can be created on 16, or even 24, fields. Field sizes represent the area that will be seen by the camera and are used when laying out, animating and compositing scenes. See figure 19.

When shows are outsourced, the key backgrounds will be produced in-house, either by pencil or in a computer package such as Photoshop. The keys will be painted and sent to the servicing studio to be used as guides for creating the intermediate backgrounds. The intermediate backgrounds will be created during the layout stage and encompass all of the backgrounds needed for each individual scene.

Figure 19 Field size

Other background elements are: overlays, underlays, overlay/underlays and held cels. These elements are all painted on to clear cels and placed flat against the background.

An overlay is positioned above the animation, an underlay under the animation, and an overlay/underlay is placed both over and under some elements of animation. Overlays usually do not require registration of animation unless they become an overlay/underlay at some point. An overlay would be used in a situation where a character was directed to walk in front of a house (which would be painted on to the background) and behind a fence, which would be painted as an overlay and placed on top of the animation. An underlay would be used if a prop was introduced on top of a background. For example, if a specific car were parked outside a building for one scene the car would be painted as an underlay. An overlay/underlay would be required if a static prop was needed for scenes where several characters were directed to interact with it. If one character is placed in the back of the shot, standing behind the static prop, and another character is to approach from the foreground, the prop would need to be placed between the animation for each of those characters.

The held cel is different from the overlay, underlay or overlay/underlay. The held cel is the only element drawn by an animator but painted by the background department. It will not move when it first appears, but as the show progresses it will at some point become part of the animation and thus requires the ability to move. It should always be prepared as a part of the animation but painted as a background to maintain visual consistency. An example of a held cel would be a gate that for the most part would remain closed, but at some point would need to swing open and close.

One scene can have multiple overlays, underlays or overlay/underlays and in the case of panning scenes they can be panned at different speeds, creating an illusion of great depth. When they are used in multiple quantities and speed the scene is called a multiplane scene and is considered complicated to shoot. When it comes to the camera work for such scenes, they are usually given to the more experienced camera operators.

Backgrounds as well as overlays, underlays or overlay/underlays and held cels are always marked with the scene number corresponding to their first appearance in the show. In other words, if a background was used for the first time in scene 16, it will keep the label BG16 throughout the entire show, irrespective of the number of scenes it will be reused in. In series production it is often the case that backgrounds will be reused across different episodes of the same series. In this case there are two possible ways to manage things. The background can be given

a different number for each new episode (the number of the first scene it appears in for each particular episode), or it can keep the original number throughout the whole serial as long as it is prefixed with a letter or number to ensure that there is no double-up on background numbers. Most find that the second method is the best way to do things.

If the background from the main set is used it must always keep its original number. Never change the numbers for key backgrounds within one show.

Panning backgrounds need to be prepared as needed (based on the requirements dictated by the storyboard and layout). A pan can range in length from a short to a long pan and is marked alphabetically to indicate this. An A–B pan is a short one, whereas an A–E pan is significantly longer. Usually, if a background is needed that is longer than A–E, a repeat pan background is used. A repeat pan has one repeated section that makes a seamless transition between the first and last pan position (for example, A–G or A–E pan + repeat section).

The letters A, B, C, etc. are used to mark peg holes alongside the pan. A is used for the first hole and then each consecutive hole is marked in alphabetical order (when a pan goes from left to right). When a pan goes from right to left, the order is reversed. If a background is reused and panned across in one direction for one scene and then in the opposite direction for another scene, the background will retain its original marking according to its first appearance in the show. In all other scenes where the background is used, it will be accompanied with a note explaining why the holes appear to be marked in the wrong order.

Pans can be horizontal (for movement from east to west or west to east) or vertical (for movement from north to south or south to north). A pan can also be diagonal, and in this case will be drawn at the angle corresponding to the slope required, creating the illusion of movement up or down a hill or slope. Also important to mention is the whiz or zip pan, which is usually created without the use of recognisable objects. Instead, this type of pan is achieved by blurring colours or speed lines.

All backgrounds are checked and approved by the art director/background department head and then by the director/animation director. The art director/ background department head must also check all intermediate backgrounds before they are placed in the layout folders to ensure they are correct in terms of the look and continuity of the show and also to make sure that all aspects of the painting reference are correct.

Background painting

In many cases, the rough style of the backgrounds is established in the pitching and development stages and developed further once the script is locked. However, the final style is developed and established during pre-production.

The average half-hour show has around 15–20 key backgrounds. Feature films will require significantly more backgrounds, although the final number will depend on the number of locations within the show. The background painting department, under the supervision of the art director or the head of the background department, does all of the painting. Background styles can vary, depending on the style of the entire show but are always painted based on the background designs or the background layout. Key backgrounds are painted with the greatest level of detail as they are painting references for all of the other intermediate backgrounds. If a show is being outsourced, all of the key backgrounds will be painted by in-house staff and sent to the servicing studio as reference.

Regardless of how nice and detailed the backgrounds are, it is always important to make sure they don't overshadow all other aspects of the show. The backgrounds should never divert attention away from the characters by being too intense or rich. It is sometimes the case that shows are produced with backgrounds that have been created with the same 'value' as the characters. They have the same line work, the same colours and are painted with such intensity that the characters don't separate well from them. This leaves the show with a feeling of flatness and over-blending, which is very unpleasant on they eye after a while.

When painting keys, it's not necessary to paint them in their original size. As explained earlier, they can be painted on a smaller scale if the intention is to use them exclusively as reference. It is also unnecessary to paint both angles for one location. It's enough to paint one angle and only the specific details of another angle, making production faster and more economical.

It is necessary to make a 'background painting breakdown list'. This list will detail all of the information needed as painting reference for every intermediate background, referring it to one of the keys. The art director or head of the background department makes this list and a layout checker checks it.

Every background has a line drawing as its base, but on many backgrounds the lines will not be visible. Some will have more or less in the way of heavy line work, depending on the overall style of the show. Today, most key backgrounds are painted on computer programs like Photoshop, but some studios still hand paint key backgrounds and do the intermediates on computer.

Sometimes, pre-existing textures are used for texturing elements of some backgrounds. For example, a background that shows the interior of a cave might benefit from the use of an organic texture of stone or rocks. In cases like this all textures used should be organised into libraries. These libraries should be grouped by episode. Within each folder, samples of the textures used for a particular background should be kept in the size they were originally used—for example, 64x64, 128x128, 256x256, or any other size.

As an addition to the key backgrounds, sometimes studios will paint atmospheric references. These are used to supply more information for creating the intermediate backgrounds. Atmospheric reference usually comes in the form of simple ground and sky paintings of the most common location; these demonstrate the location's appearance during different times of the day—morning, midday, afternoon, dusk and night. However, some studios don't bother creating these references because they consider them unnecessary.

The art director or head of the background department checks all of the background painting. They usually retouch the key backgrounds after painting to ensure they have an even quality and style. Once this is complete, the animation director needs to give final approval. Every background needs to be properly named and each naming convention should consist of the episode number and the scene number corresponding to the first appearance of the background. The same applies for overlays, underlays, overlay/underlays and held cels. In fact the numbers should be rewritten from the layouts supplied to the background paint department and filed away for safekeeping. Alternatively, they can be entered into an electronic database when the backgrounds are scanned into the directory where they are kept before being distributed for painting.

When sending background layouts to overseas studios it is always important to try to keep the original artwork in the mother studio and send good quality photocopies. Digitally prepared background paintings can be sent over an FTP site or on CD. When sending hand-painted keys, high quality colour photocopies should be kept in the mother studio and the originals shipped to the servicing studio. All hand-painted background keys should be returned to the mother studio when the series is complete.

Colour styling

Colour styling is the stage in which the characters/props and special effect models are given colour. Line work model sheets are scanned into a computer and coloured,

usually using Photoshop or a specific animation ink and paint program. The greatest attention is usually given to the colour styling of the main characters and main props. Usually the animation director briefs the colour styling artist about what they think would work best. The colour stylist then goes about creating the coloured models following these instructions but will also make their own colour suggestions, resulting in three to four initial colour models for each main character.

The animation director and the producer will approve the colour styling. Sometimes investors or clients like to be given all of the existing colour styles for review before the final selection is made. If the title was based on a pre-existing property like a comic book or a live action show, the colour styling would have to follow the references of the established property. The design and colour styling in this instance would certainly have to go through very strict approval procedures.

Approvals—just a thought

It is always a good idea to obtain a written confirmation when it comes to obtaining approvals from a client. It's all well and good for a client to approve something over the phone, but if anything goes wrong down the road it is better to have the approval in writing. This becomes particularly important when a change is required after an approval has been given. In this case (and this should be stipulated in the client contract), the client will have to cover all expenses related to the additional request. This applies for all approvals related to the production.

Sending

Checking is the KEY. It's very, very important to check every stage of pre-production. It is imperative to check the models, the colour styling, the storyboard and the camera charts against the storyboard and the dialogue tape.

Checking the storyboard continuity is important, especially if the layouts are being done overseas. If the layouts are done in-house then it is still possible to catch mistakes before the show is sent overseas. However, if a show is sent overseas without layouts then the servicing studio will work strictly to the storyboard, even if there are obvious mistakes. Be 100 per cent sure that everything works before sending the show away.

If the completed layouts are going overseas for key animation, each single folder should be checked for character, prop, special effect and background continuity.

Figure 20 Pre-production model 1

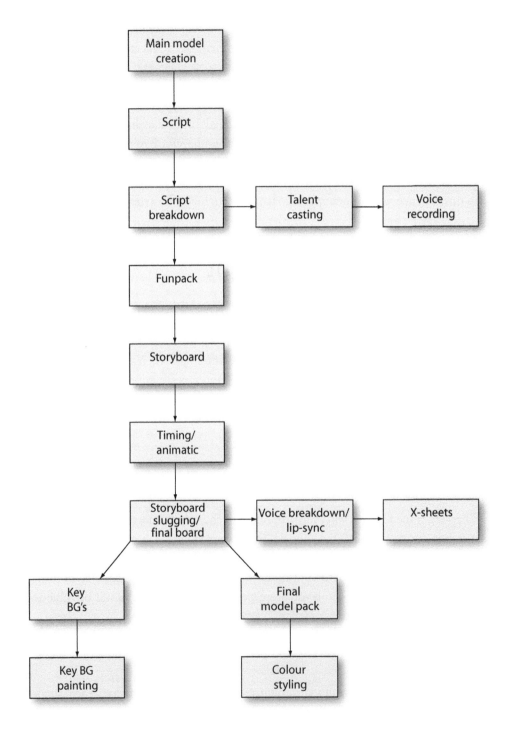

Lists should be made of all background reuses, background painting references and special effect use and application.

Usually, one overseas studio would be engaged to handle an entire series. However, if the schedule is tight there may be a need to spread the series across a few different studios. Again, this highlights the importance of thorough checking in order to make sure that each studio is given the same guidelines.

All of the shipping details (the shipping company, scheduled shipping dates, etc.) are established by the producer during the initial production stages. Once the shipping starts, a standard form containing the details of the shipment content should be created. This form should include the title of the show and an itemised list of what is being sent. The more details the better. This form needs to be completed and filed away so that there is a record of every single shipment.

8 2D production

The production phase begins with the layout process and continues through animation, digital scanning and painting and compositing. As mentioned earlier, once the pre-production elements are completed for a particular show it usually gets shipped to an overseas servicing studio. The servicing studio would have been given a copy of the schedule in the earlier stages of pre-production and by this stage they would already have agreed to the deadlines set out within it.

Overseas studios

Often, studios will send a member of their local staff over to the servicing studio to serve as the overseas supervisor. This person will be in charge of supervising the production in the overseas studio and would usually be an experienced animation director, although sometimes studios will elect to send a non-artistic person (a good production manager or producer). The person appointed to do this needs to be someone who understands the expectations of the outsourcing studio and who is absolutely clear about the way the production is supposed to look. Most overseas studios are in non-English speaking countries and they supply their services to many different creative studios around the world. Each of these studios will have different styles and expectations. The overseas supervisor helps overcome all of the language and instructional problems that are common. They also serve as the first filter for delivery materials, approving or disapproving them (calling for

internal changes), as well as preparing and sending weekly update reports to the mother studio.

Smaller studios don't usually have overseas supervisors. This is always directly due to the high costs involved in having an employee work in a foreign country. This sort of arrangement is always more expensive because things like hotel bills, a living allowance and other miscellaneous expenses need to be factored in on top of the wage already being paid. Smaller studios would rather send someone like a freelance animation director for a month or two to help establish the production pipeline and familiarise the studio with the style of the particular show. They will also help identify and train some of the local personnel to take lead roles in the production. Once they are satisfied that the servicing studio is up to speed and capable of continuing the production, they will leave.

Many animation companies will use the same overseas studio for most of their productions. This makes production easier as over time they get used to working together and there is less room for any misunderstanding. This also reduces the need to have an overseas supervisor.

Like all studios, the overseas studios have different teams. A studio's 'A team' will consist of their elite crew, their 'B team' will be the next best, and so on. It's highly recommended to insist on using the best available personnel for the project.

Complexity analysis and preparing for the layout process

Before the layouts can begin, a detailed analysis needs to be made for each scene in order to assess the level of complexity. This is the last opportunity to make sure that each scene is achievable within the time and budget allowed. By this stage the final version of the following materials should be available:

- storyboard
- character, prop and special effect design
- background/location design
- voice track
- exposure sheets
- some of the key backgrounds painted
- colour styling
- main music themes
- reference animation for the main characters

The last four items are not relevant for layout production, but they are helpful in providing additional reference.

When preparing a show for the layout process the animation director, together with the producer, production manager, art director and the head of the layout department, makes a distribution plan. This plan is constructed in order to make sure that the layout work is distributed to the right people, according to their particular skills, and to make sure that the workload of each person is fair and equal. Different factors need to be considered when working out this plan. The first element to be looked at is the project evaluation. In the same way that the script was evaluated in order to identify potential problems and bottlenecks, the storyboard is scrutinised in an attempt to try and pre-empt any additional problems.

On the basis of the storyboard, a list needs to be made of all the scenes from the storyboard together with their location or background number, overlay, underlay, overlay/underlay numbers, atmosphere notes (day/night), and all characters, props and special effects that appear within each scene. This is often called the total breakdown list.

This particular list helps to identify all scenes that have the potential to be problematic. There are several factors that will make it obvious from the script or storyboard that a particular scene is going to have a higher degree of difficulty. For example, scenes containing a large number of characters who are all moving around at once (imagine a room full of animated dancers) will always be very difficult and time-consuming to complete. Scenes with complicated levels and layers, or scenes demanding special effects will be among the more difficult in any project. Imagine a scene that consists of multiple characters dancing, with a main character dancing around in circles and pulling strings with hundreds of multi-coloured decorative Christmas balls. While this is going on the camera is panning and tracking across the shot. A scene such as this carries an incredibly high level of difficulty for animation, checking and especially for the painting department.

When the total breakdown list is ready it is given, along with the storyboard, to all of the staff members who are involved in the project evaluation. Each person is expected to go through the list and make notes in preparation for a meeting where the distribution plan will be discussed. The ultimate purpose of this meeting is to make a reliable plan that will assist all those involved in preparing for, and coping with, all of the demanding scenes. Once there is an agreed plan of action the layout preparation can continue.

Under the direction of the producer and the animation director, the head of the layout department and the production manager will formulate a plan in order to economically organise the distribution of the layouts.

The storyboard is then broken down into sections/panels so that the layout can be cinematically planned. Often key backgrounds are used to mark the flow of scenes over a certain location block. A chart is usually constructed to give a simple view of this, where scenes will be grouped according to their block location and listed in the form of a flow chart.

During the location development a topographic plan (plotting the relationship between each location, just like a map) would have been produced. These same maps should now be used to represent the progression of scenes from location to location, in order to avoid continuity mistakes. These guides need to accompany every section of the show when the scene folders are allocated to the layout artists.

In feature film productions, the process described above will be much more involved and an animation workbook will be created. The workbook uses the storyboard panels, broken down shot by shot, to create a detailed visualisation of each and every scene. Workbook artists take the storyboard panels and elaborate on them even further to include the full scene composition, exact character poses and movement, light and shadows, camera positions and movements, transitions and effects and screen direction. The director will brief all of the workbook artists on their particular scenes and the workbook will evolve out of a continual review process where the artists will submit their work for approval, sometimes several times over, until the director is satisfied that the storytelling is working. When the workbook has been completed it is scrutinised by the key production staff to ensure that everything contained within it is achievable. It will then be evaluated to grade the complexity of each scene and a report will be compiled detailing the workload for each department. The producer at this time will also make sure that the complexity level does not exceed the restraints of the budget and schedule. If they find that this is the case, steps need to be taken at this point to simplify some aspects of the direction.

The finished workbook can take the form of an electronic document or a bound paper book. It will be distributed to all key team members and will be used heavily by the layout artists. Based on the information in the workbook and the complexity analysis, a distribution plan will be drawn up.

Once the layout instructions are ready, the production manager needs to compile them together with other materials for distribution to the layout artists. The other materials needed are:

- key background designs (line work)
- storyboard
- character, prop and special effect designs

- scene folders and art materials
- copies of x-sheets for the relevant section
- audio tape/disc with edited dialogue track
- copies of reuse intermediate backgrounds from previous episodes (if any)
- colour photocopies of the key backgrounds (for reference and inspiration)

Some of these materials, like the audio tape, for example, might be considered irrelevant to the layout production, but it's better to give the artists as much material as possible so they are able to gain a well-rounded perspective of the entire show. The additional materials can also have the added benefit of providing the artists with some inspiration, which can only make for a better product at the end of the day.

The layout can be produced without the x-sheets as well, but again, it's far more beneficial for the artists to have them as they can refer to them and plan their layouts in a much more informed way. Many outsourcing studios do their layouts in-house before sending the rest of the show overseas. Some choose to prepare their key layouts in-house and then have the remainder of the layout stage done overseas. The key layouts are the major layouts of the production. They are the most complicated to complete and are always going to be the template for the rest of the layouts in each particular section. For this reason, it is imperative that they are done correctly. When a studio completes them in-house it allows a little more control over the layout process while still being able to have the bulk of the work done overseas.

Layouts

A layout is a detailed visual breakdown of each and every scene. The layout is created by transferring information from the workbook or storyboard, key background designs, character, prop and special effect designs and x-sheets. It serves as an illustrated explanation of the who, where and what of each scene combined with an image of what the camera should see. The layout artist must be able to create illustrations that reflect the right perspective and shot composition for each scene. The ability to draw figuration is also required, of course. Architects sometimes make great layout artists because of their heightened appreciation of space and perspective.

Every layout artist needs to be briefed by the animation director or head of the layout department before they begin work on the section of the show allocated

to them. Ideally, each individual layout artist should receive a section with consecutive scenes using the same location. However, this is not always possible. In cases where a section must be divided between two or more layout artists, the production manager should always supply the layout immediately preceding and following the new sub-section for continuity purposes. If these sections are not ready, a note should be left to supply the drawings for hook-up as soon as they are completed. Hook-up is a term frequently used in animation and refers to the continuity between two consecutive scenes or sequences.

Layout is an incredibly important stage of animation production. Any mistakes made during the layout production are going to find their way into the finished product if they are not picked up at this stage.

The following is a list of what should normally be found inside the layout folder when it's complete:

- The character animation layout, showing the character(s) in action. This can be anything from one to seven, or even eight pages of drawings, depending on the complexity of the action.
- The background layout, showing the background over which the action will take place. This is based on the key background for that particular location and can be single field (12 field) or it can be panning.
- The overlay, underlay, overlay/underlay or held cel, if any.
- A field guide showing the area that the camera will see. This demonstrates the size and position of the camera's field of vision as well as any movement the camera needs to perform.
- A copy of the x-sheet originally supplied to the artist.

Each of these elements needs to be on a separate sheet of paper and once complete the following needs to be written on the layout folder:

- the episode number
- the scene number
- the background number
- the overlay, underlay, overlay/underlay or held cel number, if any
- the field size
- details of the camera movement, truck/in or truck/out direction (if any), and pans (horizontal, vertical, diagonal, zip pan)
- any specific atmospheric instructions, like day, night, morning, rain, stormy
- the name of the layout artist

Once the layouts are finished, the layout artist hands them over to the production manager, who needs to mark them down as completed on the distribution list. The production manager then needs to talk with the head of the layout department and the animation director in order to arrange a time for them to check the layouts and provide the artist with any necessary feedback. When the layouts are checked, they can either be approved immediately or sent back to the artist for further changes. The artist needs to make all reasonable changes in a timely fashion. If the artist is on a freelance contract they will only be paid once all requested changes have been made and the final approval has been given. The production manager or their assistant will make sure that they keep the producer updated on the progress of the layout department, usually in the form of a weekly written report.

Layout checking

When the layouts are approved they are handed back to the production manager who will pass them on to the layout checker. The layout checker is someone who is skilled in continuity, checking across all of the layout elements. They check the layouts against the storyboard and x-sheets and make sure that the action within the folder matches the action from both of these elements. If the layouts were done without the x-sheets, they will make sure that copies are placed into the correct scene folders.

It's not unusual during the checking process to find a folder without an x-sheet or an x-sheet without a matching folder. The reason for this is that sometimes during the x-sheet process the timing artist decides that a scene is too long and that it should be split into two or three scenes, or that the show would flow better if some scenes were combined. In cases such as this, the layout checker will simply combine or split the layouts according to the dictates of the x-sheets.

The layout checker also identifies any new props or special effects that might have been additionally created during the layout stage. In this case a photocopy of the new item is taken and given to the production manager, who passes it on to a clean-up artist. They will clean the rough image and formalise it on to a standard model sheet, for inclusion in the model sheet book and also for further colour styling.

If the layout checker finds any problems or mistakes, they will inform the production manager, who will then take it to the head of the layout department for consultation and fix-up.

After the layout folders have been checked, they need to be given to the animation director or the technical director/special effects person who will then go through them and write any details regarding the special effects on the front panel of the folders. Once this is done, the production manager/assistant needs to make a detailed list of all scenes, including the numbers of the backgrounds, overlays, underlays, overlay/underlays and held cels used in each scene. A list of all reused backgrounds will be compiled at this stage. A final special effects list also needs to be compiled and it should include detailed instructions for every special effects scene.

All of the lists mentioned above will be included in the shipment to the servicing studio as part of the support materials. Remember, when sending work overseas it is imperative to make sure that all requests are clear and that the instructions are adequately detailed. In other words, the instructions contained in the shipment need to be foolproof.

Throughout this process the production manager will be in constant communication with the producer. It is the producer's responsibility at this point to make sure that the production manager is running the layout phase smoothly. As always, the producer will need constant updates on the progress of this process to ensure that the schedule and budget remain on track. The production manager is responsible for collating all reports, usually on a daily or weekly basis, and providing them to the producer.

Key motion guides

When the very first episode is shipped it is a good idea to include the following extra items:

- The animation reference materials. This means that reference scenes for all characters should be produced in order to demonstrate their movement styles. Usually these scenes would call for typical character movements, like a walk or run cycle, but if a character has a specific movement trait (a limp, for example) then an animation sample for that movement should be included as well.
- The special effect animation reference materials. It's a good idea to send reference animation for waves, rain, snow, fire, etc. Most studios have materials like this in their stock libraries, so if a scene exists from a previous production that contains some special effects relevant to the current show, it can be reused.

The old drawings can simply be photocopied and repegged, saving time and money.

- Photo references for anything that might be considered relevant. If a particular location has been designed to recreate a European forest, then some actual pictures of European forests should be sent. Reference is given on the key background, but it's often not enough and it can be very helpful to supplement it with extra material.

- Maps of locations and maps of broader episode settings with location breakdowns. If the show is based on a pre-existing live-action program and the intent is to maintain that particular style then it is important to send videotapes of the live action show for reference.

The items above are general materials relating to the overall project and are important when defining the production to the contracting studio. If the project is a multi-episode series then further items will need to be shipped which relate to each specific episode:

- designs—characters, props and special effects
- location designs
- final slugged storyboard
- colour models
- painted key locations
- x-sheets
- tapes with slugged dialogue (DAT or CDs)
- background reuse breakdown lists
- any other relevant reference in the form of photographs, tapes, etc.

Key animation

Animation is the next stage of production following the layout phase. This is the stage where the animators breathe life into the character designs by giving them motion.

Before the animation stage begins, the lead animators need to consult with the director and work out the basic movement for the main characters, thus establishing the animation style for the main pack.

When it comes to distributing scenes for animation, the same process applies as with the layouts. Scenes need to be distributed to animators in continuous logical

sections. Hook-ups (scene to scene continuity) are extremely important, and reference needs to be supplied for these scenes. However, in film productions it is common to assign a team of animators to each of the characters to ensure consistency in the character animation style.

The production manager/assistant prepares sections to distribute to the animators, guided by the animation director's instruction. The following materials are needed for distribution to the animators:

- character, prop and special effect model packs
- layout folders with all their content. A copy should be kept of all pegged backgrounds, overlays, underlays, overlay/underlays and held cels in case an animator loses anything. If items are going to be registered to a background it is necessary to supply a separate (pegged) piece of paper showing the exact registration line. This is particularly important if photocopies of the background are being supplied to the animators, as the copy can sometimes be distorted. Although digital technology allows for the manipulation all of the elements with ease, it's still a good idea to be precise
- x-sheets for the section (supply copies and keep the originals in-house)
- the voice track (tape, disc)
- workbook, if available
- tape with reference animation (if one exists)
- pegged photocopies of all stock animation used in the section

A copy of the storyboard and workbook should also be made available to the animators as they will need to read the entire board before they start to animate.

An animator needs to be able to animate or draw bodies in motion. The animators will draw key positions for the characters in a rough line. In order to do this properly they need to follow the instructions contained in the materials supplied to them. The storyboard and layout will instruct them as to where and how the action happens, and the workbook, together with the storyboard, will explain where the action is taking place on the broader scale of the show. The x-sheet will explain the time scope in which the action is happening, and the field size, together with the camera instructions from the x-sheet, will explain what the camera is going to see and how it's going to move. The voice track, together with voice breakdown from within the x-sheets, provides instructions for animating the lip movements.

Many animators literally act out the sections that they animate. Most studios have large mirrors for animators to move in front of in order for them to get a

handle on the type of movement they are trying to convey. A hand mirror is also used in the same way when it comes to animating facial movements. Some studios produce 3D models in clay or wood to help animators understand the body within the context of its environment. It's also possible to build a 3D model within the computer for the same purpose.

The animator will write the drawing positions in the x-sheets. The drawings are marked by letters and numbers. Letters represent levels while the numbers represent the position of the drawing in the sequence of motion. The animator doesn't do all of the drawings, only the key drawings that represent the extremes of the particular motion.

The term 'levels' refers to the number of elements needed to create the scene. They are called levels simply because they are stacked one on top of the other. For example, a scene will require a background and perhaps an overlay. On top of that would go the animation, which may be broken down into different sections. The first character may exist on one level, the second character on another level and perhaps the mouth movement of character two will be animated on a third level. The introduction of digital systems has brought unlimited freedom with regard to the number of levels that can be used within the one scene. Before this, the total number of levels per scene was restricted to eight or less. With traditional cel animation, where levels of cels were placed on top of one another, the animator had to be aware that each additional cel would alter the colour intensity of the overall scene. If a scene required anything over the maximum of eight levels, levels one to four would usually end up with a grey shadow because the light couldn't penetrate evenly through all of the levels.

The animation director usually calls a meeting before animation begins and explains the requirements of the show. This is an opportune time for the animation department to sit together and watch any reference tapes and to discuss the motion development of the other intermediate characters so they will work together with the main ones. Any significant special effect details, as well as any other specific issues regarding the show, should also be discussed at this time. Often the animation director brings a sample show (any relevant title) to use as a quality comparison for the project.

The animation director also individually briefs every animator on their specific section. They go through the storyboard, layouts and x-sheets together to ensure the animator has a full understanding of the scenes they are about to work on. The animator must follow the director's instructions. Any deviation from these instructions must be discussed with the director before the scenes are animated.

When the animation is complete it is handed to the production manager who will mark the scene off on the distribution list and organise a time for the animation director to check and approve it. The animation director checks all of the key drawings and once they have approved the scene it can move on to the clean-up stage. For approval purposes the animation can be tested in a line test or the animation director can simply flick through it to make sure it is working.

Line testing is the process where the animation drawings are captured exactly as they are indicated on the x-sheet. It can be captured by a video camera or it can be scanned and composited by the computer department. The purpose of performing a line test is to establish that the motion is animated in accordance with the expectations of the animation director.

Key animation clean-up

Once the key animation is approved it needs to be cleaned. In order for this process to begin, the clean-up artist needs to be supplied with the animation folders, the voice track, the relevant section of the storyboard and the model packs. The clean-up process is usually performed by artists who are less experienced than the animators (often they are animators in training). These artists are required to remove any unnecessary pencil marks, tidy up lines (where the animator has drawn several lines which can be simplified into one), make sure that the drawings match the character models and ensure that no details are missing. When this is complete, the animation director needs to approve it.

In-betweening

In-betweening is the process where the remaining drawings are completed and inserted in between the key drawings. This is done by in-betweeners—skilled professionals who are often more experienced than clean-up artists but less experienced than animators. In order to begin this process the in-betweener needs to be supplied with the folders containing the clean key animation, a copy of the voice track, the relevant section of the storyboard and the model packs. Sometimes the clean-up and in-betweening is done by the same person. It's easier to organise production by outsourcing that way.

In-betweeners must be able to read the animation keys in order to in-between. Measuring the gap between the keys gives the artist the information they need

with regard to the time and distance in the movement. The closer the keys, the slower the motion will be. The further apart they are, the faster it becomes. In-betweeners should always supply clean drawings as part of their finished work.

Once the in-betweening is done it is a good idea to do another line test to check the full animation. This line test can be shot against the background layouts in order for the animation director and director to gain a better sense of the overall scene and to make sure that all elements are working. In the United States, this style of line test is referred to as a sweatbox session. This term is said to come from the days when Walt Disney would view the rough animation with all of the animators in a small screening room. Apparently, the animators would sweat over the reaction Disney would have to their work!

Animation checking and fix-up

Once the animation is approved it needs to go through the stage of animation checking. This task is performed by designated animation checkers. These are individuals who need to have a sharp eye and a good understanding of the mechanics of animation.

They check the animation to make sure that the following elements are in place:

- each folder contains the correct number of drawings
- each drawing is correctly numbered and corresponds with the x-sheet
- all animation levels are present and clearly marked
- the individual drawings conform to the model sheets and are in proportion
- any necessary shadows are accounted for
- the continuity of elements such as props and special effects is correct
- all backgrounds, overlays, underlays, overlay/underlays and held cels are correct and properly registered

In addition to this, they may also detect new elements that require colour styling. For example, a model sheet may have been made for an explosion, but at the time it was not considered that debris would also need to be included. An animation checker will find any of these extra elements and give a photocopy of the item to the production manager for clean-up and colour styling.

The checkers must also summarise the folder elements and write them down on the top right-hand side of the x-sheets. This includes things like the total number

of frames in the scene and the background, overlay, underlay, overlay/underlay and held cel indication. Having this information on the front of the folders will speed up the camera process.

Depending on the digital system the studio uses, the checker might also be required to write down the scanning ratio for the scenes. The scanning ratio is decided on the basis of a scene's field size and refers to the continuity of the line work. It is important to make sure that all of the lines that appear on screen will be of roughly the same thickness, in part to ensure that once the drawings are scanned the line work does not get lost. This will be controlled in the scanning stage.

Any problems detected by the animation checker need to be reported to the production manager. They will liaise with the animation director who will then make decisions regarding the appropriate course of action.

Often checkers are required to perform fix-ups in in-betweening or charting. They need to be able to perform multiple tasks and must have good communication skills as they will often have to intervene when problems in the animation arise.

Throughout this process, the producer will need to be updated constantly. It is their primary responsibility to ensure that those entrusted to run this part of the production are working efficiently and that the budget and schedule are being adhered to. The production manager is the person responsible for collating all reports and liaising with the producer during this time.

Digital department

The introduction of digital systems designed specifically for animation changed the industry immeasurably. It completely eliminated some of the professionals who had previously been integral to the animation process. People such as traditional cel painters or traditional animation camera operators are no longer needed because the execution of their jobs had completely changed. Digital technology has changed the way animation is made and in doing so has increased the speed, efficiency and flexibility of production. The most common digital systems used in animation are:

- US Animation (Toon Boom)—www.toonboom.com/main
- Retas Pro—www.retas.com
- Animation Stand—www.animationstand.com
- AXA—www.seeq.com/popupwrapper.jsp?referrer=&domain=axasoftware.com

- Animo—www.cambridgeanimation.com/index.htm
- DigiCel—www.digicelinc.com

A digital manager oversees the entire digital department. They are responsible for ensuring the smooth flow of work through the department in accordance with the schedule and budget.

The digital manager usually has an assistant. Other roles within the digital department are:

- network administrator/support—takes care of the technical functionality of the system, the software, licences and the back-up system. Also responsible for troubleshooting any problems the system users experience
- scanners—responsible for scanning all animation pages and backgrounds
- scanning checkers—responsible for checking the quality of all scanned images
- digital painters—paint the scanned drawings
- paint checkers—check the painted drawings
- head of background painting—supervises the painting of all digital backgrounds
- background painters—paint all digital backgrounds
- head of camera compositing department—supervises the compositing team
- camera compositors—composite each scene
- camera compositing checkers—check each composited scene

Intermediate background painting

The intermediate background painting can take place while the animation is being done. The backgrounds are painted based on the key backgrounds as well as the information provided on the background reference list. The distribution of the backgrounds for painting is done by the head of the background department in association with the production manager.

Background painters must be talented individuals who are not only able to paint, but who also have a keen sense of light, colour and shading. Most of them will have had an education in traditional painting. They must be able to jump from style to style, according to the art direction requirements of the show. Their own style should never be recognisable.

Today background painting is mostly done on computer, using Photoshop or other similar software. This method requires the background layouts to be scanned

into the computer and painted. Depending on the level of complexity, one background artist can paint between one and four intermediate backgrounds a day.

Scanning

When the animation has been checked and approved it's handed to the digital department for scanning. The digital manager or their assistant, in association with the production manager, will take care of the distribution of work to the scanners. The digital manager makes sure that the flow of work through the department is smooth and trouble free. The production manager needs to be kept informed of the progress of the digital department at all times so that they are able to report to the producer.

Scanning is the process in which the drawings are brought into the computer and saved as files in the central project library. The scanning can be done manually or automatically. Manual scanning is done using flat bed scanners with peg holes attached to the sides (to keep registration consistent). The scanning technicians manually log, scan and change the drawings as they scan them into the system.

The automatic systems use batch feeding to get the drawings into the computer as opposed to someone scanning them by hand one at a time. A certain number of drawings are placed in the automatic feeding tray of the scanner, which is set with the correct information to begin taking the drawings in. With this process, the scanner is able to identify peg holes and register the drawings correctly. Having said that, some batch feeding systems are not totally reliable, so sometimes it might be necessary to add a mark, like four small crosses to every drawing (usually in each corner of the frame), to help the scanner find the correct registration and to avoid animation jitters during compositing.

The scanning ratio information (given at the animation checking stage) is taken by the person doing the scanning to make sure that the correct settings are used when the drawings are brought into the computer. The purpose of this is to preserve the thickness of the line that will appear on the screen. If the digital system is not vector-based, the line will become thicker as the camera moves closer toward it. Vector-based programs use a series of mathematical calculations to produce lines and curves that represent graphic images. These individual lines and curves can be manipulated, increased or decreased in size without any loss to the picture quality. On the other hand, bitmap based programs represent graphic images using a collection of tiny dots that form together to make the desired image.

It's imperative at this stage that the line thickness is regulated and that all lines are picked up by the scanner. It's no use trying to paint a model when some of the line work is missing.

How was this done before the computer age?

Before the introduction of digital systems, the completed and approved animation would be transferred from paper on to plastic cels. The drawings would be inserted into special folders with a piece of carbon paper in between the drawing and the cel and put through a hot xerox. This machine would heat up the folder as well as the pencil lines on the drawing and the carbon paper, which would then transfer the line work onto the plastic cel. The higher the temperature, the thicker the line. After that, the cels would be checked for line thickness and consistency and then cleaned using a special solution to remove any unwanted random carbon residue. Once all of the cels had been cleaned, they would be handed to the painting department.

Scanning check

Once the drawings have been scanned they need to be checked for consistency of the line work and regions and for unwanted speckles created by dirt on the paper. This is usually done by displaying the lines in an alpha channel (where the black lines become white), making stray lines and marks easier to identify and remove. The scanning checkers will need to be given a set of the model sheets in order to do this properly.

Digital ink and paint

The next stage of this process is the digital ink and paint. The drawings, now scanned and checked, are handed over to the painters. The painters need to be given a set of the colour models to use as their guide when painting the characters, props and special effects. The colour stylist will usually make a customised palette for every character, which will be used by the painters to ensure that the correct colours are painted. The creation of these palettes also makes the process much faster as the painters will only be required to fill the areas of the model using a bucket tool. The painters will attend to minor problems if they arise. For example, often lines are not properly closed within a drawing, causing the paint to leak into other areas of the model. These sorts of problems are easily fixed by the painter,

but if bigger problems are detected the drawings may have to be rescanned. In this case the digital manager will take care of handling the problem.

There is no special qualification requirement for this sort of painting as it does not require an artistic bent, only a good eye and a well-rounded knowledge of the computer software.

Paint check

The role of the paint checker is to make sure that all the characters, props and special effects are painted in accordance with the original colour styling plan. The paint checker needs to detect and rectify all paint mistakes or problems before the scenes are sent for camera compositing. In order to do this properly, the paint checker needs to have a sharp eye and be able to focus their attention on every detail.

Camera compositing

The camera compositing can begin once all of the drawings and backgrounds have been painted. The digital camera has more flexibility than the traditional camera ever had. There is no limitation to the number of levels that can be used and there is the added benefit of being able to see how the scene is going to look in a much smaller timeframe, as well as having the ability to make adjustments, changes or corrections on the spot.

Compositors/camera operators need to have a good knowledge of how animation works and be able to read x-sheets. They are required to follow the instructions on the x-sheets in order to marry the animation with the backgrounds correctly and apply the requested camera movements. Compositors also need to be given a copy of the storyboard so they can see how their particular section of scenes fits in with the rest of the show.

The compositing department should have a department head. This person's experience needs to surpass that of the rest of the compositing crew as they will need to deal with all problems relating to the compositing process. This is the last stage where problems can be addressed before the scenes are rendered and printed.

Camera compositing checking

Once the camera work is complete and the output is done, one more pass of checking needs to take place. Is the animation working? Was the field size too big? Have any levels been missed? Does the scene have the required number of frames? Is the line work correct? These are just some of the things that can go wrong during the digital process, and the compositing checker will need to keep an eye out for all of this and more. Any problems found have to be fixed on the spot and the scenes recomposited and re-rendered.

The compositing checker needs to have an understanding of the entire animation process in order to check and troubleshoot thoroughly.

Output

When all of the checking is complete and the scenes have been approved, they will need to be output to tape or disk in order to prepare for the post-production phase.

There are many different ways to output the scenes. In some studios, rendered scenes are transferred straight from a hard drive to editing systems like Avid. Other studios output their rendered scenes on to a tape format, like Betacam SP or Digital Betacam via a 'par to video' card.

The rendering resolution will depend on the media used to screen the final product. If the product is destined to be shown in movie theatres it needs to be rendered at a higher resolution than a product that will only be shown on television.

Additional special effects

After the camera work has been approved, it is possible that some additional special effects will need to be placed over the scenes. This can be done using many software packages, with Adobe After Effects being a popular industry choice. At this stage it may be necessary to include particle generators or any other special effects that were not dealt with in previous stages.

Back-ups

All of the work done in the digital department needs to be regularly backed up. It is very expensive and irresponsible to work without some sort of back-up system. Usually back-ups are run during the night when the studio is empty. Running a back-up slows down the network because it is accessing files from almost everywhere and this is why it needs to be done when no one is using the network.

There are many different types of back-up systems available. Backing up on to DLT tapes through Quantum or Exabyte is one common method.

Most studios adhere to the practice of archiving each episode, or section, as it is completed. Once a section has been successfully archived it can be removed from the system, freeing up precious storage space within the computer network. It is imperative that the computer system is kept as tidy as possible. Unnecessary files sitting on the network will not only take up space, they can contribute to the sluggishness of a computer system if it is overloaded.

Back-ups are done by the network administrator or digital manager. Many systems that are multi loaders are able to commence the back-up program using a timer. In this case the network administrator or digital manager needs to check the designated administration computer for error messages each morning and clearly label and store all back-up tapes in a safe place.

Work tracking

All studios that undertake even the smallest sections of the production in-house must implement some type of work tracking (management). See figure 21. Sometimes it can be as simple as making lists and manually keeping a 'work in' and 'work out' log. Most studios use ready-made tracking software that comes as a part of the digital software systems they use for production (like US Animation). It's also possible to negotiate with software creators to purchase a system to develop or customise a management tracking system tailored specifically for a particular studio. It's imperative to always know where the scenes are as they must be accounted for at all times.

Figure 21 Sample production report

PRODUCTION REPORT TABLE SAMPLE 26 X 22-MINUTE SERIES

EP #	TITLE	TOTAL SCENES	STORYBOARD RECEIVED FOR TRANSLATION	PRODUCTION MATERIALS RECEIVED	LAYOUTS COMPLETE	LAYOUTS CHECKED	LAYOUT LINE TEST	KEY ANIMATION COMPLETE	KEY ANIMATION CLEAN	KEY ANIMATION CHECKED	I/B COMPLETE	I/B CHECK	I/B LINE TEST
01		455	01/03/2001	21/03/2001	455	455	455	455	455	455	455	455	455
02		447	15/03/2001	04/04/2001	447	447	447	447	277	180	20		
03		432	21/03/2001										
04		451											
05		467											
06		434											
07		414											
08		397											
09													
10													
11													
12													
13													
14													
15													
16													
17													
18													
19													
20													
21													
22													
23													
24													
25													
26													

The producer's role during production

The producer needs to be actively involved in everything that occurs during the production. Of course, the producer is not going to hand out scenes to animators, but they will have to be aware of all that is happening. The producer will have to monitor the work flow, calculate spending and ensure that nothing goes over budget or over schedule. They shoulder the huge responsibility of seeing that the production flows as planned. If any elements start to steer away from the original plan, the producer will have to find a way of sorting things out and setting things back on track. Their concerns will range from fixing a broken photocopier to dealing with staff shortages if a flu epidemic hits the studio.

If the project being made is a television serial, the producer will also be constantly involved with other shows that are still in pre-production (script and storyboard development, voice recordings, etc.) as well as shows which may be in the post-production stage. During the production phase, the producer will delegate most of the hands-on work to the production manager and heads of department. However, daily contact, as well as weekly meetings, are essential to keeping the lines of communication open. The producer receives weekly reports from the production manager/associate producer, although it is important to remember that in smaller studios or low budget productions the producer may also have to fill the role of production manager.

If the production phase is being outsourced, the producer will be the key person to coordinate with the overseas production managers. Again, weekly reports need to come from the servicing studio, and the producer will have to address any issues or problems they may have. They will also need to reinforce the schedule and be prepared to take action if the servicing studio is not meeting their deadlines. Budget is not such a huge issue when outsourcing as a flat rate would already have been agreed upon before the production commenced. See figures 22 and 23.

Figure 22 Production model 1

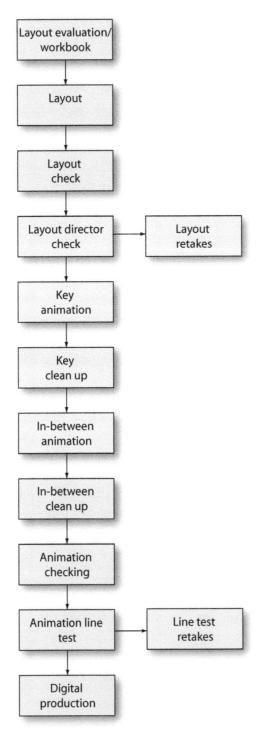

Figure 23 Production model 2

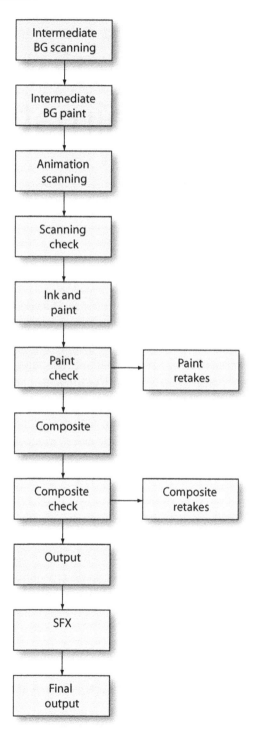

9 Pre-production and 3D animation

The development of computer software and hardware has improved the general quality of 2D animation and has made the production process so much faster. This software development is also responsible for the birth of a completely new branch of animation—3D animation. Although many elements of both genres remain the same, 3D animation has moved boundaries between what was considered possible in film making and has contributed enormously to the arena of special effects in live action, making scenes so convincing that it is often impossible for the untrained eye to tell the difference between what has been filmed traditionally and what has been computer-generated. It is fair to say that 3D animation belongs to both worlds, standing somewhere between 2D animation and live action. However, its inclinations lean more towards live action as it can be likened to filming a movie using puppets capable of independent movement.

The nature of 3D production is constantly evolving as new software tools are created and computer technology advances. The basic pipeline set out below is one variation of many. Historically, 3D production has predominantly been used for feature films, although as software and hardware become cheaper the cost of producing 3D has decreased to the level where it is now a viable medium for television production. Generally speaking, the high-end studios producing much of the feature films seen today are able to produce all of their work internally, without the need of servicing studios. However, as more and more television series are being produced in 3D, the traditional 2D servicing studios in Asia, Europe and

India have upgraded their facilities in order to provide full 3D animation services. This has increased competition, resulting in a further drop in production prices.

Much has been made of the so-called demise of traditional 2D animation in favour of 3D. There are those who believe that the current domination of the animation box office by a slew of 3D titles justifies a belief that the 3D style is here to completely replace 2D animation. This couldn't be further from the truth as 2D production still accounts for the majority of material being made, bought, sold and viewed across the world. Perhaps 3D animation should be seen not as a competitor poised to replace an entire methodology, but as an exciting new addition to the animation family.

Similarities to 2D production

There are many similarities between 3D and 2D production. The stages of development and part of the pre-production are practically identical. The design stages, development of expressions and lip-sync, storyboarding, scene planning and, more than anything else, the controlled production circumstances (the fact that everything happens within the production studio) are very much the same. Recruiting, contracts, budgeting and scheduling are also identical processes in both 2D and 3D productions. The real differences emerge when the main production phase begins. The computer takes over from the paper and pencil, and thus the process requires a different production pipeline. This process begins with the construction of 3D computer-generated models of all characters, props and sets.

Similarities to live action

The similarities with live action start with the naming conventions used in the storyboard. Instead of every camera angle change requiring a different scene number, the scenes are numbered according to their location (or changes in location) and then the different camera angles are broken down and named shot by shot. This process follows the standards of the live action environment. Other similarities to live action are the development and planning of sets, the camera treatment, composition of the shot, storyboard marking, casting of talent for motion capture (if motion capture is used), the execution of the motion capture and the treatment of the lighting.

The 3D production crew

The structure of the 3D production team is different to that used in 2D animation. Some of the roles performed are identical to those of their 2D counterparts, but there are many crew positions that are unique to the 3D process. The key team members are as follows:

- The producer plays exactly the same role in both 2D and 3D productions. They are responsible for all facets of the production, from conception to delivery. In addition, it is important that the producer keeps up to date with the latest technological developments, including new software and plug-ins. An understanding of the mechanics of 3D animation, as well as the relevant technological knowledge is crucial for successful production.
- The line producer/production manager has an identical role to the one performed during the 2D animation process. They work closely with the producer in managing the production pipeline.
- The director performs the same role as the 2D director and is responsible for the creative development of the project.
- The script producer looks after the script department in exactly the same manner as their 2D counterpart.
- The art director looks after the design concepts for the show and works with the director in order to set the feel of the entire project.
- The lead modeller is in charge of the modelling department. This person supervises the modellers and checks all models before submitting them for further approvals.
- The lead animator is responsible for overseeing the animation process. They supervise and check all of the animation before submitting it for further approval.
- The technical director looks after all of the technical aspects of the project. They are responsible for setting the technical parameters for the show and will also be involved in liaising with software developers and programmers in order to implement new computer programs and plug-ins.
- The lead texture artist is responsible for the texturing department. They supervise the texture artists and check all of the textures before submitting them for further approvals.
- The lead special effects artist is an experienced animator or technical director with a knowledge and passion for special effects. They usually work closely with the technical director.

- The modellers create all of the 3D models.
- The texture artists apply textures to the 3D models.
- The animators animate the 3D scenes.
- The special effects team will apply all of the necessary effects to each of the animated scenes. If the level of special effects in the show is high, the lead special effects artist will form this team. If there are few special effects then the lead artist will take care of this process alone.
- The render wrangler is in charge of rendering the finished scenes and preparing them for further stages of production.
- The motion capture team is part of an outside facility, hired by the producer. They take care of the motion capture preparation, the shoot and the subsequent file clean-up.
- The network administrator takes care of the computer network in order to provide an undisturbed work environment for the whole team. This person is also in charge of installing software, allocating rendering space and maintaining servers, etc.

Development

Today 3D animation is used to produce feature-length films, short films, television and cinema advertising, television serials and specials, computer games, interactive movies and educational games, to name but a few. It is the producer's role to ensure that the concept they are running with will be perfectly suited to the 3D medium. The project development will take place in the same way as for the 2D project, with story ideas and design concepts being created. The major difference for the producer here is that they need to determine the technical requirements of the show and plan the schedule, budget and crew construction accordingly. The producer will work closely with the director and technical director during this phase to lock off the technical requirements of the show. If the project is going to be distributed as a computer product (such as a game) then the technical parameters will be quite different to a show being produced for television or the cinema. This will impact on all stages of production, from scriptwriting to modelling, to animation and post-production. All production limitations need to be clearly communicated to all staff members so that there is no room for error during the production.

Scriptwriting

The script producer will need to assemble a team of writers and begin the scripting process. Again, this actual process is identical to the 2D scripting stage. The only difference here is that the limits on the scriptwriters may be less severe than with 2D, particularly with the number of locations or sets that can be used. The script producer will oversee the production of all 3D scripts and the director, producer and client will approve them. With 3D production, the technical director should also be included in the script approval process to ensure that the scripts do not contain anything that may be technically unachievable.

Model design

The director will work with the art director and designers in order to create all of the necessary character, set (the 3D version of the background) and prop designs. These lists will need to be initially drawn from the locked script, and the production manager and coordinator will be responsible for this. All of the model views described in the 2D design process—for example, turnarounds, facial expressions, cross-section and topographical maps—are also necessary for 3D production. On higher budget productions, actual sculptures of the main characters may be produced using clay or Plasticine.

Once the line work of the designs has been nailed down, the art department will go ahead and work on the colour schemes for the show. They will make up various combinations of colours in consultation with the director and will ultimately submit several combinations and alternatives for selection.

Once the line work and colour schemes have been approved internally they will need to be sent to the client before the model sheet books can be compiled.

Dialogue recording

As with 2D production, the dialogue recording can take place either before or after the storyboard is complete. This process does not differ from a dialogue recording for a 2D project. Once the dialogue is recorded the sound engineer will break it down line by line for the animators to use in their respective scenes.

Storyboarding

The storyboard artist needs to be provided with a completed script, dialogue track (if available), blank storyboard panels and all relevant designs. The director should brief the storyboard artist, who will then complete the board in the same way as for a 2D project. The big difference for a 3D project, however, is the scene breakdown, as explained above. Once the storyboard is complete and has been initially approved by the director, it should be distributed to the lead modeller, lead animator and technical director for feedback to ensure that everything detailed in the board is achievable. It can then be signed off by the director and producer and sent to the client.

Animatic

Depending on the budget of the production, an animatic may be created once the storyboard is complete. This can be achieved in one of two ways. The storyboard can be scanned and edited in the same fashion as the 2D animatic, or alternatively, very rudimentary models may be made up and blocked out in the 3D space according to the storyboard. These models can be created specifically for the animatic, or if the modelling phase is advanced enough, wire frames of the actual character models can be used. The dialogue will be added as the reel is assembled and the basic camera movements will be incorporated. An assistant editor will assemble the finished scenes and the director and animation director will then sit down together and refine the story, timing and blocking. At this stage it is important to also involve the technical director, lead animator and modeller in order to provide operational feedback. The finished animatic reel will then need to be approved by the producer and client.

If an animatic is not going to be produced and the animation is going to be sent offshore, then it is a good idea to have an experienced timing director create timing sheets for the show. This is done by supplying the completed storyboard, model sheets and dialogue track to the timing director, who will act out the scenes while timing them with a stopwatch. They will then record all of the timing directions on to a timing sheet, which can be an identical document to the 2D exposure sheet. These sheets are then shipped with the rest of the show to the servicing studio.

Modelling

The easiest way to understand the 3D model is to compare it to a chocolate Easter bunny. It follows the shape and contours of a bunny on the outside, yet is hollow on the inside. This is what a 3D model looks like—an empty shell that is defined by wire frames. Imagine that the chocolate is the wire frame, holding the model in shape, while the coloured wrapping paper around it is the mapped texture applied to the surface of the model, providing it with its colour.

There are two major modelling styles in 3D animation—low polygon and high polygon modelling. The decision to produce a project with low or high polygon numbers will depend on the nature and the purpose of the project.

Models built for film and television are always high polygon projects. This means that they have a high number of polygons in their model building structure. The use of a high number of polygons gives a smooth, curvy look to the models. For games and real time Internet streaming the models are nearly always low polygon. In other words, they are built using as few polygons as possible. What are the reasons for this? As film and television productions are subject to broadcasting, the project is rendered and put on to a tape for delivery and broadcast. In real time games and Internet streaming projects there is no rendering stage. The animation streams while the clip is being viewed and the speed of the computer processor or bandwidth will decide the final look and running speed (frame rate) of the visuals. The low polygon count gives a rough, edgy look to the models, but it also allows the project to be delivered effectively in real time due to a smaller overall file size.

In order to begin the modelling process, complete lists of the required sets, characters, props and special effects need to be compiled from the locked-off script. The producer, director, production manager and head of modelling should sit down together and set the modelling parameters and guidelines. The director and producer should also have a meeting with the entire team to explain the expectations for the project. From that point on, the head of modelling and the production manager will take care of the distribution and completion of the models and the producer and director will look after the approvals.

Modellers are allocated their props, sets and character models to complete. They are given model sheets, and if they are dealing with character models they are also given parts of the storyboard portraying the particular character using a range of extreme facial expressions.

In the case of sets, the modellers are given model sheets and topographic maps of the location along with samples of the storyboard depicting the use of the

location. When planning and building the sets the greatest of care needs to be taken with regard to the arrangement of space and proportion. As the camera's behaviour in the 3D environment is the same as in live action, it is important to always make sure that all possible ground has been covered to avoid shooting 'out of the set'. Often sets are located within the sphere that includes the sky in order to allow for high camera angles.

It is always important to be mindful of the skill level of each particular person when it is time to distribute the modelling work. The most experienced individuals should build the characters, those with an average amount of experience should be designated the sets and the least experienced modellers should be given the props to build. Sometimes, separate teams are set up to build the different categories of models. Some modellers will prefer to build nothing but sets regardless of their capability to build perfect characters. All modellers need to have artistic and technical skills. A background in art, especially sculpturing and architecture, is very helpful.

When the models are finished they need to be approved by the head of modelling and then rendered out. Once they are rendered, they need to be given to the director, producer and client for approval.

There is an interesting modelling method around called Cyber scan. Cyber scan is a special 3D laser-based non-contact scanner which can scan an object and automatically convert it into a 3D item by inputting 3D point data from the subject, which is then converted into a polygon structure for further modelling. This is probably the most efficient way to get realistic human heads and can be done for humans and animals as well as objects.

Photogrammetry is a similar method that uses scanned photographs to recreate images in the 3D environment. This style of software detects and analyses shading and line information across several samples of photographs and converts that information into a basic model.

Depending on the nature of the project the most popular software currently being used is Maya and LightWave for high polygon modelling, and 3D Studio Max for low polygon modelling. Of course there are a number of other programs on the market, like Softimage, Rhino and True Space.

When the modelling is complete the next phase of pre-production can begin—the insertion of the bone system (skeleton). This is called 'rigging' or 'boning'.

Kinematics and rigging

There are two distinct ways of creating basic animation—by using either forward or inversed kinematics. Basically, forward kinematics is when every part of the model needs to be moved manually from the 'parent' to the 'child' to create the motion. So to move a character's hand, for example, each joint along the arm would need to be moved, from the shoulder down to the hand. Inverse kinematics involves moving the child, resulting in the movement from the child to parent along a pre-calculated trajectory. So moving the hand alone will result in the arm and shoulder moving into the correct position as well. The terms 'parent' and 'child' are used to name parts of the models. The parent, or root object is the basic object that other parts of the model are attached to. The child is every object that is attached to the parent.

Since inverse kinematics makes it possible to manipulate the articulated structure by the end effector, it can be used as an animation technique for easy motion control. Forward kinematics, on the other hand, is a much slower and more intricate method of animating a model. However, it allows for the movement to be much more controlled and exact than with inverse kinematics. Most often characters are created to allow for the implementation of both methods. This process is called rigging or boning (adding bones/skeleton) to the character. This structure will allow the characters to produce movement.

Rigging is the process of setting up the model skeleton to be animated by either of these methods. This process can be incorporated into the modelling phase and thus performed by the modelling team, or it can be done by specialised riggers, who will work hand in hand with the modellers to make sure that the movement of all characters works properly. The technical director of the project will oversee this process carefully, often being the person to initially set up the rigs for implementation on the models.

Skinning

This is the process that literally gives the character its skin. Actually, the skinning process can be likened to sewing. 'Skinning' refers to the process of creating a skin that will cover the outside of the model in much the same way as you would make a pattern to sew a dress that will cover the body. Most 3D packages provide a function to create this skin surface and wrap it around a model. This can be done manually or with the use of an automatic skin generator. Usually each model

will be given back to the original modeller for this process, although sometimes one designated person or a small team will perform this role.

Testing the models

Once the characters have been boned and skinned it is necessary to test their motion. Walk cycles and stock motions will be compiled at this stage and will double as testing material. Sometimes an intricate motion capture file will be used to test the mobility of the character. In most instances, the head of animation will perform these tests or allocate someone to do them. This is the stage where any problems with the model need to be detected and rectified. Even if there are no obvious problems, the head of animation should supply comments regarding any concerns they may have.

Lip-sync

Just as with 2D animation, lip shapes need to be developed for any of the characters that will need to speak or produce facial expressions. Usually, each individual studio will have their own standards when it comes to the number of lip shapes they use, but it seems that either 12 or 24 lip shapes is the average. Each lip position requires a separate head and in 3D animation automated lip-sync software is used. This means that each sound will use a pre-prepared head with the appropriate lip shape, which will be displayed automatically once the dialogue track is inserted into the project. Software programs like Magpie or Reallusion can be used for this purpose, although there are many other packages currently available. Many companies have proprietary-developed plug-ins for 3D software that they use for automated lip-sync functions.

When producing low polygon models, file sizes are usually an important consideration. In this environment it is prudent to identify all non-speaking characters, as well as those who do not feature largely in the show (usually this means they are only ever in the background of a shot and do not come close to the camera). These characters will be built without the ability to talk, so their lips will just be textured on to their face. Their eyes will be textured simply so they won't have the ability to blink or move them. This will save file space by cutting the number of polygons appearing on screen at any one time, without compromising the look of the show to any large degree.

Texturing

Texturing is the process of applying/painting textures to characters, sets, props and special effects. Textures can be taken from natural resources (stone, metals, grass, wood grains, etc.) or created artificially. The most common software used for texturing are Photoshop and Detailer. Texturing can be compared to the painting process that occurs in 2D animation. It requires painting talent as well as a well-rounded knowledge of the various computer software packages used for this purpose. Most texture artists have a strong background in either graphic design or painting, although architects often make excellent texture artists, especially when it comes to texturing sets, because they have a good understanding of space and light distribution with regard to objects of an architectural nature. Having said that, it's important to be aware of the fact that texturing is a very specific profession and nearly everyone entering this field will require some degree of extra training.

There are different ways in which textures can be applied to a model. For obvious reasons the face of a model will always require the most attention and as a result larger bitmaps are used to create these textures. A bitmap is a collection of bits, or data. The lesser exposed areas of a model, like the lower part of the body, legs, etc. can be textured with smaller maps (if file size is a consideration). With low polygon modelling for sets, tiling is a common process. This is done by applying a single map and reusing it over and over again in order to save on file size.

At this stage, some of the lights can be textured on to objects, and lighting bodies can be put in place ready for the lighting phase, which will take place once animation is complete.

The head of texturing, together with the production manager, takes care of work distribution and collection. The director, producer and eventual buyers will need to approve all of the models.

Textured models provide a good visual indication of the final look of the product and will be used to prepare presentational set-ups for marketing and merchandising if needed.

Libraries

All models and textures are filed and organised into libraries based on their model type (character/set/prop/special effects). Each animator imports the elements needed for any particular scene from these libraries. This is the way to keep things tidy

Figure 24 3D Pre-production model for 3D animation

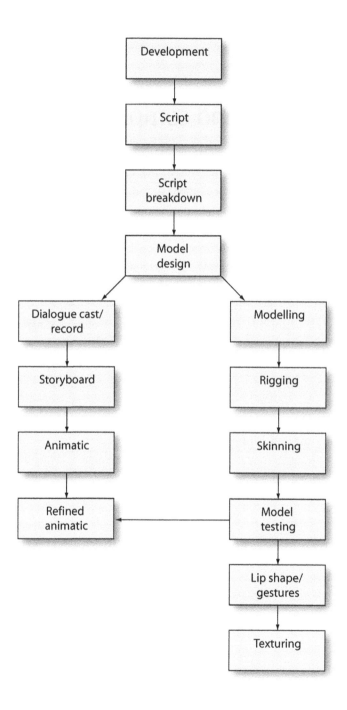

and under control and to execute all updates from one central location. It is necessary to have version control software on the network to be able to track all details regarding changes, such as the author, time and location of the change. The technical director will set up this library and ensure that it is maintained correctly.

Refined animatic and complexity analysis

Once all of the models have been completed they can be incorporated (at a low resolution) into the animatic. The animatic will be further refined as these elements are added to produce a final reel that contains the character and set models, character blocking, poses and interaction with each other, the camera angles and movement, the screen direction and continuity as well as basic lighting. This will allow the director to lock off their screen direction, to make sure that the models work within their environment, to check continuity and to make sure that the way in which the story is being told is working.

Once the reel, or sections of the reel, have been approved it is the job of the producer and production manager to meet with the technical director and lead animator in order to analyse the complexity of each scene. This will determine the scene allocation plan and will be a checkpoint for the producer to ensure that the directorial requests do not jeopardise the schedule and budget.

Once the models and animatic are fully complete, it is time to move on to the animation stage. There are two different ways to approach this process. The first is through using motion capture to create the basis of the animation files. The second and most popular method is to have a team of animators create the animation from scratch.

10 3D production

Motion capture systems

Motion capture, or performance animation, is the process of capturing real life movement and translating it to a 3D character. A motion capture system consists of a collection of sensors (usually reflective sensors that are stuck on to a motion capture suit) that simultaneously feed position and orientation data to a computer. By carefully mounting sensors to a human body, the person's movements can be recorded in real time and the recorded data can be played back by channelling it to a virtual character. If the position of the sensors on the human and their equivalent positions on the virtual character have been configured correctly, then the results should be very good. This type of motion tracking can be done in two ways, either optically, or magnetically.

While wireless magnetic tracking systems have now come on to the market, traditional magnetic systems usually require cables to be attached to the body of the actor, thus restricting their movement. Optical tracking systems involve reflectors and a set of cameras, which allow the person full freedom of movement. The downside to this is that periodically the reflectors can become obscured, preventing some of the data from being captured. In contrast, magnetic trackers produce data continuously.

Specialised optical systems are used for capturing facial expressions and there are also some mechanical and hybrid systems currently on the market. People, animals and objects can be captured. More information on motion capture systems and brands can be found at the links listed below:

- Optical motion capture systems
 Adaptive Optics Associated—www.aoainc.com
 Charnwood Dynamics—www.charndyn.com
 Measurand Inc.—www.measurand.com
 Motion Analysis Corporation—www.motionanalysis.com
 Northern Digital Inc.—www.ndigital.com
 Phoenix Technologies Incorporated—www.ptiphoenix.com
 Vicon Motion Systems—www.vicon.com

- Magnetic motion capture systems
 Ascension Technology Corporation—www.ascension-tech.com
 General Reality Company—www.genreality.com
 Polhemus Inc.—www.polhemus.com

- Mechanic motion capture systems
 Digital Image Design Inc.—www.didi.com
 Puppet Works—www.puppertworks.com
 Immersion Corporation—www.immersion.com

- Hybrid motion capture systems
 Digits 'n Art Software Inc.—www.dnasoft.com

Preparing for motion capture

Preparing a motion capture session is similar to preparing a film shoot. Meticulous planning is required in order for the session to run smoothly and to achieve the desired results. The first step is to hold auditions and assemble a cast. Often with motion capture it will be necessary to look for people with specialist skills; for example, people with martial arts or dancing experience. Talent agencies can propose suitable people from their books, or an open audition can be conducted.

Once the auditioning process is over and the cast has been finalised the rehearsals and ultimate capture sessions can be planned. This is done in much the same way as a live action shoot is planned, using table planning and call sheets. The whole project is analysed and a breakdown for motion capture is made (the producer or production manager will create this). On the basis of this breakdown the scenes for each day of shooting will be allocated, endeavouring to balance each day with an equal number of difficult and light scenes as well as trying to have a consistency

of locations and talent. As with the recording process, refreshments must be organised for the cast and crew. The motion capture studio may provide this service, but it is important to check with them at the time of booking.

Rehearsals are usually held in a separate location as it's too expensive to keep the capture space occupied for rehearsals, but short, fast rehearsals should be done on location on the day of the capture.

During the capture the dialogue track or the animatic will be used as a guide for the length and action of the performance. Every captured scene is also recorded on videotape for the animators to use as reference later on. Throughout the session, the motion capture assistant will keep a capture log, which is a list containing all of the day's captured scenes, each take number, any directorial comments as well as a clear indication of the takes selected for clean-up. Note that it is not always necessary to capture the entire project. Scenes containing minimal and simple animation, for example, need not be captured. Generally, the scenes which require the most skill and experience to animate will be the ones slated for motion capture, such as martial arts scenes or scenes containing difficult choreography.

Because this process is only capturing human movement, it is not always necessary to hire different actors for every character. A cast of between four and six people is usually sufficient to cover all of the characters.

Props also need to be taken into consideration for the motion capture shoot. Generally, where an actor is able to effectively mimic the use of a prop, it is best not to use anything. This is because any object that is introduced into the motion capture space (specifically for optical systems) has the capacity to block markers, which will affect the final data. However, there are many instances where props are necessary in order to capture the required movement correctly. It can be difficult for an actor to realistically feign a sword fight if they don't have a sword to act with, so the talent needs to be supplied with a similarly shaped object to use during the capture. Climbing or flying may be necessary for a scene, in which case a scaffolding or trapeze rig will need to be hired. Perhaps one of the characters has been designed to wear heavy boots, in which case they must be captured wearing weights or heavy shoes in order to affect the correct walking patterns. Markers should be placed on the object so that it can be captured along with the actor's movements. It is always important to take into account the weight of the prop as it has an enormous impact when it comes to providing a convincing pattern of movement.

The rates of pay for motion capture actors vary depending on whether they are rehearsing or capturing, with the rehearsal time being paid at a lower rate. Motion capture is still a relatively new technology, and in many countries there

are no base rates set out for the payment of actors engaging in this type of work. It is best to consult with the various actors' unions or representatives in order to arrive at a fair rate of pay based on the type of show the actors are being contracted for. Just as with the voice talent, a signed contract needs to exist for every actor before a capture session can begin.

Once the motion capture shoot is complete, the captured data is cleaned of any static and noise, configured to the appropriate 3D software and delivered to the animation studio.

It is good to have all of the 3D models finished before the capture starts as this will help the motion capture staff mark up the actors using the most appropriate marker set for their character. If models are not available at the start of capture the shoot can go ahead as long as the position of the markers (for an optical system, for example) follows the model hierarchy typical of the 3D software used to create and animate the models. Motion capture data can display various problems, the most typical being a type of noise or jitter. If this problem occurs, the motion capture studio must reclean and smooth the raw data.

Motion capture can make the animation process much faster, although that may not necessarily translate to lower production costs. It is practical in the sense that it helps less experienced animators produce larger volumes of animation in a shorter timespan. This means that above average results can be achieved with an inexperienced or very small team of animators. One of the major disadvantages of motion capture is that many young animators who start working with motion capture files can begin to feel incompetent animating any other way. This is detrimental to their personal growth as animators because it does not allow them to extend their skills. When a strong animation team has been assembled, motion capture is best left for a small number of highly difficult scenes, while the rest of the show can be animated by hand.

Animation

As mentioned earlier, the animation can be completed in a variety of ways— through the use of forward or inverse kinematics and with or without the use of motion capture files. The production pipeline remains relatively unchanged regardless of the method used.

Before the animation process begins, the production manager will need to compile an animation pack for each scene. The pack needs to contain the following items:

- model sheets
- a copy of the storyboard with the appropriate scene section marked
- the location of the sound files for insertion into the scenes
- the location of the motion capture files (if motion capture is used)
- a list of all assets on a scene-by-scene basis (breakdown)

Access to the motion capture session videotapes will also be required.

The head of animation, together with the production manager, distributes scenes to animators according to capability—harder scenes are given to the more experienced team members, while the lighter scenes are allocated to the less experienced animators. Sections are mostly broken down according to locations and characters that appear within the scenes.

A proficient animator will have a strong understanding of animation mechanisms/ rules as well as the ability to use the related software. In other words, the 3D animator needs to have the same qualities as a 2D animator, plus the ability to use computers and 3D software. Many studios advertising for 3D animators ask for at least one year's experience in traditional animation.

The initial step in the animation process is a briefing from the director and head animator. This needs to be done with each and every animator, for every scene in the production, and must occur prior to them commencing any animation.

The actual animation process will usually occur in several different stages, or passes, with the director approving each pass individually. A typical three-pass structure would consist of an initial set-up pass, followed by the main animation pass and completed by a polishing, special effect and lip-sync pass.

The initial pass is generally referred to as blocking or set-up and is where the overall timing and in and out character poses are established. This process is used when an animatic has not been previously created so the material completed at the end of the blocking pass equates to an animatic. It will be timed and will have all of the scene's sounds and camera movements in place. If motion capture is to be used in a scene, this pass can be skipped and the animator can move straight on to the first pass of the scene.

During the first pass the character movements are animated and, if applicable, the motion capture files are placed into the scene. At this stage the scene does not contain the facial expressions or lip-sync. By the end of the first pass, all of the animation should be in order and at this stage the scenes can be dropped into the animatic (if one was created) for a final check before moving on to the second pass.

During the second pass, all of the elements in the scene are finessed. Expressions are added, lip-sync is activated and transition effects are placed into the scenes according to their intended durations. Once the second pass is complete the project should be looking pretty much finished, with only the final lighting and special effects to be done.

The bulk of the animation is usually done with a wire frame or biped display as this is less taxing on the computer and aids in screen refresh rates, saving valuable time. The texture display can also be turned off for this purpose. When the second pass is approved, work can begin on the lighting and special effects.

Lights and special effects

Lights work as atmospheric magic. They enhance scenes and emotions, carry underlying messages and improve the overall look of the project.

The use of lights in 3D is similar to their use in live action, with basic lights being used in scenes during the animation process. During the second pass, the director will instruct the animators on how to set up the atmospheric lights in order to achieve the look they have envisioned. When the second pass is approved the scenes will go to a small group of animators who specialise in special effects and lighting. This team will run another pass over the show, finetuning the lights and special effects and ensuring the lighting continuity from scene to scene. This is the stage where the project gets its final polished look.

Special effects are the eye candy of many projects and the 3D community loves them. Model sheets or reference photos must be presented to the special effects people. These people are usually the most technically minded of the animation team. A lot of special effects come in the form of plug-ins with software packages, so creating them becomes easier and easier and over time the artists are able to draw from a huge library. On the other hand, a good deal of special effects need to be created from scratch, requiring lot of ingenuity and creativity on the part of the SFX artist.

Compositing

Once the scenes are rendered, they are broken down into their separate elements. They can then be tweaked and enhanced by the compositors in a variety of ways. Usually this process will be used to add additional effects to a scene. If a scene

needs to be fixed and rerendered it can be done across the entire scene or just to the individual frames (depending on the output format). If the output is a row of TIFF images, it is possible to simply fix up and reoutput the problem frames as opposed to re-rendering the entire scene again.

Rendering

When all of the final elements are locked down they can be assembled and rendered, which is the process of drawing all of the elements together to form a single file image or movie. Rendering at a low resolution will occur constantly throughout the animation process in order to view the work in progress and instigate any necessary alterations. When the animated scenes are ready for final output to tape, they must be rendered at the highest possible quality. All studios will have what is called a render farm. This is a collection of high-powered computers that are networked to one another and are reserved entirely for the rendering process. A render wrangler will be appointed to look after this department and will work with a small team of people (usually junior technicians) in order to render every single scene. Because of the complicated nature of most 3D scenes, the computers need a good deal of time to process and consolidate the information in order to produce the rendered scene. Scenes can take anywhere from minutes to hours to days to render, so this process is time-consuming if the project being rendered is a full-length feature. The rendering scenes need to be monitored and the computers themselves need to be attended to as they can often lock up when performing complicated tasks such as this. In busy studios, the render farm will often operate on a 24-hour shift in order to keep scenes moving through the pipeline as quickly as possible. When the render and output of scenes is complete the picture and sound post-production can begin.

Backing up project files

As with 2D animation, 3D animation requires the stringent backing up of all computer files. Performing regular back-ups is an absolute must for every project and 3D animation has an immeasurably higher volume of data than 2D productions. Work is continually being accessed over the network, which needs to be free of clutter in order to facilitate fast access and storage of files on an hourly basis.

Studios producing 3D projects usually have to have a lot of rendering power, storage space and back-up servers. (See section about back-up for 2D animation in chapter eight.)

Hybrid productions

It has become fairly common to see producers mixing different forms of media with a view to producing the best possible quality products. It is not unusual to see 2D projects using 3D elements, or live action projects incorporating 2D or 3D animation. Usually, 2D television serials use 3D elements for enhancing the look and individuality of the show, especially in the area of backgrounds/locations.

If 3D backgrounds are to be incorporated into a 2D animated show, the producer and director will first have to isolate the scenes they wish to apply this treatment to. This will be done when the final draft of the script is complete.

When the scene list is finalised the producer will employ the services of a designer who will create 2D model sheets of the backgrounds required. A 3D modeller will then be employed to build the elements in a 3D animation package like 3D Studio Max or Maya. In order to do this, the modeller will need to be provided with a copy of the storyboard along with model sheets of the background layouts. The 2D background layouts supplied should illustrate at least two different angles—a frontal view of the location as well as a cross-section of the location. In addition, it is a good idea to also supply a floor plan (like a topographic map). The size of the show's main character should always be indicated on any backgrounds to avoid unnecessary resizing of the set further down the track.

The director needs to brief the modeller and explain the requirements of the background the modeller is about to create, as well as what they hope to ultimately achieve by using 3D backgrounds. Such backgrounds can be very expensive and their use is usually limited to two to three backgrounds per episode. It is helpful if the backgrounds can be reused to avoid having to build brand new models for every show. Even when locations can be reused, the rendering for each (or nearly each) scene needs to be done separately, taking into account the field size and camera movement.

A form of rough layout for all of the scenes that will use the 3D elements needs to be done. This is not a real layout, rather a simplified version with enough information to explain the type of motion the characters will have within the scene.

Once the modelling is finished and approved, the modeller needs to render the images for the layout artist, trying to match the angle and size as indicated in

the rough layout. The rendered stills need to contain small tracking crosses for registration.

The stills then need to go back to the layout department, where the rendered images will be used as the background layout in order to make the final layout. The rendered stills need to be repegged, making sure that the positioning crosses are kept in line. Once this is done, the animation can continue as usual. If there is no camera movement it is possible to just render certain static blocks of images. If any sort of camera movement is indicated in the x-sheets then things are going to be a little more difficult. In this case, the rendering has to follow the camera movement from the exposure sheets and the animation has to match every registration mark from the set. If a camera move is indicated for every frame then a separate render is required for every individual camera move. So if there is a long pan, where a character interacts with a background (registration will be needed for this), there will need to be 20 to 30 separate still images (set renders) in the layout folder.

The images can be rendered as a TIFF or as Targa files, or in any other format that the head of the camera department requests. Regardless of the file type chosen, it must be possible to import it into Adobe After Effects, or a similar program, for compositing. The compositing and post-production will happen in the same way as for 2D animation.

Three-dimensional elements become an integral part of live action through special effects. Many movies would lose all of their magic if the 3D special effects were removed. Imagine *The Lord of the Rings* without its enchanting 3D effects, or *The Matrix*, or *Reign of Fire*. The movies would still have their stories and polished acting, but they would miss that final link that takes the audience over the edge of imagination and straight into the kingdom of believable fantasy.

Figure 25 3D production with motion capture

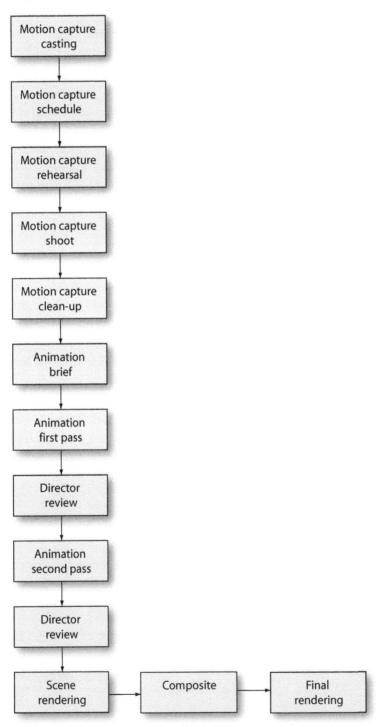

Figure 26 3D production without motion capture

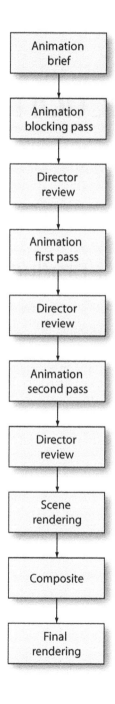

11 Post-production

Picture post-production

Post-production is the stage where all the elements of the project come together. Images are locked off and combined with the voice track, sound effects and music. At this stage the producer will have to continue to supervise and monitor all the episodes that are still in other stages of pre-production and production as well as oversee the diversity of tasks related to the post-production (editing, sound, mastering and tech checks). The producer should have already made arrangements with a post-production facility earlier in the production stage. They should have contracts in place for these facilities and should also have short-listed a group of composers for consideration. The producer also needs to work on the preparation of the front and end credits.

The post-production crew should consist of the following people:

- producer
- director
- animation director
- post-production supervisor
- editor and assistants
- composer
- music/sound editor and assistants
- sound supervisor
- tech check and duplication personnel (lab staff)

Rushes and retakes for in-house productions

Once a batch of scenes is rendered and the output is done the producer, production manager and digital manager need to review the scenes. This is done before the material is shown to the director and is referred to as the stage of internal retakes. This encompasses all of the scenes with mistakes that are so obvious that retakes on them cannot be avoided under any circumstances, those which would definitely have been called for fix-up by the animation director. These scenes need to be redone quickly regardless of where in the production process the mistakes have occurred.

When dealing with an in-house production it's faster to show the director groups of scenes as they are finished rather than wait until the entire show has been rendered. Doing it this way means that once the show is completely rendered the majority of the initial reshoots have already been dealt with.

Once the fix-ups on these scenes are done, the rendering and output process is repeated and the materials are ready for the animation director to view. The scenes should always be printed in continuous order if possible. However, an entire show will never be rendered in the one batch, rather in sections as groups of scenes are finished. Rendered scenes on tape are referred to as rushes. Files are put to tape as opposed to say, a DVD, because of their size (the total size of a rendered 22-minute show could be in excess of 25 GB!) and also because having loose files does not provide any sort of time code reference. For smaller projects scenes could theoretically be burnt to DVD and brought into a non-linear editing system simply by copying files from the DVD on to the system disk. However this can only be done if the strictest rules apply to the naming conventions of each file and if the editing package used is able to reconnect the files to a finished edit if the source material is needed again.

Rushes and retakes for productions with overseas elements

When dealing with a servicing studio, a fully completed set of rushes should be delivered with slates (or ID boards) inserted at the head of each scene. The studio will usually deliver the rushes on digital Betacam tape for the purpose of editing, and also on VHS for fast and easy viewing. The director together with the producer

will review the rushes and call for retakes. At this point the director will also view the VHS tape and make their initial editorial notes. This practice is commonly referred to as a paper-and-pencil edit and can save a considerable amount of editing time. Alternatively, some studios prefer that the editor be given the rushes first because small mistakes can often be corrected within the editing system, or cut around or cut out in order to save time and reduce the retake burden on the digital department.

Retakes can be called for a variety of reasons, ranging from simple things like painting mistakes, to the more complex such as model and proportion mistakes, errors in animation movement, background, character, prop, or special effects continuity mistakes or lip-sync mistakes. Once the list of retakes is complete it can be sent to the servicing studio. It is important to note that when retakes are received, some of them might still contain problematic elements and a second and third round of retakes may need to be called for. To be certain that the retakes are going to be fixed correctly it is imperative to make sure that the scene numbers are correct and that the instructions are clear.

Editing can begin before the retakes are delivered, using all of the existing scenes, including those that are listed for fix-up. The inferior scenes are simply used as place holders until the rectified scenes arrive.

Non-linear editing systems

The old systems of video tape-to-tape editing and film editing have been superseded with the introduction of non-linear editing systems such as Avid and Final Cut Pro. Non-linear editing allows for footage to be stored on a computer disk, making it possible to access all of the material randomly and to edit a piece without having to methodically move through the timeline in a linear order. This means that an editor can make changes to any part of the show without having to continue through and re-edit everything that follows from that point on in the timeline.

Digitising, the assembly and sync

There are several steps that need to take place before the editor can begin cutting the show. When the rushes arrive at the post facility, an assistant editor needs to digitise or capture all of the material into the editing computer. This is the process of converting analogue signals from a tape into a digital format that is compressed and stored on a computer disk. With this method there is no real danger of tape

damage no matter how many times the footage is viewed. This is because digital information stored on a computer disk does not gradually degrade with repeated access the way it does when it's recorded on videotape.

Once the pictures and sound have been digitised, the assistant will log the rushes. This is done by identifying each scene and creating a new file for it, so instead of having one huge media file there will be hundreds of smaller files, each representing the individual scenes. Splitting the media this way makes it easer to identify scene numbers on the timeline and allows for shot replacement to take place when the retakes arrive. The assistant will then assemble all of the scenes, in order, on to a timeline and begin adding in the dialogue track at the appropriate points so that the audio is in sync with the picture. This can be done by lining up the first sound of audio with the first mouth movement of the talking character, or it can be achieved by following the original track reading on the camera charts. If an animatic has been edited in the same software package then it is possible to take the animatic sequence containing the dialogue placement and simply drop the completed pictures over the video track. The dialogue will be more or less in place and will only require minor adjustments as opposed to a full sync. Once the sound and picture are synchronised, the editor can begin the rough cut.

The edit

The rough cut is the first pass of editing, where the editor tightens up the cut and ensures that the pacing and storytelling is working. Because the timing of the show is fine-tuned to such a degree in pre-production, the animation editor's role is more of a reactive one than in the live action environment. They will not have a variety of shots to choose from for any particular scene and must work with the one version they are given to shape the show properly. However, in some cases, and particularly in feature productions, the editor will have been involved in the production from the animatic phase. By cutting the animatic the editor is able to have a greater input on the pacing and shot configuration in the early stages of pre-production.

Once the rough edit is complete, the producer, director and animation director will view the rough cut and make comments. Further retakes will also be called for at this time.

The editor will then go back and finesse the cut, incorporating the comments received from the directors and producer. They will also make sure that the cut comes in at the correct duration. It is usual at this point to send the cut to the client for their approval. Any notes they send back must be incorporated into the edit before it is moved through to the sound edit stage. Once all of the comments

have been addressed, the editor will create the fine cut or timing lock. This means that no further editing will take place and that the timing is locked off.

The entire process detailed above is also referred to as the offline edit. This term refers to the fact that the footage captured by the assistant editor has been done so at a resolution that is high enough for the editing process but too low for broadcast. The reason this is done is to save disk space during the editing process. Video footage digitised at a broadcast resolution can take up over 1 GB of storage space per minute of media. In a busy post house it will usually be more space effective to have the media stored at a lower resolution, taking up less disk space. This is particularly important when the project is a television series because multiple episodes will need to be stored at any one time as they move through different stages of the editing process. In situations where the offline and online editing is done in-house the editor may elect to edit in online resolution. The decision here will be based on the amount of disk space they have available to them.

Editing from a server

When a video server is used, the original footage can be viewed and edited by anyone with a video link to the server. This is generally someone within the production facility, but thanks to high-speed Internet connections it could even be someone in another city, or in another country. In the case of animation and special effects, which are labour-intensive, projects are often electronically transferred to countries where labour is comparatively cheap.

This method is used in the computer gaming industry, where the material is not destined to be mastered to tape and time code is of little significance. However in cases where the media is transferred from the animation output system straight into the editing server for broadcast material, it is advisable to lay the scenes straight down to tape if there is a digital tape system available. Provided the scenes can go straight on to a digital Betacam machine, this will save a lot of time backing up the huge files on the editing server and will provide a consistent time code base for these scenes, regardless of the project they will be used for.

During and after the editing process the director will start making guidelines for the approach they wish to take with regard to the sound design, music and foley. They should already have a clear idea of what is required prior to the formal spotting session.

Linear editing

The term linear editing refers to a process whereby a program must be edited progressively from start to finish because changes made to any part of the cut will affect everything from that point onwards. If a show is being printed to film at the rushes stage, things will need to be done a little differently. Scenes that have been printed to film will commonly be collectively called a work print for the purpose of editing.

Traditionally, 35mm film was the popular delivery format for most shows. Shows delivered in this format are edited on a linear editing table or Steenbeck. In this case, the negative would be preserved and the editing was done from a work print or cutting copy. The dialogue would be transferred to 35mm magnetic tape and edited along with the picture. The picture editing would then go through the same approval process as described above, although the cut would need to be converted to video in order to obtain outside approvals if the client was unable to get to the editing facility.

These days, features that are delivered on 35mm film are usually converted to Digital Betacam tape for the offline editing process, so that the movie can be edited in a non-linear system.

Test screenings

In feature productions there are usually several rounds of test screenings conducted. The first of these screenings is usually done once the rough cut has been completed. This allows the creative team to consider feedback from their target audience in order to make sure that the story and character development is working on screen. Temporary music and sound effects will be used to give the audience a better sense of the overall package. If a large quantity of revisions is needed another screening will take place prior to the picture lock. The next screening will happen when the sound design is in place. These screenings can take place at any time and at the discretion of the producer and client.

Sound post-production

The sound post-production takes place once the offline edit is complete and the picture has been locked off. A locked off picture ensures that no timing changes

will be made, but reshoots can still be occurring at this time. It is important that the timing does not change once the picture is sent to the sound department. The reason for this is that if changes occur, then the final mix will not match the picture when it comes to combining them at the end of this process.

Rendering for sound and music

To be able to create sound effects, music and foley the sound department will need to be provided with a time-coded copy of the edited picture to work to. The time code for long format shows will have the first frame of picture starting at 01:00:00:00. Generally, commercials or smaller pieces will start at 01:01:30:00. The format for this edited picture will depend on the needs of the sound department and the type of equipment they are using. Generally, Betacam SP or time-coded VHS will be good enough as they are only guide tapes. The sound department should also be supplied with copies of the storyboard, recording script and director notes or a cue sheet listing every place in the project where the director envisions a sound or music cue. This should include a description of what they want to accomplish with the cue, the specific place where the cue begins, the specific place where the cue ends and any increases or decreases in volume.

Spotting sessions for sound

The director and producer will both attend the sound spotting sessions where they will decide on the treatment of sound effects, foley and music for the project. The director prepares notes (cues) for briefing the sound supervisor, sound editor and foley supervisor as well as the music composer and music editor. During the spotting session decisions will be made about any necessary revoicing as well.

Other members of the post-production team can attend the spotting session and it is common to include the sound supervisor, sound and music editors, composer and sound designer in the one spotting session. Alternatively, the director may decide to have separate sessions with each of the sub departments (sound, music, foley) after the initial spotting session with the producer. The director may also provide samples of audio research in order to help in the creation of the sound, music and foley. This will consist of material they have chosen to best exemplify the style of sound they want and will be in the form of CDs or videotapes of sample projects.

Sound effects

Nearly everything that appears on the screen has some type of sound associated with it. Drops of water, sea waves, blowing wind, a speeding car—all of these things need sound effects. Sound effects are created to make the visual magic more convincing and bring it closer to the reality of everyday life, where our senses are used to images accompanied by sounds.

Most of the sounds that will accompany the picture are usually taken from extensive sound libraries. Ready-made sound libraries are available for purchase on CD at a very affordable price. The director briefs the sound supervisor and/or sound editor on their requested treatment of the sound effects based on the notes made during the spotting session. If any additional sounds are required that are not present in the existing sound libraries, they will have to be created. In this case the sound designer will create or source these sounds.

Every show also has an element referred to as background sounds or atmospheric sounds. For example, if two characters are talking in front of a school fence during recess, all of the common noises that a typical school yard produces (children yelling and playing, balls bouncing, cars stopping and starting, etc.) will be part of that atmospheric track. These sounds are edited to the picture using cue sheets as a guide. If the budget for the project is limited, there might not be any money for the creation of new sounds, so the existing libraries will have to do. If the project is based on a pre-existing live action show, it may also be possible to request permission to use the sound libraries of the original project.

Music

There are two main approaches that can be taken regarding the preparation of the music. Ultimately the selected approach will be influenced by the budget of the project. In both cases the director prepares cues, or notes for the composer to follow. The two different approaches to the music production are as follows:

1. General sequences of music can be prepared and laid down as needed once the final cut is available. This music is not scene specific, but rather follows the themes of the show in general. For this approach the music can be prepared ahead of time, before the sound effects and foley are worked on. The music department is supplied with copies of the storyboard, post-recording script and edited dialogue. They use these materials to select the appropriate music sequences, and the sound department will edit them into the soundtrack as they lay up the effects. However, it is important to note that with this method there may be the need for the composer to go through the finished episode

and create tiny bits of music to tidy up specific edits. This method would only be used in the television serial environment, where the budget is low and the schedule is tight.

2. Music is specifically composed for the show after the picture is locked. It is necessary to supply all the materials mentioned above as well as the locked picture with burnt-in time code. This is the preferable approach towards the music composition. Of course, it is a more expensive way of doing things, but the contribution it makes to the end product is well worth the expense. Preparing the music in this way will provide more variety and can be used to build on the detail and story specifics that become obvious once the editing is done. Ultimately this method results in a superior product in terms of the music materials and songs, as the moving image has a definite influence on the composer's inspiration. If there are plans to publish the music from the series on CD, and if the show becomes popular, this is definitely the best way to go.

Foley

The word foley has a slightly different meaning in animation than it has in the live action environment. In animation it's used to mark sounds made by body movements. This includes things like a character's walk, the sound that dress fabric makes when a character bends or the sound a character will produce when sitting down on a leather sofa. In live action it has a broader definition.

Foley effects are sound effects added during post-production (after the shooting stops). They include sounds such as footsteps, crockery clinking, paper folding, doors opening and closing or glass breaking—in other words, many of the effects the sound recordists did their best to avoid recording during the shoot. With animation these types of sounds would never have been made in the first place and are a part of the sound effects added in post-production. In animation, foley considers sounds that the body makes while interacting with other objects or bodies. Foley is usually done on television serials with large budgets and always included in feature films and direct-to-video material. It's not overly common to have foley included in lower-budget projects. In these instances, the sound effects department would take measures to compensate for the lack of foley.

ADR

Revoicing, or ADR (automated dialogue replacement), is the stage where the voice or voices of the characters will be replaced with new ones. Why would it be necessary to revoice characters? One of the common reasons is a poor quality of

sound at certain points in the dialogue track. Also, there might be a need for additional lines to be added. In cases where additional lines are added it is usual to try to introduce these lines as a voice-over, in order to avoid having to produce any additional animation. A voice-over line is one where the character doing the talking delivers the line when they are not on screen. This type of line is also commonly referred to as an O/S, or off-screen line. Another way of avoiding additional animation is by using inter-cuts, or any other suitable shot to take the camera away from the character, thus creating the appropriate place to insert a voice-over line. Pick-up lines, which were added by the director at animatic stage, would also need to be included in the ADR, as well as all ancillary noises such as gasping, laughing and extra crowd voices. The director may also decide that they want to alter the delivery of an original line.

Another reason for revoicing a character is the client's whim. Sometimes the client will change their mind about the choice of the voices (even if they had approved these voices earlier on in the production) and it might be necessary to replace one voice talent with another.

In another case, there might have been the opportunity to use a well-known celebrity's voice for the character. If the celebrity was not available at the time of the original recording the dialogue would be recorded using another voice actor with the intention of using that voice as a guide track for lip-sync in animation. Once the picture is locked, it can simply be revoiced with the intended actor.

A copy of the storyboard, the recording script and a tape version of the episode (usually a digital Betacam or Betacam SP) with burnt-in time code will need to be supplied for the revoicing session. During the revoicing process, the voice talent will have to watch the tape closely and aim to sync their dialogue against the existing image. The tape is rolled again and again until an acceptable take is obtained.

Revoicing is a slow process because it requires the meticulous matching of the rerecorded lines with the existing image. This means that the new dialogue needs to have the exact timing as the original dialogue track and every element of speech has to match with the lip shape that is on the screen at the time.

ADR in some studios is called PSD, or post-sync dialogue.

On-line edit

Non-linear editing

Once the picture retakes have been placed into the cut, the time code designations on all of the edit decisions can be saved on to a computer disk in a format that

can be read by the online editing system. This information is referred to as an EDL, or an edit decision list. The off-line EDL is then loaded into the online editing system. In this phase the original footage is captured into the editing system at a broadcast resolution and used to make the final version (the picture master). As part of this process, transitions, special effects and colour corrections are added. A copy of the picture master is then supplied to the sound department to check the sound effects lay-up before they mix the audio.

Linear editing

If the project is to be delivered on 35mm film, the edited work print would be sent to a laboratory for negative matching. The negative copy of the film would then be cut to length according to the work print, by reading and matching the edge numbers of each print. From the edited negative, another positive (interpositive) and negative (internegative) are produced. A second internegative will then be produced, and this copy is referred to as the check print. The check print is used to check the colour quality of the show. The director, producer and editor would view this print and request any necessary changes. This viewing can be done by observing whole scenes or by viewing stills taken from individual scenes. Factors that influence an imbalance of colour are differences in exposure, colour temperature and changes in the film stock that was used. The laboratory handling the film duplication will liaise with the director and producer regarding any colour anomalies and have them corrected. For television products shot on film, the colour can be checked by putting the cut negative through a telecine machine, which captures the image and converts it to a video format (thus converting the frame rate). The co-ordinates for the colour correction can then be worked out using the videotape, and applied back to the negative print.

Credits

The producer is responsible for preparing the front and end credits. Note that it is often necessary to prepare a couple of different versions of the credits to satisfy the broadcasting needs of different countries. Sometimes, the use of long back credits will have to be replaced with a single board containing the studio name. Sometimes it won't be possible to credit the employees of the overseas studio. In this instance the studio as a whole will be credited only, with something like: 'Produced using the Animation Services of (insert studio name)'. The inclusions

and arrangement of the credits will depend on the provisions made in the contract with the investors/client as well as the length of the program time slot. The precise information is taken from the contract in consultation with the legal department.

Front credits usually consist of the program title boards, which will include the name of the project, the episode title and production company. Credits for the executive producer, producer, director, composer, series creator and writer may also appear at the front of the show.

The back credits will list all of the crew members, service and facility providers, as well as the investor/client logos, although on occasion the investors/clients will appear on the front credits. Credits always require meticulous checking and approval from the legal department.

Final mix

The stage where all of the sound elements—dialogue, sound effects, foley and music—are placed together is referred to as the final mix. Each of these elements have been prepared on separate tracks (also called strips or stems), and they are now laid together to create the final mix.

Their levels are adjusted and combined according to the dictates of each scene, as well as any directorial instruction. The configuration and technical specifications of the tracks for the final mix are made according to the client's requirements (as set out in the contract). The producer will supply the sound department with all of the necessary instructions regarding this.

Once the mix is complete it is sent to the director, producer, executives and client for approval. Based on this viewing, alterations may be called for, although most of the time these changes will simply constitute a little finetuning of the mix. An example of this would be a director asking to lower the volume of a particular sound effect, or perhaps bring it into the soundtrack a second earlier. The sound department will then go back to the mix and make any of the necessary changes. Once the mix is approved, it is referred to as a sound master.

Different clients will have different delivery requirements when it comes to the sound. It is important to make sure that all the necessary versions of the soundtrack are complete before the final master (containing both the audio and video) is made. Final mixes are usually delivered on a tape, such as a DA-88, or as files on a CD or DVD. If the project is to be delivered on film, a sound negative will be made.

Final master

The final master is the version that is made by marrying the online picture copy of the show with the sound master. Usually, the sound is laid back or recorded on to the online tape. This can be done at the time of the online, or separately at a dubbing facility.

The final master needs to be produced to the specifications of the client and the most common master format these days for television broadcast is a digital Betacam tape, with the audio across four tracks. Channel one left and right are usually devoted to the final mix of the dialogue, while the left and right tracks of the second channel are reserved for the music and effects. This is the common configuration when shows are going to be dubbed into foreign languages, as the separating of the dialogue from the music and effects tracks allows for the clean extraction and dubbing of the dialogue.

The final master will also contain a textless version of the credits and any other specified requests like textless backgrounds and alternate versions of the credits.

In film projects, the final internegative will be married with the sound reel in order to make a test release print. This print will be checked again and signed off by the producer and lab technician before it can be duplicated for distribution.

Composite elements reel

The composite, or the elements reel, contains all of the separate generic elements of the program. This is the tape that keeps all of the various source data together, removing the need for the editor to be constantly accessing this material from a variety of different tapes. This includes things like the opening and closing boards, textless versions of the front and back credits, and logos, etc. Textless elements are copies of anything that appeared in the show with text. As the title suggests, the text is removed, leaving just the background or piece of footage over which the text originally appeared. Textless elements are supplied when the show is to be translated into a foreign language. The supply of the textless elements allows for the translated text to be replaced over the correct background or scene.

Tape duplication

For projects mastered on to tape, duplication is required in order to produce the requested number of copies of the program for delivery to clients, buyers or for any other purposes. As the term suggests, this is the process of simultaneously playing a tape in a playback deck and recording on to a blank tape on a play/record deck. Professional duplicates are always made in a tape facility set up to handle broadcast quality material. Duplicates are usually in the form of a lower-quality tape than the master, such as VHS. A direct copy of the digital master, made on the same media, would be called a clone.

It is imperative that care is exercised when ordering tape duplicates to ensure that they are made in the correct playback system. Different countries use varying systems of playback. The United States and Japan are two of the countries that use the NTSC TV system. PAL is the system favoured throughout most of Europe, although France uses the SECAM system. Australia and New Zealand also use the PAL system.

To learn more about world TV standards go to: www.ee.surrey.ac.uk/Contrib/WorldTV or www.kropla.com/tv.htm

The producer is responsible for supplying the tape facility with the specifications regarding the delivery formats. The most common format presently in use for television production is Digital Betacam. Previously, D1 and D2 were also widely used, but they are becoming almost obsolete now as the Betacam format has come to dominate the market.

Tech check or quality assurance

Every master and delivery master tape (or clone) needs to go through a technical check before it's shipped to its destination.

The technical check is usually performed at a laboratory specialising in appraising tapes for television broadcast, and most large dubbing facilities can provide this service. The technical check is a process in which the technical correctness of the material intended for broadcasting is confirmed. This would include things like colour discrepancies and sound and image distortion. If the tech check is not satisfactory, the tape needs to be taken away and the problems rectified before resubmitting it to the lab again. Once the tape has passed the check it will be sent back to the studio with a written report indicating that it is of a satisfactory standard for broadcast. A copy of this report needs to be shipped together with the tape.

It is possible to pass the technical check at one facility and then fail it in another, particularly when tapes are being shipped overseas. This is due to varying international standards, but can also be attributed to the particular media being used for the final master.

Closed captioning

For television production, depending on the delivery destination of the product, it may be required that closed captioning is provided for the program. Essentially, captions are subtitles or translations of the spoken word into text, which permit deaf and hard-of-hearing people to read what they cannot hear.

There are two kinds of captioning—open and closed. Open captions always appear on the screen, while closed captions must be 'opened' to be seen. Closed captioning is the process whereby captions are converted to electronic codes and sent out with the regular television signal, specifically on Line 21, a portion of the picture not normally seen. There are 525 horizontal lines in an NTSC television picture and 625 in a PAL picture. Line 21 appears at the top of the picture and occurs just prior to the lines that carry the picture information.

Closed captions are hidden within normal television broadcasts and on videotapes. A telecaption decoder, or a television with a built-in caption decoder chip, is all that is needed to make the captions visible. There's no special service to subscribe to in order to receive the captions. Rather, captioning is made free for all viewers by the television and home video industries, who rely on grants and donations to supply this service.

Delivery

When the delivery master and necessary duplicates arrive back from the lab the delivery items can be shipped to the client. Along with the delivery of the film reels or tapes there will usually be a few other elements that need to be sent. These include things like:

- the post-production script, which is a summary of the episode broken down by each scene, sound, song and sound effect and is used to help create the international version. See figure 27
- an updated copy of the post-recording script for revoicing

- an updated cast list for revoicing purposes
- a music cue list, which is a complete listing of every piece of music used for a film/television program. It indicates the start and end points and total durations of each piece. It's primarily used for tracking the music rights and royalties. See figure 28
- publicity still images

It's not necessary that all of these materials are sent at the same time as the tapes, but they need to be submitted to the clients in a timely fashion.

Figure 27 Post-production script

PRODUCTION COMPANY:	SERIES TITLE:
EPISODE TITLE:	EPISODE NUMBER:

Shot no.	Shot start	Shot duration	Shot description	Music
01	01:00:00:00	00:01:20	Fade in to opening title sequence. WS donkey runs toward camera. **DONKEY:** *YEE-HAH!*	*Music starts*
02	01:00:01:20	00:01:08	WS Pigs dancing in congo line across screen. **PIGS:** *RA RA RA RA RA-RAH!*	
03	01:00:03:03	00:00:11	MS donkey chewing grass. **DONKEY:** *(CHEWING NOISES)*	
04	01:00:03:14	00:01:21	CU of pigs laughing. **PIGS:** *(LAUGHING) HA HA HA HA HAAA!*	
05	01:00:05:10	00:00:23	WS Chicken walks into shot and joins pigs. **CHICKEN:** *GUYS, YOU STARTED WITHOUT ME?*	
39	01:00:55:16	00:02:14	Fade in to series title card. **'SERIES TITLE'** Fade out.	

Figure 28 Music cue sheet sample

PRODUCTION TITLE:	EPISODE No:	EPISODE TITLE:
PRODUCTION COMPANY:	NUMBER OF EPISODES:	
COUNTRY OF ORIGIN:	DURATION:	RELEASE DATE:
WRITER:	DIRECTOR:	YEAR OF PRODUCTION:

SEQ	TITLE	WRITER/PUBLISHER	RECORD CATALOGUE No.	PERFORMER	TRACK No.	DURATION	TYPE OF USE	VOCAL/ INSTRUMENTAL

Figure 29 Film post-production model

Figure 30 TV post-production model

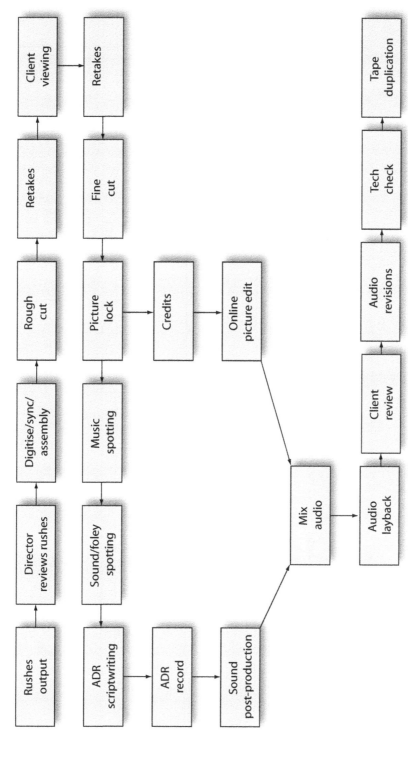

Figure 31 Itemised 2D post-production schedule—5 x 22-minute episodes of children's TV

POST-PRODUCTION	WK 1	WK 2	WK 3	WK 4	WK 5	WK 6	WK 7	WK 8	WK 9	WK 10	WK 11	WK 12	WK 13	WK 14	WK 15	WK 16	WK 17
Rushes delivery	EP 1												EP 1				
Sync/assembly		EP 2												EP 2			
Rough cut			EP 3												EP 3		
Client review				EP 4												EP 4	
Fine cut					EP 5												EP 5
Sound post/ADR																	
Retakes																	
Online																	
Final mix																	
Client approval																	
Master																	

12 Producing Flash, stop motion and multipath movies

Producing Flash animation

Flash animation was born out of the need to create functional and aesthetically pleasing animation for the World Wide Web. The program first burst on to the scene midway through the 1990s and was the brainchild of a company called Future Splash. They named their innovative program Future Splash Animation. Before Future Splash came along, animation was being created for the Internet with the use of programs like Adobe Photoshop. These programs, however, were still very clunky and primitive. The advantage that Flash had over programs such as this is that it was vector based as opposed to being bitmap based. In simple terms, this means that the images within the program would be made up of lines and curves which were not only easier for a computer to process, but also meant that the images could be scaled up or down without any loss in picture quality. The bitmap images of Photoshop, on the other hand, were comprised of pixels, which are tiny little squares clustered together to create the one image. When used for streaming animations across the web, these bitmap images would not display smoothly, as the processing of the pixels was a taxing task for the computers of that time.

Future Splash was bought by Macromedia in 1996 and renamed Flash version 1. The program has been further developed over the past nine years and is now the number one program used to create web animations. Traditional animation studios are also beginning to recognise Flash as a tool to aid in the production of film and television projects.

The beauty of Flash is that it can be used in the studio setting by a large team of animators and production staff to produce animation for television broadcast, or it can be used in the home environment for the production of small animations for the web. All that is necessary is a decent computer system, an understanding of animation and a vivid imagination!

The Flash production pipeline

There is no definitive pipeline set up for Flash production as it is still evolving as a tool for large-scale production. However, the following is a basic overview of how a larger size Flash project can be made.

Development and scriptwriting

Development and scriptwriting will be no different to the processes used in 2D and 3D production. The project must be evaluated, planned and budgeted for and a team of professionals must be put together for the production process. A script must be written which conforms to the production specifications and will go through the same revision processes as any script written for broadcast. It is important to note that Flash production can cut the budget and labour needs by as much as 40 per cent as compared with traditional animation. This figure, of course, will vary greatly depending on the style of animation to be produced.

The development phase for small, 'at home' projects may be as simple as an idea which never makes its way into any formalised document but remains in the creator's head. A script may not even be necessary for such a project.

Design

The design phase can be accomplished in one of two ways, depending on the preference of the design staff and the productions needs. Design can be done on paper, in the traditional way, by experimenting with and revising the designs until a paper version is locked off. The designs can then be scanned into Flash for the production of digital models sheets. Turnarounds, comparison sizes, expressions and lip shapes can all be created within the program itself. Alternatively, the models can be created entirely inside Flash with the use of a drawing tablet.

There are reasons to justify each method. Of course, it goes without saying that creating the models directly in Flash saves a huge amount of time and paper. However, some artists are not comfortable using a tablet to draw, and at the end

of the day it is always better to have well-constructed and interesting models than to push an artist to use a method which may not get the desired results. The design style will also be another influential factor in the decision to use paper or the drawing tablet. Realistic design styles tend to be better served with hand drawings, while a more loosely created cartoon style will work well if it is created wholly in Flash.

Once the design is complete the model sheets can be printed out and bound as hard copies, or better yet, they can be left as digital model sheets in a centralised place on the computer network for easy reference. An experienced colour stylist can then add colour to each model.

As with traditional animation, the voice recording can take place once the script has been locked off and the main designs have been approved.

Storyboards

Storyboards can be drawn in the traditional way, or they can be created directly in Flash with the use of an overlay template to replicate the traditional storyboard page set-up. If the storyboard panels are to double as layouts, then it is often better to hand draw a clean storyboard and scan the panels into Flash. The hand-drawn pages would first need to be scanned and vectorised in a program like Adobe Streamline and each panel should be cropped and saved with a logical file name.

Animatics

The digitised storyboard will be edited together with the sound file of the voice recording in the traditional way. However, animatics created in Flash can be a lot more dynamic than those created for 2D animation as the program allows for simple animation to be incorporated. Things like walk cycles, special effects and expressions can all be added to the animatic to enhance its effectiveness in timing out the story and guiding the animators.

The layout process

The layout phase can be evaluated in the same way as for traditional animation, and similarly a workbook can also be produced. The only difference here is that the workbook can be created entirely in Flash.

The layouts themselves can be done in one of two ways. The simplest method is to use the finished storyboard panels as a layout guide and from that build scenes based on the information given in the board. Alternatively, the animatic

process can be expanded to include all key posing and the animators can use this as their layout guide.

Of course, there is also nothing to stop a studio creating layouts wholly or partially on paper and scanning them into Flash.

Exposure sheets

A variation on the traditional exposure sheet, or x-sheet, can be created on the Flash timeline with the use of markers. The audio track will be imported into the timeline and by moving up and down the track an animator can add in markers for fluctuations in the voice track and accents in the music, voice or special effects. These markers will indicate to the animator the key timing issues within a scene. Of course, the traditional method of timing on to x-sheets can be used as well and is often preferable for larger size productions.

Asset management

One of the key roles in the production of computer-based animation is keeping track of all of the assets. Such assets would include things like the scanned storyboards, animatic files, audio files, digital model pack, layout files, lip-sync files, colour models and animation files. In larger productions there will be a person dedicated to this particular job. It is their responsibility to set parameters and naming conventions, and account for, manage and make accessible all assets as they are created.

Animation

Animation in Flash can be done in varying degrees. Key animation can be hand drawn and scanned into Flash for in-betweening. Both the key animation and the in-betweening can be done entirely by hand, scanned into Flash, painted and then tweaked in Flash by the animation department.

The cheapest way, however, is to animate completely in Flash. This animation process will be broken down in much the same way as the 3D method, with the director briefing the animators before they begin work on a set-up or rough pass of animation. This rough version will include all of the key posing and will need to be checked and approved by the director before the next stage of animation can begin. In this next stage, the animator will add all of the in-between drawings and expressions. Lip-sync is also added at this stage, using pre-designed mouth shapes which are dropped into the timeline at the appropriate place. Once this

pass has been approved, the animator may be required to go back and add in any required special effects to their scene.

Post-production—broadcast

Before the finished scenes can be exported as a movie file (such as QuickTime) the animator will need to add an identification board (or slate) at the head and tail of each scene. The files can be put down to tape, or imported directly into an editing system such as Avid or Final Cut Pro. From this point on, the post-production process will be identical to that which has been described in chapter eleven. It is important to remember that if the Flash project is to be distributed as a film or television property, the correct aspect ratios and title and action safe areas must be adhered to, both in the production and rendering phases.

Post-production—streaming animation

If the project is destined to be shown on the Internet the sound and picture editing can begin to take place while the animatic is being made and can be built upon as the production advances. Either way, the post-production can be handled in the flash program if the project is simple and does not require huge amounts of sound effect lay-up. The finished file can then be optimised to the smallest possible file size and output as an SWF (Shockwave for Flash) and uploaded to the host site for viewing.

Producing stop motion animation

Stop motion animation is the father of all animation styles and as such is one of the purest forms of animation in existence. Stop motion is a form of animation which is created by capturing or photographing an image one frame at a time. The image will be altered every few frames or so, and when the film is played back at the correct speed, the illusion of fluid movement is achieved.

The industry's need for low cost, time-effective solutions has seen this genre slide somewhat into the background when it comes to mainstream productions, although it remains popular in advertising and short pieces. Tim Burton's *The Nightmare Before Christmas* is one of a few obvious exceptions. Much of the work previously done as stop motion for film effects has been taken over by 3D packages. However, the drop in price of technical equipment, particularly digital video cameras, has seen a renewed interest in home-made movies.

Below is a quick overview of the basic production process, although the pipeline will vary greatly depending on the style of project and final format.

Script and storyboard

As with all projects, the stop motion production will need to start with an idea that is developed into a script. In smaller experimental pieces without dialogue a script may not be produced at all. However, larger productions will need a script to be written in order to structure the show and provide dialogue for a recording session. Once a script has been locked off, the character and set design can begin. A storyboard can then be produced as either a detailed 2D style storyboard (if the production is lengthy) or as a series of rough drawings mapping out the basic character moves and camera angles (for small scale productions).

Model production

Stop motion can be produced using a variety of different models. Characters, sets and props can be made out of clay, Plasticine or wood. Puppets or marionettes are also a popular choice. The models need to be created to the specific needs of the production with regard to the type of movement and interaction they are capable of. All models will need to be tested to ensure that they move correctly. This should be done as actual stop motion tests before the beginning of the animation phase in order to allow time for any readjustments.

Lip-sync and timing

If lip-sync is required the voice track can be broken down and an animator can assign lip-sync markers to guide the stop motion animator. Regardless of the size of the project, some degree of lip-sync will need to be worked out ahead of time if the project contains dialogue.

A timing director can also be used to time out the actual animation before it goes into production. This is important if the project is longer than 15 minutes or so, as it will save a significant amount of time during the actual animation process if the animator has a 'road map' to follow. On larger scale productions an animatic can be produced either from the storyboard panels or within a 3D software package. If the project is smaller, the animator may elect to time the movement on the fly, as the actual animation is done.

Animation

Stop motion can be produced by connecting a video camera into a computer and interfacing it with a program such as Adobe Premiere. Still images can then be shot frame-by-frame and captured into Premiere for assembly. Before the animation stage can begin the workspace needs to be set up. Central to the workspace is the area on which the animation is to take place. This space needs to be set at a comfortable height in order to make access easy during the long hours, days and weeks of shooting. Having to constantly bend down to adjust models will take its toll on the most agile of people! Next, the camera and lighting need to be set up. The placement of these objects is important as they will need to be locked off in order to maintain continuity in light and camera position throughout the shot. This process needs to be repeated with every new camera angle. Higher budget productions will make use of motion control technology, which allows for the camera to be taken off its tripod and moved across the staging area with frame-by-frame accuracy. This is computer controlled and can be stopped and started as necessary in order to allow time for model repositioning.

The animation itself will almost always be shot on two's—that is two frames for every position change. The animation is achieved by repositioning the models slightly every second frame and with programs like Premiere it is easy to preview a sequence of shots and go back and readjust and reshoot if necessary. As a rough guide, an experienced animator can shoot about 30 seconds of stop motion (one character only) in a day.

Post-production

The finished scenes can be edited in the package they were captured in (if the package is capable of editing) or they can be transferred into a separate editing package. Larger productions will follow the same post-production model as described in chapter eleven. Smaller projects may be edited in Premiere or another similar package and output as a QuickTime movie or DVD file.

Producing 3D streaming Internet productions

Brilliant Digital Entertainment has been a trailblazer in the production of 3D multipath movies, using their proprietary toolset, B3D Studio. B3D Studio is a device for creating and delivering streaming media content for the Internet and

allows for 3D animation to be created in mainstream software packages such as 3D Studio Max and Maya. The animations are then imported into B3D Studio and edited, compressed and delivered. To date, B3D Studio has been primarily used to create multipath movies and webisodes. A multipath movie is a form of interactive storytelling for the Internet, CD or DVD. This particular style of movie allows the viewer to make choices throughout the show that will decide the progression and eventual outcome of the story. A webisode is a serialised version of a multipath movie for Internet delivery. Webisodes are usually short in duration (five to seven minutes long) and are delivered in a compressed file format that should be no greater than 2 MB in order to allow for easy downloading.

The applications for B3D Studio are not limited to these two formats. Other major markets for this software are:

- corporate presentations
- corporate interactive training
- educational purposes
- product presentation
- online computer gaming
- banner advertising
- medical presentations
- music projects with e-commerce elements

The delayed development of broadband had a major role in slowing down the Internet streaming revolution. In the mid 1990s many companies ventured into this arena, but sooner or later the majority of them terminated their projects or branches dedicated to this and reorientated themselves into other, more lucrative markets. This was simply a case of the ideas being ahead of the technology. When the technology didn't advance as quickly as had been anticipated many companies had no option but to abandon their ideas for a while. As broadband has become available to a wider group of users, interest has again increased in streaming content for the web.

Apart from B3D Studio, there are some other major 3D real-time software packages on the market:

- Pulse—www.pulse3d.com
- Wild Tangent—www.wildtangent.com
- Viewpoint—www.viewpoint.com

The multipath pipeline

Multipath production is a complex process. It has all the organisational characteristics of any big production and typical production protocol must be respected in order to craft a product of high quality. The pipeline set out below lists the major steps needed to produce a multipath movie or webisode. Particular emphasis is given to the scriptwriting and post-production processes, which differ enormously from that of regular animation production.

Interactive scriptwriting

Interactive scriptwriting (storytelling) is new and exciting. It's also challenging because not only does the writer have to produce a good script—no easy feat—but it must also be interactively compelling. Interactivity can be narrative or non-narrative. Narrative interactivity is positioned and designed to directly affect the storytelling. Non-narrative interactivity allows the viewer to press a key and create an effect that does not change the story but rather adds to the experience.

Writing for the Internet also requires a totally different perspective than is needed to write for film or television, due to the technological challenges and advantages that real-time 3D playback offers. Lighting effects on 3D models look great. So do special effects, and these are easily created. On the other hand, scripting a lot of action will be costly in terms of file size and download time, so it's probably wise to keep that in mind and concentrate on story and character development and special effects. Music works brilliantly, as does comedy, so including these elements is a great idea. These are all things that the interactive scriptwriter needs to be aware of when constructing their script. In truth, there is always a way around the technology and interactive scriptwriting, like all writing, is only limited by the imagination.

The length of the average interactive script is about three times that of linear or traditional scripts (of course, this also means the production time is trebled). The script for a half-hour interactive episode will total approximately 90–100 pages. This includes all of the narrative and non-narrative (secondary) interactivity. A 90-page script in 12-point Courier type will contain about 90 scenes. A very rough rule of thumb is that one page of script will translate to one minute of screen time.

PARALLEL SCENES

A parallel scene is one where the viewer's focus is shifted to a different character or perspective or story plot point dependent on the path taken. Imagine a storyline with two different paths. The story's heroine is holding a magical jewel with

supernatural powers in the first path. She moves through the second path without the jewel. On each path she encounters an evil god, but the interaction with this character is going to be different for each path, depending on whether she has the jewel. This is an example of different, yet parallel scenes within the narrative.

CONDITIONAL SCENES

These are a necessary evil. They don't add to the interactivity but are dictated by the story. In other words, they are scenes that give characters information, thus altering their course of action. For example, if a character is told that her new love will die if she sends her army into battle, then this piece of information will dictate her actions. Similarly, if a character doesn't have the necessary information regarding an enemy's weapons, then he won't know how to defeat them. These are the facts that the characters need in order to determine the story. There can be no interactive swapping of paths unless there is a bridging scene where the character learns the information that has already been established on the previous path. The directive is that, where possible, conditional scenes should be minimised. However, it is understood that there are times where conditional scenes simply cannot be avoided.

ENDINGS

A good interactive production should have at least three different endings, although four is preferable and five is great. Actually, the more alternate endings the better, although production time and costs will often limit this. Of course, movies with one ending are easier to produce. Therefore the interactivity is limited to viewer choices that converge to one point at the end of the movie.

SCENE NUMBERING

Each new scene must have a different number and/or letter. For instance, scene 5A can lead to 5B or 5C. Even if 5C is a continuation of 5A it should be given a new letter. Usually, in linear scripts, the start of each new scene is marked by a change in time and/or place. In interactive scripts, due to the nature of computer programming, it's useful to divide scenes into mini-scenes or sub-scenes. Each sub-scene is given its own title in B3D Studio's scripting module.

CHARACTER AND LOCATION NAMES

For both interactive and non-interactive scripts, it's imperative that character and location names are consistent. If a character is initially called 'Scientist' it's important to keep that name whenever the character appears in the script. It becomes confusing if the character is referred to by another name (a surname, for instance) later on

in the script. The same applies for locations. If a place is called 'the light cave' then this title must be used throughout the entire script.

COMPELLING INTERACTIVITY

It's vital that the interactive choices posed to the viewer are compelling, otherwise it is a waste of time to create an interactive piece in the first place. This means that when the viewer reaches an interactive branch in the story, the stakes must be high, or in other words, the choice made needs to have a substantial effect on the story. An example of a good interactive choice is: Should the hero chase his enemy in order to save his city from possible destruction or should he save the people hanging from the destroyed bridge first? The element that makes this a good interactive point is the fact that both options are important. The viewer must decide for the hero which path to follow and there will be consequences to each decision. Once the choice is made then the consequences will affect the story in different and exciting ways. An example of poor interactivity would be something like: Does the hero fight his enemy or does he decide to have lunch first? This might work for comedy, but will detract from the tone of the story in any dramatic product.

Project set-up

Once the script has been locked off, the technical director can begin setting the project up in B3D Studio. This would include the creation of all of the necessary scene files, as well as programming the interactivity into the project. The interactivity will then need to be checked against the script and flow chart to ensure that all scenes follow on from one another as designed.

Design

Using the concept and the script as a basis, conceptual design drawings of the characters, props and sets are developed and produced. This is the stage where the overall feel and look (style and colour) of the piece is developed and established.

Once the designs are approved, a detailed study of each prop, set and character must be made. The end result of this study is the classic model sheet. Producing animation is not like shooting live action, where there is a certain amount of freedom to, for example, capitalise on points of interest in a location, or to freely appropriate costumes from the wardrobe department. Every single last prop, set or character (every visual element within the script) has to be designed on paper so it can later be built and textured in the computer.

Storyboard

From the script, the director produces a shooting script that outlines and elaborates on all the required shots and edits. This serves as the basis of the storyboard. The storyboard artist then uses the elements contained in the shooting script and the model sheets to create the storyboard. The finished storyboards are subject to client approval.

Modelling and texturing

When the storyboarding is underway, the 3D modelling can begin as well. This is the process of creating the 3D computer versions of the entire cast, props and sets based on the model sheets. Each visual element in the script requires a separate model to be made. For streaming media projects special attention needs to be given to the polygon size of the models. Because this project is to be streamed in real-time, the model sizes must be low in order to accommodate acceptable frame rates and low download sizes. When the basic models have been completed they can be moved into the next stage of production, which is the skinning and rigging process. Lip-sync and gesture poses for the character models will also be made at this time. The models can then be textured, again paying attention to the number of maps used in an effort to keep the file size down.

Recording and sound

The dialogue can be recorded as soon as the script has been locked off and the voice actors have been cast. Once the dialogue has been recorded it is digitised into the system and timed by the director in preparation for the animation stage. The director will do this by laying up the sound and spacing it out in B3D Studio. Depending on the type of project, procedures for the sound preparation stage can vary. If the project is a music webisode, a track of sync sound will need to be produced. This will act as a guide soundtrack for the lip-sync.

Animation

Motion capture is commonly used in multipath projects, where deadlines are often very tight. The show is cast, the scenes are rehearsed and captured and then cleaned up, ready for insertion into the animation scenes. The animation process will go through the same stages as described in chapter ten. Effects and lighting will be added once the director has locked off all of the animation.

Lip-sync

The lip-sync function is partly automated and utilises sound sync files by morphing between a number of different character heads. Each scene is opened up in B3D Studio and the dialogue is phonetically typed into the lip-sync box. This generates the sync by providing markers that trigger the different heads, thus creating the illusion that the character is talking.

3D post-production for multipath movies

The real difference in multipath movie production, apart from the script development and model sizes, is evident during the post-production stage, where the protocol for interactive productions is similar to that of the gaming industry. Once the animation has been completed and signed off by the director, a B3D editor will go through the entire show and tighten up the timing and effects. This process is nowhere near as lengthy as a standard picture edit as the scenes have been pre-edited on the fly by the director. The scenes can be rendered out individually and placed on to tape for the purpose of sound post-production. The sound post-production will be carried out in exactly the same way as described in chapter eleven. The only difference is that once the sound is complete, the final mix material will be provided as individual scenes so they can be inserted back into B3D Studio.

While the sound post-production is being undertaken the technical director will begin preparing the project for its ultimate web delivery. The first process that needs to take place is the tagging of all elements.

Tagging

Tagging is the process used to make a project viewable on as many computers as possible. The aim is to 'mark' what would be visible or invisible on different computers, depending on the individual user's computer configuration. Basically what this does is cut out some of the bells and whistles for those users on lower-end or slower machines. So, for example, a forest scene may be tagged to only show a few trees on a lower quality machine, while on a high-end machine a multitude of trees will be visible. This cuts down on the screen elements for lower-end machines, saving on load rates and allowing lower-end users to view the product at an acceptable frame rate.

Overdraw factor

The overdraw factor is a term used to describe the increase in file size due to different levels within the scene being in front of each other. For example, if a scene contains a fence, a row of trees, a house and then a back fence, there are already four levels of models, even if they are built within the one set. The higher the overdraw factor the bigger the scene file becomes. A good part of the tagging and optimisation process is dedicated to reducing this overdraw factor.

Optimising

Optimising goes hand in hand with tagging and it is yet another way of assuring the playability of real-time Internet streaming projects. During this procedure all of the models are optimised to a minimum number of polygons and all of the textures are reduced in file size without loosing the 'look' of the project. All animation 'leaks' (extra parts in front and behind the used parts of animation) are also removed.

Localisation

Localisation is the preparation of the project for release to different countries and cultures. It involves the translation of the dialogue, recording in foreign languages and the translation and replacement of any titles or screen directions that contain English text. Once this is done, the project is rebuilt in each of the different languages and a QA (quality assurance) check is done. It is essential that the QA checker is fluent in the relevant foreign language.

Building the project

When the scenes are ready, the technical director will build the project in B3D Studio. This is the process of combining all of the elements to become a single, playable file. These elements include the character models, sets, props, lip-sync, sound, interactivity, fades, lighting and special effects. The build is then checked by the director and production team before being passed on to the quality assurance team for technical checking. Any corrections made to the project will require further builds to be made.

QA procedures

Quality assurance is the stage that checks and verifies the technical quality of the show. The QA procedure basically involves checking that all of the elements are in place. It is almost a cross between the final reshoot stage and the technical

checking phase in 2D animation production. With projects that are not rendered, QA has to be repeated until all the elements are approved. Because of the way the interactive show is structured, each round of fix ups, or alterations, will require the project to be completely rebuilt. This often means that things that were okay in the first build may not be in subsequent builds because of alterations made to the libraries. QA is an extremely tedious and time-consuming process.

Every tester must make a QA report log and submit it to the production manager or QA manager (if this position exists separately), who then takes care of the fix-ups required and organises a new build and QA test.

Bug reports and software development

Many companies that work within the 3D Internet field are simultaneously software developers and animation production houses. This means that the production department usually works using Beta versions of the software. A Beta version is an 'unfinished' release of software that is still in development. The programming department will pass on the latest Beta versions to the production arm, not only to use to create their projects but also ultimately for them to test the software in a production environment. This means that production becomes the QA department for the software development—an advantage for the programmers as they are able to test their product and receive immediate feedback. Unfortunately, it is a disadvantage for the production department as it slows down the entire process and introduces many technical obstacles. There is also the extra time that needs to be factored into production for things like bug reporting and fixes. Every software problem encountered by production needs to be reported to the software development department and usually the technical director of the show will spend a great deal of their time consulting with the programming team about these issues.

Publishing

When the director, producer, buyer and technical department are happy with the project, it can 'go live'. This means that the project can be placed on a server where it will be available to public users for downloading.

Of course, before this can happen it needs to be tested on an internal server using a variety of Internet browsers to make sure that it can be retrieved (downloaded) and played properly.

Projects can be syndicated to many different web portals, using either pop-up syndication or full hosting syndication. Pop-up syndication links a second party web portal to the content that resides on the project producer's server and displays

it through a separate pop-up window. For this type of hosting the second party would need to be supplied with their own channel (link) to the content as well as a customised logo or graphic for them to display on their site. This means they do not have to create any new elements for their site, they simply need to add the new icon and then page a code supplied by the project producer (an automated process) when the project needs to be accessed.

Full hosting syndication is where the full content of the show is delivered for complete hosting on the second party site. Full hosting partners (like Warner Bros. Online or VH1) build their own web page with graphics supplied by the producing studio (to their specifications). The content would play off their website, within the customised projector. The projector's skin and shape could be changed according to the needs of a particular web portal.

The theory behind financing Internet content was to make a profit from the advertising that runs in an allocated space within the projector's skin while the 3D animation streams. If the second party portal co-financed the project, then the advertising revenue would be split between the portal company and the animation studio. If the portal contributed only a minor amount of the initial finance for the project, the advertising revenue would usually all go to the production company, with the benefit to the portal being free content.

Similarities and differences between interactive 3D streaming and video games

The only difference between a multipath movie and a game is the level of complexity of the engine. All other production elements are the same, or very similar.

3D Studio Max can be used to build low-polygon characters, sets and props and motion capture files can be added to gain realistic movement, mirroring the processes used in the computer gaming industry. Interactivity, hot spots, collecting objects, even mood control features, are elements that both genres share. They even have the endless QA and bug-fixing processes in common!

Glossary

above the line costs (also called creative expenses) expenses related to personnel retained on contract. This includes directors, producers and writers as well as talent fees, royalties and licensing fees.

ADR revoicing or automated dialogue replacement is the process of re-recording and replacing voice tracks once an initial edit has been completed.

alpha channel an extra image channel that is kept with an image file and stores information regarding the transparency elements of an image for the purpose of compositing.

animated film any film where each frame is produced individually (or frame-by-frame) and then projected at a speed of 16 frames per second or faster in order to give the illusion of movement.

animatic a digital reel containing the storyboard panels cut together with basic camera movements and the recorded dialogue. The animatic is used to time the project as well as check continuity and story development.

animation from the Latin word *animate*, which means 'to bring life to'.

animation checking the process of checking the completed animation for errors and omissions.

animation director person who oversees all animation-specific tasks that are connected with the directing position in the instance where the appointed series director does not come from an animation background. These tasks would include working with the director on storyboards, layouts, designs and colour styling.

animation timing the act of timing each scene of the storyboard and dialogue track.

answer print the first film print made by a laboratory that combines both the sound and picture masters. It is a test print, and the producer must approve this print before duplicates can be made for distribution.

art director sometimes called the visual development director, this person is in charge of the artistic style of the project. They are also responsible for supervising the design and background departments.

aspect ratio refers to the width to height ratio of the screen. The aspect ratio for standard television is 4x3 or 1.33:1, meaning simply that the width of the screen is 1.33 times wider than its height. This is also the most common aspect ratio for computer screens. The aspect ratio for standard widescreen is 16x9 or 1.77:1.

'as recorded' script a version of the script made after the recording session, which includes all additions and alterations made to the dialogue by the director and actors while they were recording.

assembly the act of putting together all of the scenes in sequential order and marrying them to the soundtrack in an editing system.

assistant producer the direct assistant to the producer.

associate producer an experienced production manager who may share some of the line producer's duties.

atmosphere a reference to the time of day and weather conditions of a scene.

atmospheric sounds (sometimes called background sounds) sounds that are placed in the soundtrack to represent the common noises heard on location. Traffic, birds chirping, balls bouncing and generic background chatter would all be examples of this.

automated lip-sync used throughout 3D production, this is the process whereby dialogue lines are phonetically typed into a lip-sync package and linked to their respective library mouth movements in order to produce the effect of a character talking.

automatic scanners scanning machines with a built-in batch feeding mechanism, which allows a group of pages to be placed on a batch-feeding tray. The scanner will then drag each piece of paper on to the scanning bed one at a time.

AVI Audio Video Interleaved is a Windows native file format for producing compressed audio and video files.

back credits the credits which appear at the end of the program, which will include all credits for crew members.

background list a list that will include all of the backgrounds to be used in the show.

back-up a copy of all computer files created and stored on a separate media device. Back-ups of all computer files must be made in order to safeguard the

digital material should the originals become corrupted or accidentally deleted, or if the hosting media (computer drive) fails.

below the line costs the incidental costs of the project, such as crew members and equipment.

Beta software an unfinished release of software that is still in development. Beta software is always released to a small circle of users for the purpose of testing and bug reporting.

Betacam SP an analogue half-inch videotape.

bitmaps these are made up of tiny pixels and are generally used for photo-realistic pictures. Photoshop is a bitmap-based graphics package.

blocking the act of setting up the basic character positions of a scene.

broadcast resolution refers to the resolution of material being high enough to be accepted by broadcasters for film or television viewing. The exact specifications for this will vary slightly from country to country and from broadcaster to broadcaster.

budget a financial construction of the project, based on estimates of the time, complexity and the human resources needed to complete it.

budget, detailed a representation of every single cost associated with producing a project.

budget, external created for the benefit of the project investors. This budget will always reflect the highest possible forecast for all costs.

budget, internal reflects the true estimate of all costs a studio would expect to pay under normal circumstances.

budget, summary a representation of the budget showing only the major categories of the production and their associated costs.

bug reporting refers to the reporting of every problem encountered while using Beta software. Reports always go to the programming team, who will work to fix the bugs.

captions subtitles, or translations of the spoken word into text, which permit deaf and hard-of-hearing people to read what they cannot hear. There are two kinds of captioning—open and closed.

cast list a list of all of the speaking characters and the actors who provided their voices.

casting agent organises talent-casting sessions for the initial character voice selection.

cels in traditional 2D animation, cels are clear plastic sheets upon which the animation and overlays or underlays are painted. Cels can be stacked on top

of one another for each scene, but there is a limit as too many cels will cause the final image to look slightly discoloured.

CGI animation animation created by computer-generated images.

character list a list which includes every character that appears in the script.

character, set and prop designers the creative executors of the director's and art director's ideas. They work with the directors to design all of the props, sets and characters.

check print a film print made from a copy of the edited negative. It is used to check the colour quality of the film.

chinagraph pencil a white wax-like pencil used to mark the film stock during the editing process.

classification codes attached to everything that screens on television and in movie theatres. They are there to advise the consumer of the nature and age suitability of the show, using general age groups as a guide.

clay animation a form of stop motion animation created with the use of figures made out of Plasticine, clay or other flexible materials which is shot frame by frame.

clean-up the process of removing unnecessary pencil marks, tidying up line work and making sure drawings match character models. Designs, storyboards, model sheets and animation will all undergo this procedure to some degree or another.

click track an audio track that contains a metronome beat to simulate the tempo of a piece of music that is yet to be fully written. This provides a guide track for animators to create any necessary movement in time with the music, which will be dropped into the track during sound post-production.

clone an exact digital copy from an original digital source. For example, a digital Betacam copy of a master digital Betacam tape will be called a clone, as opposed to a dub or copy, as the act of replicating digital material does not result in any loss of quality. Therefore, such a copy would be an exact replication in every way.

closed captions the process whereby captions are converted to electronic codes and sent out with the regular television signal, specifically on line 21, a portion of the picture not normally seen.

colour styling the process of styling the colour pallets for all characters, props and special effects.

colour stylist the artist charged with styling the colour themes for all models.

composite elements compiled during the editing phase, these are the generic elements of the program and include things like opening and closing boards, titles, credits and textless versions of all boards and credits.

compositing the act of marrying all elements in 3D production and applying camera moves. Further compositing can be done to completed scenes in both 2D and 3D by applying filters and effects.

compositing checkers crew members charged with the duty of checking the accuracy and quality of all composite scenes.

compositors artists charged with the duty of compositing all scenes. They can specialise in camera compositing, or in effects compositing.

conceptual design development this process involves the development of the artistic look and feel of the show. It encompasses main character and set design and will endeavour to set the tone for the show during the development stage.

conditional scenes scenes used as a tool in interactive scripts to give characters story information in order to alter their course of action.

continuity the process of ensuring that all scenes contain the same appropriate information with regard to character positions, wardrobe and props when cutting from one scene to another.

contracts contracts are drawn up when employing freelance staff and will detail the type of work they will perform, their remuneration and working conditions, and will include confidentiality clauses for the protection of the project.

contract, creative a contract issued to a crew member who is producing creative elements for the project. This type of contract will stipulate that all artwork produced is the property of the contracting studio.

contract, non-creative a standard contract issued to clerical staff or other crew members who are not involved in the creative aspects of production.

co-productions any production that is undertaken by more than one company, with all parties contributing creative services.

copyright legal protection granted to all original creations ensuring that they cannot be copied without recognising the creator.

copyright clearance specialist a person or company who is responsible for checking all script and storyboard properties against existing registered copyrights to make sure that the material is not in breach of any brand or trademark.

core production team (or nucleus team) a small group of personnel who are absolutely essential to the life of the project. It would include the director, producer, writers, designer, technical personnel, accounting personnel and admin personnel.

credits a list appearing at the opening and closing of the show, detailing the contributing artists, companies and personnel.

crew plan a breakdown of the staff members needed to complete a project. The crew plan should include all assumptions for crew positions, their level of experience and projected working time.

cut-out animation also referred to as collage, this is the animation of flat elements (characters, props and backgrounds) that have been cut out of photographs, magazines, paper, cardboard or fabric.

Cyberscan a 3D laser-based non-contact scanner where an object can be scanned and automatically converted into a 3D item.

DA-88 audiotape an audiotape with eight tracks available for recording. The tape itself is a hi-8mm metal particle tape.

DAT (digital audio tape) a magnetic tape used to record audio files; also used to back-up computer files.

detailer a 3D texturing software package.

diagonal pan a camera move along a background either from the top left-hand corner to the bottom right-hand corner or vice versa.

digital Betacam tape a digital half-inch metal tape format, able to record four channels of audio as well as picture and time code.

digital camera compositing the process of marrying 2D animation and backgrounds and applying the necessary camera movements. This is done using the information provided on the x-sheets.

digital department encompasses the scanning, digital ink and paint and compositing departments in 2D animation production.

digital manager manages the flow of work through the digital department.

digital paint checkers crew members charged with the duty of checking each and every painted level to ensure consistency and accuracy.

digital painters crew members charged with the duty of painting each and every animation level. This is done with the aid of an animation computer package.

digital painting the process of painting each and every 2D animation cel once it has been scanned into a computer.

digitise the process of converting analogue signals from a tape into a digital format that is compressed and stored on a computer disk.

direct-on-film animation animation made by painting, etching or otherwise altering raw film stock.

director responsible for the overall creative development of the project, from collaboration with writers, through to guiding designers and storyboard artists, voice casting and selection, composer briefings and colour styling approvals.

They are also responsible for approving the layout and animation, calling retakes, approving music and the final mix; ultimately they are the person responsible for signing off on the final project.

DLT (digital linear tape) a device used for archiving and backing up digital media.

drawn animation animation consisting of images drawn on cel, paper or a similar medium.

drop shadows the shadows characters cast on the ground underneath them or on the objects around them.

dubbing the act of making duplicates of a master tape.

DVD (digital versatile disk) a CD-sized disk capable of storing several gigabytes of video and sound images.

editing the assembly and cutting of the show. The show must be cut to length and scenes may be shortened or removed in order to make sure the story is paced properly.

EDL (edit decision list) a list of the time code designations for each and every cut in the edited show. It will also contain shot duration, transition and freeze frame effects and tape source information.

employee contracts a binding legal agreement between a producing studio and an employee, setting forth the conditions and length of employment.

executive producer the highest-ranking producer, this person is always responsible for selling a project and may also be heavily involved in the production process.

exercise fee represents a small percentage of the total production budget, which is paid to an original concept owner if a show is green lit to move from development into production. A percentage of this exercise fee is paid up front as the option price before a buyer or studio takes the concept into any form of development.

exposure sheet (x-sheet) produced by the timing director and animators, details the timing, character, dialogue and camera information for each scene.

feature film a theatrical film which is longer than 60 minutes.

field the area included in the camera's vision.

field guide a grid that shows the size and position of the camera's field of vision.

film processing the procedure where exposed film is developed and treated to produce a negative or positive image.

Final Cut Pro a non-linear editing software package created by Apple computers.

final master the version that is made by marrying the online pictures with the sound master. It is the final version of the show used for dubbing and delivery.

final mix the stage where all of the sound elements—dialogue, sound effects, foley and music—are placed together. Their levels are adjusted and combined according to the dictates of each scene, as well as any directorial instruction.

fine cut a cut of the program which has been edited down to the correct length and represents the final version of the edit.

Flash see Macromedia Flash.

flat bed scanner a scanning device with a flat sheet of glass on to which the image is placed. The image is then held stationary while the scanning sensors pass over and under it.

foley (in animation) used to mark sounds made by body movements. This includes things like a character's walk, the sound that dress fabric makes when a character bends, or the sound a character will produce when sitting down on a leather sofa.

forward kinematics a 3D animation technique whereby every part of a model needs to be moved manually along a logical chain in order to create motion.

frame a single picture image of film or videotape.

frames per second the number of frames an imaging device (computer, videotape, camera) can consecutively play within a second of time.

freelance employee a crew member employed on a project-by-project basis. They may be paid in relation to the number of hours worked, or the number of elements (storyboards, designs) produced.

front credits the credits which appear at the start of the program, and include things like the production company and investor names, as well as the director and producer credits.

full hosting syndication where a second party site has full rights to host a show on their own website. The content is played directly from their website within a customised projector.

green light used to signify that a project has been approved for production. When a project is approved for production it means that the initial agreements have been signed and the finances necessary to produce it are in place.

head animator the person responsible for supervising and checking all of the animation stages; used in all forms of animation production.

head of background painting the person responsible for supervising the background painting team and ensuring the quality of all work produced by the background paint department.

head of camera compositing the person responsible for supervising the compositing team and ensuring the quality of all work produced by the compositing department.

head modeller the person responsible for supervising and checking all of the 3D modelling stages, specific to 3D animation productions.

head texture artist the person responsible for supervising and checking all of the 3D texturing stages, specific to 3D animation productions.

held cel a single cel that needs to be painted to sit on top of a background. It will begin as a static element, but as the show progresses it will at some point become part of the animation; thus it requires the ability to move. It is used when a portion of the background needs to be altered.

High Definition TV (HDTV) a television signal which is broadcast at a higher than normal resolution. The higher resolution is achieved through the use of extra lines and bandwidths.

high polygon modelling 3D models that consist of a high or unlimited number of polygons. High polygon models always have a smoother, rounder appearance than their low polygon counterparts. They are generally used for broadcast, where the quality of images must be of a high standard.

horizontal pan a camera move along a background either from left to right, or right to left.

hot Xerox the method of using heat and carbon to print images on to animation cels; used in the days before digital systems were available.

hybrid animation any project that uses two or more different animation techniques. For example, a predominantly 2D project may use special effects that were created in a 3D program, thus making it a hybrid project.

in-betweening the process of drawing all of the images that fall between the key animation drawings.

information technology (IT) specialist responsible for maintaining all computer hardware and software for the studio.

in-house production production, or the portion of a production, which is done on the premises of the parent studio.

interactive script a script written to include various forms of interactivity, such as multiple story paths.

interactivity anything that allows the user to directly interact and alter a product. Interactivity can be used in Internet serials and gaming, or in the print media.

intermediate backgrounds intermediate backgrounds will be created during the layout stage and encompass all of the backgrounds needed for each individual scene.

internegative print a film print that turns into a negative when printed from a positive print. It is used to produce opticals and titles.

interpositive print a positive film print made from a negative print. This must be done using specialised film stock.

inverse kinematics a 3D animation technique whereby the movement of a specific part of a model will initiate an equal movement along a logical chain in order to create motion.

invigilation comes from the Latin word *invigilatus,* past participle of *invigilare*, to stay awake, be watchful.

JPEG file a file format used to represent graphic images, usually photographs. JPEG is short for 'joint picture group'.

key animation key positions of a scene drawn by an experienced animator. The key drawings usually refer to the start and end poses of each action a character performs. In-betweeners will then go and fill the gaps between those key drawings in order to complete the animation for the scene.

key backgrounds the main backgrounds of a show, depicting a broad view of each location in the script. The key backgrounds will be used as reference for all of the intermediate backgrounds.

key background painters responsible for painting background keys under the instruction of the art director or director.

key layouts the major layouts of the production. They are the most complicated to complete, and they act as the template for the rest of the layouts in each particular section.

kinematics refers to motion and the factors that influence it.

layback the process of recording the final audio mix on to the master picture tape.

layout a detailed visual breakdown of each and every scene. It is created by transferring information from the storyboard, key background designs, character, prop, special effect designs and x-sheets into illustrated form. A completed layout will contain a background illustration, illustrated guides of the character positions, camera and field information and effect placement information.

layout checker person responsible for checking the continuity across all of the layouts. They also identify any new props or effects that might have been additionally created during the layout stage.

legal department a group of legal professionals dedicated to ensuring that the project is produced within all legal guidelines by creating and monitoring all contracts, union fees, credits and client agreements and dealing with all copyright and licensing issues.

leica reel created when pencil tests, model tests or motion tests are added to an animatic.

letterbox the effect produced when a widescreen image is projected or screened on a standard television, which is made for full screen or 4:3 aspect ratio. Black bars are placed at the top and bottom of the widescreen image, thus producing the letterboxed effect.

levels the number of elements used to create a scene. Each element, be it a held cel, animation cel, overlay or underlay, represents a new level.

libraries an integral part of 2D and 3D software, libraries help to keep all elements of the models, animation, backgrounds, lighting and effects in order.

licensing the act of buying the rights to produce a product or project based on an existing property for a set period of time, in return for a percentage of the profits.

lightwave 3D a software package used to create 3D models and animations.

line producer the producer primarily responsible for running the budget and schedule of a production.

line test also called a pencil test, this is the process of capturing animation drawings exactly as they are indicated on the x-sheet and producing a movie of the results. Line tests are used to check that the animation is flowing correctly before it is sent to the digital department for scanning, painting and compositing.

linear editing an editing process where by the program needs to be edited in a methodical fashion from the start of the show to the end because changes made to any part of the cut will effect everything from that point onwards.

lip-sync the mouth movements given to characters when they speak. This is achieved in 3D programs by creating separate head models for each character to represent all of the necessary mouth shapes. In 2D this is done in pencil by going through the track read of the dialogue and allocating mouth shapes where appropriate on the x-sheets.

lip-sync specialist lip-sync specialists create and insert lip-sync (mouth movement) instructions into the x-sheets.

live action refers to any piece of footage shot with actors and sets, which exist in the real world.

localisation the preparation of a project for international release. It involves the translation of the dialogue, recording in foreign languages and the translation and replacement of any English text. If necessary, the project also needs to be culturally adjusted to the particular country.

locked-off cut often referred to as being a locked-off picture, this occurs when all picture editing has been completed and the timing of the cut is not going to change.

low polygon modelling 3D models built with a low number of polygons. Low polygon models usually look a lot more angular than those built using a high number of polygons. This type of modelling is common in the gaming and web industries, where file sizes and frame rates need to be kept at an optimal level.

Macromedia Flash an animation software package allowing for Internet delivery and rendered output.

macro-organisational entity defines a type of organisational structure. Macro-organisational entities are those that encompass the highest-level structures—for example, government.

magnetic film 35mm film stock used to print the soundtrack.

magnetic motion capture system the older form of motion capture system. It works by attaching cables to an actor, which are then hooked into a data capture machine in order to plot their movement for adaptation to a 3D model.

Magpie a 2D and 3D lip-sync and animation timing software package.

main character packs these packs contain illustrations of all main characters used in a television series.

main pack a comprehensive booklet containing all main character and location designs, as well as a series overview and objective. It is used to provide all artists with a definitive guide for the show.

main props pack contains all of the recurrent props used in a television series.

main special effects pack contains all of the recurrent special effects used in a television series.

manual scanners scanning machines that require material to be scanned individually by manually placing each piece of paper on to the scanning bed one at a time.

marketing/merchandising/public relations liaison the person responsible for the publicity of the property. They advise the producer on the preparation of all the necessary publicity/promotional materials needed to sell the product.

M&E track music and effects soundtrack.

Maya a computer software program used to create high-end 3D models and animations.

mezzo-organisational entity defines a type of organisational structure. Mezzo-organisational entities are those that encompass the mid-range level structures—for example, large businesses or corporations.

micro-organisational entity defines a type of organisational structure. Micro-organisational entities are those which encompass the low-range level structures—for example, an animation production company.

mixing the process of combining all of the soundtracks together (dialogue, music and effects).

model checker the person responsible for ensuring the models are completed correctly and that all elements are intact and consistent across the show.

model mapping the process of delineating and breaking down the models into separate regions for the purpose of texture mapping.

model sheets sheets drawn up with the finished designs of all characters, props and sets. These sheets are used as reference throughout the production.

motion capture a motion capture system consists of a collection of sensors that simultaneously feed position and orientation data to a computer. By carefully mounting sensors to a human body, the human's movements can be recorded in real-time and the recorded data can be played back by channelling it to a virtual character. This type of motion tracking can be done in two ways, either optically or magnetically.

MP3 File short for MPEG audio layer 3, this is an audio compression file format.

music cue sheet a music cue sheet is a complete listing of every piece of music used for a film/television program. It indicates the music publisher, writer, style and duration of the music and is used for tracking music rights and royalties.

narrative interactivity part of the structure of an interactive script, where interactivity is positioned to directly affect the storyline.

negative a film print that shows only the negative image. The term can also be used to describe raw film stock that is made specifically for printing negative images.

non-linear editing all computer-based editing processes, which allow the editor to access all of the material randomly and to edit a piece without having to methodically move through the timeline in a linear order.

non-narrative interactivity part of the structure of an interactive script, where interactivity adds to the viewer's experience yet does not affect the story in any way.

NTSC playback system NTSC, short for National Television Standards Committee, refers to the colour television system consisting of 525 lines of information that is scanned at a rate of 30 frames per second.

offline editing the process of editing using either a copy of the original footage (for film production) or a low-resolution digital version (for non-linear editing).

online editing the assembly of the offline edit using the master footage. Compiled together using the edit decision list. This is the final step in the picture editing process, in order to prepare the show for broadcast and distribution.

open captions a transcript of the dialogue that appears on screen as each line of dialogue is delivered. Also referred to as subtitles.

optical motion capture system this particular motion capture system uses reflectors to track human movement. The reflectors are stuck independently to an actor and are filmed by infrared cameras. The advantage of this type of system over the older magnetic style is that it allows the actor full freedom of movement.

opticals film effects, titles or transitions.

optimising the exercise of globally reducing the file size of models, textures and animation in low polygon 3D projects. This is done to ensure a smoother playback for real-time Internet streaming projects.

option where a buyer or studio pays a concept creator for the rights to develop a property for a specific amount of time.

overdraw factor a term used in Internet streaming projects which describes the increase in file size due to different levels within a scene being in front of each other. The higher the overdraw factor the bigger the scene file becomes. Part of the tagging and optimisation process is dedicated to reducing this overdraw factor.

overlay (O/L) an element that is positioned above (over) the animation. Used in 2D animation.

overlay/underlay an element that is positioned both above (over) and below (under) the animation. Used in 2D animation.

overseas supervisor the person responsible for managing production in an overseas studio (where part of a production is contracted out to such a studio).

PAL playback system short for phase alternating line, PAL is a colour television system consisting of 625 lines scanned at a rate of 25 frames per second.

paper and pencil edit the editorial notes a director makes while viewing the initial rushes of a show.

parallel scenes a component of the interactive script, referring to scenes that shift the viewer's focus to a different character or storyline if they choose to branch out to an alternate path.

peg holes used in 2D animation in order to keep each drawing registered properly. They consist of three evenly spaced holes at the top of each page. These holes will fit over matching peg bars on an animation desk. Each page of animation is drawn while being held by the peg bars, to ensure continuity between each and every drawing.

performance animation see motion capture.

persistence of vision the theory used to explain the mechanism for motion perception in cinema. Described by Paul Roget in 1828 as an effect usually

attributed to the 'eye-brain combination', it occurs when images are flashed quickly in front of the eye, with the brain briefly retaining each previous image.

photogrammetry a form of software that uses scanned photographs to recreate images in the 3D environment. This style of software detects and analyses shading and line information across several samples of photographs and converts that information into a basic model.

Photoshop a cross-platform graphics-editing package created by Adobe.

pick-up lines additional dialogue recorded after the initial recording and before the start of animation. This dialogue is usually recorded by the director during the animatic phase in order to fill out any holes in the storytelling.

picture lock the act of locking off the picture edit of a program for the purpose of creating an edit decision list for the online edit. This version will include all of the retakes and will be locked for timing.

pilot a piece of animation, usually about one to three minutes in length, which is used to give a brief introduction to the characters, music, themes, premise and style of the project.

pitch bible a document that presents the story concept, analyses the targeted audience and sets forth the relevance of the project. It describes the format and length of the project and outlines the major character design and settings. It may also include some sample story outlines. This will be used initially to pitch a project, and then later revised and used as a guide for all those working on the project.

pixels the individual images, or dots, which form together to create an electronic image.

pixilation animation the process of animating live objects by photographing them one frame at a time.

polygon a small individual shape used to build 3D computer models.

pop-up syndication an Internet streaming syndication deal where material can be played from a second party portal, which is linked to the content that resides on the owner/production company's server. The material is played through a window that opens up on screen and automatically links in with the mother server.

post-production all activities that take place once the animation is finished. It encompasses the editing process, all aspects of the sound design, music composition, mastering, technical checking and dubbing.

post-production script also called an export script, this is a written summary of the episode broken down scene by scene. It contains time code reference points,

dialogue, shot descriptions, music and special effect cues for each scene and is used for international language versions.

Premiere a multi-platform non-linear editing software package by Adobe.

pre-sales the act of selling a show to a broadcaster, distributor or other buyer before a project goes into production.

producer the person who oversees the entire production process. They make sure that all requests from the buyer are taken care of, are responsible for sorting out the type of crew they will need, and for recruiting, budgeting and scheduling. They also work to control the creative assets of the project, namely the script and the style development.

production accountant the person responsible for assisting with the creation of the budget and for tracking all spending for the duration of the production.

production assistant often a direct assistant to the production manager especially when there is no production coordinator. They will be required to do most of the filing and photocopying and production running.

production coordinator the assistant to the production manager.

production manager a close co-worker of the producer. They are responsible for ensuring the smooth flow of work through the production pipeline.

production secretary handles most of the paperwork associated with the production under the directive of the main production administration arm— that is, the producer, production manager and production coordinator.

project approval when a project is approved for production it means that the initial agreements have been signed and the finances necessary to produce it are in place.

project build a web-specific term referring to the compression and consolidation of completed project files into one web-ready streaming file.

project development one of the earliest stages of production, this is the development phase that establishes the core production team and evaluates and plans the structure of the project. The script and artwork are also developed during this stage.

project pitch the process of outlining an animation concept to prospective buyers in order to sell the project.

project plan a detailed breakdown of assumptions made by the producer during the development stage. This would include things like an outline of the complexities of the project and the proposed pipeline needed to achieve the end result.

props objects that do not appear as part of a background, and which are used to enhance the storytelling.

props list a complete list of all props that appear throughout a project. This should be referenced to the page of script where the prop first appears.

publishing (Internet) the process of placing a completed web project on a server where it will be available for public users to download and view.

puppet animation a branch of stop motion; refers to the animation of puppets (or other objects) constructed of wood or other materials.

quality and assurance the stage where the technical quality of web-based, Internet streaming projects is checked and verified.

read through the act of reading through and rehearsing the script with the voice actors before entering the recording booth.

Reallusion an automated 3D lip-sync software package.

recording director the person responsible for directing the voice talent during a recording session when the director/animation director is unable to do so.

recording script a script that is specifically prepared for the director, voice actors and sound engineers to follow during the dialogue recording session.

recording technicians members of the technical crew responsible for the studio recording of all dialogue.

reference animation small scenes that are animated in order to be used as a guide for the specific animation of characters. These reference scenes are commonly used when the animation is being outsourced to a servicing studio.

reference animators responsible for producing reference animation for each project.

registration the act of aligning all separate 2D levels so that they create the correct image. This is done through the use of peg holes and registration markings (lines).

release print refers to any film print that is made with the purpose of releasing to theatres or distributors for public screening.

render wrangler the crew member charged with the duty of rendering all material and maintaining the rendering farm.

rendering the process whereby a computer will draw together all of the material of a scene and perform the necessary mathematical equations in order to create the final scene. 3D models can also be rendered in order to create an image for viewing outside the computer.

rendering farm a collection of high-powered computers dedicated to rendering large volumes of material.

repeat pan the practice of moving a camera over a background more than once in order to give the illusion of continuous movement along a greater space.

retakes also known as reshoots, these are any scenes which need to be shot again due to errors in animation, painting, compositing or any other area.

rigging the process of setting up the model skeleton to be animated using either the forward or inverse kinematics system.

rough cut the term given to the edited version of a project prior to approvals and picture lock.

scanners crew members charged with the duty of executing all scanning for a project.

scanning the process in which hand drawings are digitised into a computer and saved as files in a central project library. This is the first step in the digital production of 2D projects.

scanning checkers crew members charged with the duty of checking the accuracy of all scanned elements.

scene breakdown a scene-by-scene description of a show, which forms the basis of the script.

schedule the animation schedule is the summary of all work needed to complete the project. It is broken down into stages and services and expressed in the form of a timeline.

scratch recording a recording that takes place with 'stand in' actors or crew members before the actual actors are called in for the real recording session. This is done for the animatic production and allows the director to finetune their approach to directing the voice talent.

screenings viewing sessions of the work in progress, held in order to gain public reaction to help finetune the show.

script breakdown a table made from the script, which lists all of the major elements of the show according to the scene they appear in. This breakdown will be used to formulate the information lists for the production.

script coordinator helps organise the script properties, check the naming consistency of the characters, locations props and special effects, and the format of the script. They also help organise scripts for recordings.

script development the broad term under which the varying script stages occur. The stages included under this term are: script idea, synopsis or outline, scene breakdown, first draft, second draft, third draft, and then finally the polished script.

script drafts the different versions of the script as it evolves into a fully polished piece.

script edit the process of reviewing and altering a script before it is released for production.

script editor works with the scriptwriters to ensure the uniform quality and dialogue consistency of all scripts. They check each and every script, editing and finetuning the action and dialogue.

script plotting a session between the script producer, writer and director where a story idea is discussed and refined before the writer begins working on the script.

script polish the process of finessing a script, particularly the dialogue, after the script has been edited and before it is released for production.

script producer/supervisor oversees the script development and makes sure that all scripts, as well as the dialogue within them, are written with a consistent quality and style. They also ensure that local classification criteria is adhered to in each script.

scriptwriters the creative team of writers who construct the script.

servicing studio a studio that provides animation services in part or in full to a producing studio. Servicing studios generally only provide their services for hire, as opposed to developing and producing their own original material.

shadow pack contains details and examples regarding the casting of shadows on all characters.

shooting script a version of the final script created by the director which contains detailed information regarding shot composition and timing.

short or experimental subjects a theatrical or television film which is shorter than 30 minutes.

short feature film a theatrical film that is between 30 and 60 minutes in length.

silhouette animation the animation of cut-out silhouettes.

size comparison a chart of all the characters displayed side by side so that their true size relating to the rest of the characters can be identified.

skinning the process of creating a skin that will cover the outside of a 3D model.

slates also called identification boards, or ID boards, these are static images placed at the start and end of every scene in order to identify the scene number, frame count and studio name.

software porting the act of exporting models and animation from one software package to another.

sound design the act of adding sound effects to an audio track in order to enhance the storytelling.

sound engineer the person in charge of the technical quality of the dialogue recording.

sound master the final version of the full sound mix.

sound negative a negative magnetic film reel containing the final mix audio.

sound post-production the collective term used to describe the processes involved in creating the soundtrack for a show. This would include the ADR record, sound design, music composition, foley, mixing and mastering.

sound reading the stage in which the recorded sound is converted into a phonetically written 'transcript'. Sound reading will provide the animators with information about the exact pronunciation and timing of the dialogue in order for them to create the correct lip shape movements (lip-sync) for each of the talking characters. Also known as dialogue breakdown and track reading.

sound sheet a sheet containing a grid representing a frame (usually 25 or 30 lines, or frames per page) on to which the sound breakdown is written.

special effects (SFX) used in all forms of film-making as a means of enhancing the atmosphere and drama of a production. They can be hand-drawn or computer generated and would include such things as explosions, fire, rain, dust and light effects.

special effects list a complete list of all special effects that appear in a script, referenced to the page of script where they first appear.

special effect specialist the person responsible for the creation and implementation of all visual special effects within a project.

spotting session a session, or meeting, where the director, producer and sound department will decide on the treatment of the sound effects, foley and music for the project. The director prepares notes (cues) for briefing the sound supervisor, sound editor and foley supervisor as well as the music composer and music editor. During the spotting session a decision will be made about any necessary revoicing (ADR) as well.

steenbeck flatbed editing table used to edit film.

storyboard the translation of the script into pictures in order to plot the visual development of the story.

storyboard artists responsible for creating/drawing the storyboards under the instruction and briefing of the director.

storyboard slugging the process where the instructions for the timing of character and camera movements and the exact positioning of dialogue are written into the storyboard.

Streamline a software package created by Adobe, which allows images to be scanned into the package and then manipulated to alter the line work and colour.

subtitles text that appears on screen to represent the dialogue of a show. This can also extend to listing special effects and music, and is used for foreign

language shows where the text is translated and presented as a subtitle, and for the hearing impaired.

sweatbox sessions the US term for the process of viewing the rough and clean animation and backgrounds, as well as the special effects animation and colouring by the director.

sync during editing, this refers to the matching of picture with the soundtrack. During the animation stage, it is the term used for creating mouth shapes to match the dialogue track.

synchroniser a machine used to track read 35mm magnetic film before the rise of digital systems. This was achieved by threading the film on to one of the synchroniser's rotating wheels and moving the wheel back and forth on a frame-by-frame basis. Several reels of film can be placed on the machine at once in order to run them in sync.

tagging a 3D web/gaming specific term which refers to the process used to make a project viewable on as many computers as possible. The aim is to 'mark' what would be visible or invisible on different computers, depending on the individual user's computer configuration. This cuts out some of the bells and whistles for those users on lower platforms, or slower machines, saving on load rates and allowing lower-end users to view the product at an acceptable frame rate.

talking character list a list of all characters in the script with dialogue. It is prepared for the purpose of organising the voice recording.

tape dubbing the process of simultaneously playing a tape in a playback deck and recording on to a blank tape on a play/record deck. Professional dubs are always made in a dubbing facility set up to handle broadcast quality material.

technical check the process of confirming the technical correctness of the material (master tape) intended for broadcasting. The check is performed by experienced lab technicians, who go through the master tape to check for any defects or breaches in technical standards.

technical director the person responsible for the assured flow of all technical aspects of the project. They must evaluate the design and script expectations from a technological point, recognise all possible obstacles and limitations that could be experienced and suggest how to overcome them.

telecaption decoder a device used to display the closed caption information which is broadcast with each television show. Many television sets have built-in telecaption decoder chips.

telecine a machine that captures an image from a film print and converts it to a video format (thus converting the frame rate).

textless elements any element of the production that includes text (credits, investor logos, title boards) must have a version created without the text, leaving just the background. These elements are placed at the end of the finished master tape and are used for foreign language versions where the broadcaster/ production company will insert their own text according to the language they will broadcast in.

texturing the process of applying/painting textures to 3D characters, sets, props and effects. Textures can be taken from natural resources (stone, metals, grass, wood grains, etc.) or created artificially. The most common software used for texturing is either Photoshop or Detailer.

TGA file a graphic file format that supports 1 to 32 bit images. Sometimes called a targa file, it stands for truevision advanced raster graphics adapter.

3D animation computer animation using models that have been created in a 3D space.

3D animation blocking the first stage of the 3D animation process, also referred to as 'set-up'. It is where the overall timing and in and out character poses are established.

3D animation first pass the second stage of 3D animation, where the character movements are animated, and if applicable the motion capture files are placed into the scene. At this stage the scene does not contain the facial expressions or lip-sync.

3D animation second pass the third stage of 3D animation, where all of the elements in the scene are finessed. Expressions are added, lip-sync is activated, and fade out/ins are placed into the scenes according to their intended durations.

3D modelling the process of making a 3D character, prop or location model for the purpose of 3D computer animation.

3D Studio Max a software package used to create 3D models and animations.

thumbnails small illustrations done by a storyboard artist in order to map out the storyboard in shorthand before embarking on the rough panels.

TIFF file a Tagged Image File Format used to present graphic images.

timecode the numbering of every single frame of picture. The standard representation of this is in hours, minutes, seconds and frames—e.g. 01:01:30:00

timing the time taken for a character to perform the action in the scene. This needs to be set ahead of the actual animation.

timing director an experienced timing artist responsible for all timing decisions for a show where there is no animatic. If an animatic is produced, the timing director will create the exposure sheets based on the animatic while further honing the timing aspects of the show.

topographic map a map of a location that indicates the spatial relationship between landmarks and their terrain.

total breakdown list a list containing all of the scenes from the storyboard together with their location or background number, overlay, underlay, overlay/underlay numbers, atmosphere notes (day/night) and all characters, props and special effects that appear within each scene. This is used as a reference for the layout artists.

TV safe area the portion of the screen that will be visible on all television sets. This accounts for different manufacturing specifications for all television sets and allows for an average field of vision.

2D animation any animation made using hand-drawn images that are shot in succession and played back at speed to create the illusion of movement.

underlay any element placed underneath part of the animation.

vector graphics a digital image format that is comprised of objects made up of mathematical calculations. Vector images are able to be scaled up or down without any loss of picture quality.

vertical pan a camera move along a background either from top to bottom, or bottom to top.

VHS tape the video home system tape, which is a half-inch analogue tape.

visible time code also referred to as 'time code display', or 'burnt-in time code'. This is where the time code of a program is burnt into the video picture so it is visible when the tape is viewed.

voiceover a voiceover line is one where the character doing the talking delivers the line when they are not on screen. This type of line is also commonly referred to as an O/S, or 'off-screen' line.

voice talent the actors who provide the voices for the animated characters.

voice/talent casting the process of auditioning and selecting the actors who will provide the character voices for the project.

WAV file a sound file format developed by Microsoft for PC playback.

webeo an animated web streaming production. The term is usually connected with streaming animated music videos or shorts. The average webeo is between five and seven minutes long and is less then 1MB in size.

work print a copy of a negative film print which is used to perform the editing process in order to preserve the original negative. Also called a cutting copy.

workbook a breakdown of the storyboard panels used to create a detailed visualisation of each scene. The workbook will include details on the full scene composition, exact character poses and movement, light and shadows, camera

positions and movements, transitions and effects and screen direction. The workbook is then used as a basis for the layout production.

writer's bible a detailed extension of the pitch bible, this document will contain the locked-down character and environment descriptions, story arcs and plot lines and will be used as reference by all of the project scriptwriters.

zip pan (or whip pan) a very quick pan achieved by blurring colours or speed lines. It is commonly used as a transition between scenes.

Resources

Further reading

Acuff, Dan S., *What Kids Buy and Why: The Psychology of Marketing to Kids*, Free Press, New York, 1997.

Anderson, Gary H., *Video Editing and Post-Production: A Professional Guide* (Fourth edition), Focal Press, 1998.

Corsaro, Sandro and Parrott, Clifford J., *Hollywood 2D Digital Animation—The New Flash Production Revolution*, Premier-Trade, Muska & Lipman, 2004.

Cotter, Bill, *The Wonderful World of Disney Television: A Complete History*, Hyperion, New York, 1997.

Erickson, Hal, *Television Cartoon Shows: An Illustrated Encyclopedia, 1949–1993* (Second edition), McFarland & Company, 2005.

Kerlow, Isaac V., *The Art of 3D Computer Animation and Effects* (Third edition), John Wiley & Sons Inc., New Jersey, 2004.

Laybourne, Kit, *The Animation Book* (New digital edition), Three Rivers Press, New York, 1998.

Peaty, Kevin and Kirkpatrick, Glenn, *Flash Cartoon Animation*, Friends of Ed, 2002.

Pilling, J. (Editor), *A Reader in Animation Studies*, John Libbey & Company, Sydney, 1997.

Raugust, Karen, *The Animation Business Handbook*, St Martin's Press, New York, 2004.

Scott, Jeffrey, *How to Write for Animation*, Overlook Press, Peter Mayer Publishers Inc., 2003.

Winder, Catherine and Dowlatabadi, Zahra, *Producing Animation*, Focal Press, 2001.

Funding bodies/information links

Australian Film Commission—www.afc.gov.au

Australian Film and Television Links—www.fti.asn.au/links

Bavarian Film Commission Fund—www.film-commission-
 bayern.de/index.php?Sprache=DE&SeitenID=2

Britfilms—www.britfilms.com/resources/fundinginformation

Canada–CIFVF—www.cifvf.ca/english/about-en.html

Centre National de la Cinematographie—www.cnc.fr

German Federal Film Board (FFA)—www.ffa.de

German Funding Resources—http://asef.on2web.com/subSite/seaimages/
 Europe_ResourceDirectory_Germany.htm

Guide to film financing—www.fundingfilm.com/page/page/870227.htm

Irish Film Board—www.filmboard.ie

Irish Film Institute—www.fii.ie/links.asp

Singapore Economic Development Board—www.sedb.com/edbcorp/sg/
 en_uk/index.html?loc=home

UK Funding Bodies—www.artscampaign.org.uk/funding

Worldwide film association links—www.mfilms.com/index.php?page_id=18

Regulatory bodies

The American Motion Picture Association—www.mpaa.org

Australian Broadcasting Authority—www.aba.gov.au

Australian Office of Film and Literature classification—www.oflc.gov.au

British Board of Film Classification—www.bbfc.co.uk

Canadian TV Classification System—www.media-awareness.ca/english/
 resources/ratings_classification_systems/television_classification/
 canadian_tv_class_syst.cfm

Federal Communications Commission (US)—www.fcc.gov

Film France—www.filmfrance.net

Singapore Media Development Authority—
 www.mda.gov.sg/wms.www/aboutus.aspx

Magazines

Animation Journal—www.animationjournal.com
AWN Magazine—www.awn.com
Computer graphics world—www.cgw.com
Digital Media World—www.dmw.com.au
Digital Video Magazine—www.livedv.com
Kidscreen—www.kidscreen.com
Toon Magazine—www.toonmagazine.com

Software

3D Studio Max—www.discreet.com
Adobe Premiere—www.adobe.com/products/premiere
Adobe Streamline—www.adobe.com/products/streamline
After Effects—www.adobe.com/products/aftereffects
Animation Stand—www.animationstand.com
Animo—www.cambridgeanimation.com
Avid—www.avid.com
AXA—www.seeq.com/popupwrapper.jsp?referrer=&domain=axasoftware.com
B3D Studio—www.brilliantdigital.com
DigiCel—www.digicelinc.com
Final Cut Pro—www.apple.com/finalcutstudio/finalcutpro
Lightwave—www.newtek.com
Macromedia Flash—www.macromedia.com
Magpie—www.thirdwishsoftware.com
Maya—www.alias.com
Media 100—www.media100.com
Microsoft Excel—www.office.microsoft.com
Microsoft Project—www.msproject.com
Movie Magic—www.likemagic.com.au/pages/mmshome.htm
Photoshop—www.adobe.com/products/photoshop
Pulse—www.pulse3d.com
Reallusion—www.mobile.reallusion.com/technology.asp
Retas Pro—www.retas.com
US Animation (Toon Boom)—www.toonboom.com
Viewpoint—www.viewpoint.com
Wild Tangent—www.wildtangent.com

Market-places

E3—www.e3expo.com
Film Market Reference—www.allfilmmarkets.com/markets.htm
Milia—www.milia.com
Mipcom—www.mipcom.com
Mipcom Junior—www.mipcomjunior.com
MIPTV—www.miptv.com
NAB—www.nab.org
Napte—www.natpe.org
Siggraph—www.siggraph.org
Tokyo International Animé Fair—www.taf.metro.tokyo.jp

Motion capture systems

Optical motion capture systems

Adaptive Optics Associated—www.aoainc.com
Charnwood Dynamics—www.charndyn.com
Measurand Inc.—www.measurand.com
Motion Analysis Corporation—www.motionanalysis.com
Northern Digital Inc.—www.ndigital.com
Phoenix Technologies Incorporated—www.ptiphoenix.com
Vicon Motion Systems—www.vicon.com

Magnetic motion capture systems

Ascension Technology Corporation—www.ascension-tech.com
General Reality Company—www.genreality.com
Polhemus Inc.—www.polhemus.com

Mechanic Motion Capture Systems

Digital Image Design Inc.—www.didi.com
Puppet Works—www.puppetworks.com
Virtual Technologies, Inc.—www.immersion.com

Hybrid Motion Capture Systems

Digits 'n Art Inc.—www.dnasoft.com
Motion Systems—www.ptiphoenix.com

General reference

The American Federation of Television and Radio Artists (AFTRA)—
 www.aftra.org

The Animation Academy—www.theanimationacademy.com

Animation film society—www.asifa-hollywood.org

Australian Media and Arts Alliance—www.alliance.org.au

British Actor's Equity—
 www.4rfv.co.uk/outside.asp?id=5545&to=www.equity.org.uk&cat=159

Graphic file formats—www.dcs.ed.ac.uk/home/mxr/gfx

Screen Actor's Guild—www.sag.org

Television Broadcast standards—www.ee.surrey.ac.uk/Contrib/WorldTV, or
 www.kropla.com/tv.htm

The Union of British Columbia Performers—www.ubcponline.com

Index